Beginning Research in the Arts Therapies

of related interest

Music Therapy – Intimate Notes
Mercédès Pavlicevic
ISBN 1 85302 692 1

Music Therapy in Context
Music, Meaning and Relationship
Mercédès Pavlicevic
Preface by Colwyn Trevarthen
ISBN 1 85302 434 1

Music for Life
Aspects of Creative Music Therapy with Adult Clients
Gary Ansdell
ISBN 1 85302 299 3

Art-Based Research
Shaun McNiff
ISBN 1 85302 621 2 pb
ISBN 1 85302 620 4 hb

Music Therapy Research and Practice in Medicine
From Out of the Silence
David Aldridge
ISBN 1 85302 296 9

Beginning Research in the Arts Therapies
A Practical Guide

Gary Ansdell

and

Mercédès Pavlicevic

Cartoons by Lutz Neugebauer

Jessica Kingsley Publishers
London and Philadelphia

First published in the United Kingdom in 2001 by
Jessica Kingsley Publishers Ltd
116 Pentonville Road, London
N1 9JB, England
and
325 Chestnut Street
Philadelphia
PA 19106, USA.

www.jkp.com

Library of Congress Cataloging in Publication Data
A CIP catalog record for this book is available from the Library of Congress

British Library Cataloguing in Publication Data
A CIP catalogue record for this book is available from the British Library

ISBN 1 85302 885 1

Printed and Bound in Great Britain by
Athenaeum Press, Gateshead, Tyne and Wear

Contents

Figures and Tables

Hints and Tips

To our teachers and our students:
who join us in the community of inquiry

Every act of looking turns into observation, every act of
observation into reflection, every act of reflection into the making
of associations; thus it is evident that we theorise every time we
look carefully at the world.

(Goethe, *Scientific Studies*)

Acknowledgements

Many people have helped us to produce this book.

Our students on the Master of Music Therapy training course at the Nordoff-Robbins Music Therapy Centre in London have survived much of the material in the book and have offered feedback on its usefulness (a few even laughed at Gary's jokes).

Getting teaching material into a publishable form takes time, and we are grateful to Pauline Etkin (Director of the Nordoff-Robbins Centre, London) for allowing us to spend some work time on this project. She also arranged a flight to Johannesburg for Gary (through the generous sponsorship of KLM via the Nordoff-Robbins charity) for us to have an intensive week of writing early in 2000.

Our hosts for the writing week in South Africa were Millie and Magda – who provided a log cabin, summer tranquillity, long dinners under the bougainvillaeas, geese, a duck pond and gin in their wonderful home in Onrus, near Cape Town. Their warm, relaxed hospitality was essential and inspiring.

Thanks to Lutz Neugebauer, cartoonist and music therapist, who has added humour and visual stimulation to a potentially dull subject.

Finally, thank you to Stuart Wood for commenting on the material at an early stage and Benita Pavlicevic for her contributions to Franz' data analysis.

Gary Ansdell and Mercédès Pavlicevic
London and Johannesburg, August 2000

Preface
Beginning Research: Sustaining Inquiry

Perhaps you've picked this book up out of an interest in researching your work. More likely it's out of panic! You may need to research a dissertation for your MA course; or your current or potential employer has demanded that you write a research report to 'evaluate your work'. If your motivation *is* 'panic' that's fine by us.

Be reassured straight away that a certain amount of panic is only to be expected if you've trained primarily as a practitioner in an arts therapy and suddenly find, for whatever reason, you need to do research. The *image* of research is, we admit, daunting. The reality is, however, more manageable – as we hope to show. This book has developed from our own experiences of beginning research and of teaching students beginning theirs. We know that it can be embarrassing to ask professional colleagues about the real basics, to admit you don't know how to search the literature or use a database, that you confuse 'quantitative' with 'qualitative' or don't know a Chi-square from a cheesecake!

We've therefore set out to explain the process of 'beginning research' in four stages, outlining what you need to plan, know and do. To lighten what could become a rather dull text we've added a subplot: the research adventures of art therapist Franz Mozarella and music therapist Suzie Kaftan. Franz has to provide an evaluation report on his work for his boss while Suzie has to write a dissertation for her MA. We follow them through the triumphs and travails of the research process – and also see how their supportive relationship develops… But don't treat it too literally – perhaps the pair also represent a developing allegorical relationship between words and numbers, thought and feeling, art and science, Apollo and Dionysus…

Only in recent years have arts therapists become involved in researching their own work (rather than have it researched by professional researchers). Each of the arts therapies now has a number of 'research experts' in their midst, as well as students on Master's level training courses who are learning research methods and producing dissertations. A growing body of home-grown research is resulting from their efforts. This is a wonderful result in a short time.

A down-side to this has perhaps been that published material on 'researching the arts therapies' has tended to be rather philosophical, debating what *kind* of research is needed. Much recent debate between those researching the arts therapies has centred around whether research should be *qualitative* or *quantitative*. This argument has often turned from being one on methodology to what David Aldridge (1996) has called 'methodolatory' – the worship of the method. Indeed, as Aldridge remarks, some people have spent their time arguing for method rather than doing research.

Our book suggests that you find more about what you really want to research, and *how* you want to research this, by actually *doing* it. For this you will need basic research skills rather than the intricacies of methodological debate. True, you could always turn to research guides in other subjects such as psychology, but you then need to 'translate' their advice for the arts therapies, and for their unique research issues.

Consequently, we have set out to write an intentionally *practical* guide, only touching briefly on the philosophical and political aspects of research. Our belief is that, whatever kind of research you do, there is a common endeavour: of *sustaining inquiry* into well-developed questions that emerge from real-life situations; investigating them rationally and critically and communicating the knowledge gained to colleagues within and without your discipline.

We're rather against this trend of portraying qualitative and quantitative methodologies as irreconcilable choices – and especially of the almost moral tone as to what arts therapists *should* do. As will become apparent to you in this book, we take a rather pragmatic line on methodology, although Franz' and Suzie's very different research aims, designs and products represent a quantitative and a qualitative approach respectively. We suggest that your methodology of choice will simply depend on what you are trying to do. We should not just ask 'which method?' but 'what for?'

We write this book as two music therapists, teaching a research course and supervising students writing research dissertations for a music therapy Master's degree. We hope, however, that the basic guide to research which this book outlines will apply equally to any of the arts therapies, which have grown from very common soil, and share many common research needs and problems.

We are not specialists, however, in other arts therapies and consequently you will need to make certain 'translations' for yourself from the basic 'recipes' we offer. And while nominally Franz is an art therapist, his project is not much involved with the process of his work. You will therefore still need to look at the literature of your own arts therapy in order to find guidance to the subtleties of researching that particular medium, and to use its research practitioners for specialist advice.[1]

Finally, we wish you well! Research is by turns scary and exciting; terminally frustrating and one of the most intellectually satisfying pursuits. What it is *not* is a quick, cursory dip into an area, which is why we characterise research, in any form, primarily as *sustained inquiry*. A process first, an attitude towards your work and your openness to understand more about it – for yourself, for others. In moments of doubt a researcher keeps looking, listening and thinking.

All research is concerned with the nature of argument and evidence. As a start to your thinking consider this story on the subject, featuring the Sufi Wise-Fool Mulla Nasrudin:

> Sitting one day in the teahouse, Nasrudin was impressed by the rhetoric of a travelling scholar. Questioned by one of the company on some point, the sage drew a book from his pocket and banged it on the table: 'This is my evidence! *And* I wrote it myself.'

> A man who could not only read but write was a rarity. And a man who had written a book! The villagers treated the scholar with profound respect. Some days later Mulla Nasrudin appeared at the teahouse and asked whether anyone wanted to buy a house.

1 We have indicated specialist 'research terminology' throughout the book by bold type. Ours is not the book to treat all of these concepts in detail, but we urge you to look them up in other more general research textbooks.

'Tell us about it, Mulla,' they said, 'for we did not even know that you had a house of your own.'

'Actions speak louder than words!' shouted Nasrudin, and from his pocket he took a brick, and hurled it on the table in front of him.

'This is my evidence. Examine it for quality. *And* I built it myself.'

(Shah 1985: 82)

STAGE 1

Preparing

Research needs careful preparation. Not just sharpening your pencil and making sure your calculator still works, but preparing ideas about what you might want to research (Chapter 2) and then plotting and planning how you can carry such research through (Chapter 3).

Beginners' Nerves

Getting started – Thinking about research, theory and practice

Franz and Suzie sip cappuccino in the famous North London haunt, Café Mozart, after a long (and to Suzie somewhat panic-inducing) day at the local Arts Therapies Research Symposium.

'I need a title ready for the seminar next week,' says Suzie, 'and I haven't a clue what to do! And today didn't help either – all that talk of "qualitative" this and "quantitative" that and "phenome"… I can't even say that one! I mean, what's all that got to do with art therapy? But if I haven't got any ideas by next seminar, Peter Purt, who's my tutor, will give me one of his looks!' (Franz, listening to Suzie, suddenly catches himself giving her one of his looks and quickly looks down at his cappuccino.)

Suzie blows the froth on her cappuccino and sighs. This was not why she'd gone in for art therapy at Gamut College, she thinks sullenly.

Franz isn't much happier, but for a different reason. He cuts through his Sachertorte with surgical precision as he tells Suzie: 'I thought it was a lot of hot air! I mean, all those self-important people. All they argue about is theory and philosophy! I bet they don't even do it themselves. I mean nobody actually told you what to do! And if I go to my manager in six months' time and say that I'm still thinking whether it's best to do qualitative hermeneutics or action research, he's not going to be very

sympathetic. I thought they were going to actually help me think how I can prove that my work makes a difference at Ivory Leaves.' Franz dissects another slice of Sachertorte and reflects that this was just what he'd suspected the arts therapies were like – flaky!

But as Franz looks over to Suzie, who's got a little moustache of cappuccino froth, life unexpectedly doesn't seem too bad... They decide that the day has been quite exhausting and it's time to go home and have a quiet night in, Suzie to Wembley Park, Franz to Bayswater. Before leaving, Suzie and Franz swap telephone numbers. 'In case I hear of any other courses which might help you,' adds Suzie, blushing imperceptibly as she sticks a little yellow 'Post-It' note on Franz's black leather jacket.

Performance nerves

The time has come – and there's no getting away from it or hiding behind jittery nerves. Research is knocking at the door. Either it is your Master's dissertation, or pressure from the line manager at work, who may also be under pressure from the hospital, school, day centre or clinic accountant to justify funding your post as an arts therapist. Or you might simply be an enthusiastic arts therapist who needs a bit of pressure and entertainment. You decide to do a research project.

You know that your skills are in actually *doing* the work: being a therapist, writing up reports, putting together presentations, perhaps even fundraising for instruments or art materials. But 'research' feels different; more serious – even just a bit more important. You are going to have to put your nose down, tweak your mind towards sustained inquiry and produce a piece of research. 'Evidence-based research' is what everyone's talking about these days and you feel a little unsure of yourself... and where and how do you begin research in any case?

Let's look at some of the thoughts you might be thinking.

Some notes (of caution and encouragement)

I've got loads of clinical experience – have worked with this patient group for many years, and read papers at conferences – surely doing research shouldn't be too difficult?

Traditionally (i.e. a long long time ago), arts therapists wanting to do research would approach (or be approached by) an expert in research methods. This would be a psychologist or a researcher in one of the social sciences. This usually disempowered arts therapy clinicians, who continued to be therapists, and became adjuncts to the researchers – unless they themselves became researchers. This often meant mysteriously acquiring new thinking skills and an ability to distance themselves from their practice. Does this scenario appeal to you? Do you think it is useful to arts therapies research?

An encouraging development in arts therapies research is that increasingly, since the early 1990s, arts therapists are 'doing it for themselves', rather than getting 'researchers' to 'do' their research for them *about* arts therapy practice. In other words, we can all do research, by extending our clinical skills towards this most exciting endeavour.

The thinking emerging during the 1990s is that practitioners who extend themselves to include research in their working lives (rather than leave aside being practitioners and embracing research) are uniquely placed to do research, having an insider's knowledge and understanding of the practice. But there are some difficulties. One is that as a researcher who is also a practitioner, you need to be aware of your personal, professional and clinical biases and see how or whether these can interfere with the way that you plan your project, the way that you write about it, your data collection, data analysis and so on (more about this later).

Your finely honed therapeutic skills and clinical intuitions will enrich your thinking about what you want to do, what questions you want to ask, and what answers you are looking for. You now need some research skills. Your clinical enthusiasm needs to be married to a different structure of thinking and working: that of research. In terms of what research to do – or what to research – do remember that the most useful research studies in terms of professional development are those that speak directly to clinicians, to your colleagues. Your questions might fascinate you personally – and, as

you'll see, they need to fascinate you to fuel your researcher's zeal – but do they have wider relevance? More about this later.

I've no time!

We've no sympathy here, so get this thought securely out of your mind. The truth is that there is *never* enough time – and research *always* feels pressured. In fact, we suggest that feeling pressured is the only way to actually 'do' it – but you can help yourself to minimise 'deadline' pressures by being organised. We'll offer you a few 'lifelines' (and 'deadlines') with regard to planning your time. Having too much time can work against you – you're far less likely to complete your project without time constraints.

I wasn't good at maths at school, numbers don't make too much sense

Research doesn't necessarily mean counting or measuring, and incidentally, doing research doesn't even mean that you are a clever clogs. Rather, your capacity to be patient, dogged and organised is what will stand you in good stead. Plus a bit of flair, of course, and an openness to absorbing new concepts, including statistical ones, not to mention words with different meanings (such as 'normal', 'significant', 'internal validity' and 'process': more about these in Chapter 9). In any case, many research skills are non-mathematical: research in the arts therapies can involve many skills you've used or associate with your own training or work as an arts therapist.

I'm not very good at writing – and as an artist, I think in pictures (or music or movement) rather than words

Yes, of course, thinking in words is different from thinking in sound or form or movement – but these are not necessarily antithetical to one another. Nor does thinking in words mean that you need to stop thinking in artform. On the contrary, the latter enriches our thinking and conceptualising. (We hope you like Lutz' cartoons.) But there's no getting away from writing, since your research 'product' will undoubtedly involve a written text. A good place to start is to think about reading. How often does something you read not keep your interest? Despite the content of the text being interesting, sometimes weak or incoherent writing can get in the way. We suggest that you write as much as possible, as soon as possible, and throughout this book we'll be

urging you to stop reading and get writing. It is a skill that comes with practice – and with being self-critical. It is not enough to 'just write'! You need to monitor constantly what and how you are writing. And don't be afraid to prune your writing: after all, the most severe pruning gives the best blossoms in spring (more in Chapter 4).

I'll drive my partner insane

Not only your nearest and dearest, but probably your friends as well. Don't feel too badly about it – 'sharing and caring' is our motto. And in fact, do talk about your project – endlessly if necessary: talking, like writing, is a good way of getting your thoughts in order – using words.

So let's get started. Let's leave nerves behind.

Research – what it is and what it is not

> Research is a systematic, self-monitored enquiry which leads to a discovery of new insights which, when documented and disseminated, contributes to or modifies existing knowledge or practice.
>
> (Bruscia in Wheeler 1995: 21)

What does this mean? Do we really understand the quote above?

Systematic

This means not haphazard but focused, organised, with a rigorous method. Research is not simply having good ideas and stringing them together in a fit of creative enthusiasm. Nor is it putting together a collection of pictures or musical examples from clinical work with a client. Perhaps we can think of research being a series of steps, of activities, that relate to one another in a planned way. Part of the planning of a research project comes from becoming familiar with existing research methods, and drawing from these each step of the way. In other words, your planning (rather like your practice) is informed rather than being only spontaneous.

Self-monitored

This means constantly checking your own thinking, your own 'doing' of research – where you are in the context of the total research project. This means being able to be both inside *and* outside the research process – rather like being a therapist, some might say.

Inquiry

This means gathering information in order to address your research question, organising your information and reflecting on it in order to gain new insights and outlooks about your project. You need to check out earlier scholarship: who is already working in your field? What sources do you need to acknowledge? What peripheral inquiries do you need to explore? What gaps have you identified in existing scholarship? And so on. You then muse about it, look at it again – perhaps from another angle. Your constant reflecting helps to gain new perspectives, knowledge, concepts and explanations. You also need to return to various parts of your project over and over again, and refine your thinking and doing each time. Remember that research is a cyclical activity.

Contributing to existing knowledge

This means making your findings and insights accessible to colleagues through communicating them, rather than letting your project collect dust. Write it up for a journal, or present it at a research or professional seminar with colleagues. Don't hog your project. Don't be secretive about it – you risk depriving yourself of interesting and challenging comments and questions. As we've already said, research is seldom 'new'. This means that although 'your' research idea might feel new (and exciting), you do need to rummage around (as we shall see in Chapter 4) and find out what has already been done and written about in your area of interest. And remember: your research will contribute to this area too.

Reading research

We'll look more closely at 'how to read' in Chapter 4. In the mean time, though, we suggest that you continue reading this book critically: this means

monitoring for yourself what you agree and disagree with, what you find helpful and why, why not, and so on. Be vigilant! Be critical!

Practice, research and theory

Perhaps at this point, we need to clarify the distinction between practice, research and theory – each closely connected to the other.

- **Practice** aims to 'treat' clients. It is that part of the work involved in doing sessions, in writing up and preparing sessions, and also in liaising with other colleagues, reporting on the work, and so on. In other words, practice *does*.

- **Research** aims to develop knowledge and provide new insights into the work, by studying, possibly, the practice itself.

- **Theory** not only draws from, and connects with, other theory (whether philosophical, psychological or biological) but also is based on research and practice. Theory describes, organises, supports and explains – it can provide a framework that helps us to make sense of what we do, as practitioners and/or researchers. Remember the Greek root of the word: *theoria* = to view (see Figure 1.1).

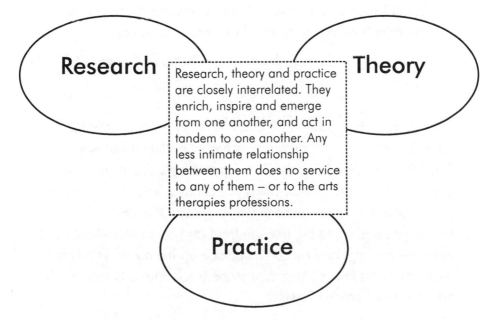

Figure 1.1 Research, theory and practice

Here we have emerging overlaps: that research, theory and practice overlap with one another and influence one another. This, of course, has implications for us being both practitioner and researcher, since it would be naïve to think that either role can be kept separate from the other – as we shall see later on.

Leaving nerves behind

Here are some questions we suggest you can ask yourselves at the beginning of your research project:

- What does my research seek to find out?

- What questions do I want to answer?

- On what areas of knowledge will I need to draw?

- What do I, as a clinician, already know that is relevant?

- What are likely sources for the information I need? What already exists – and what can I add to it?

- What are the potentially useful ways of doing the research – what methodological options do I have?

- What limits must I set in the scope of my project?

- What obligations do I have to fulfil concerning the course requirements or research reports at the workplace?

(Adapted from Orna and Stevens 1995: 21)

'I'm going to show John Audit that just 'cos I'm an art therapist doesn't mean I can't think,' muses Franz, cycling down Kentish Town Road and dodging the 214 bus to King's Cross. 'It's a bit like cycling: a nice clear bit when you can just weave between the traffic, and then other times when you're stuck with the 214 behind you and some big truck in front and cars everywhere, and everyone hooting, and carbon monoxide up my nose.' The lights turn green and Franz plunges past the truck, into a long smooth ride towards Camden Town.

Hints and Tips
Get organised!

- Get organised! Buy some nice notebooks and pens, make space to store information (more about this in Chapter 3) and get some healthy food into the refrigerator and some wine!

- Begin reading 'critically' (more in Chapter 4) – this book is a good place to start – and keep notes of what you read: do you agree with what you read? Why? Why not?

- Stick to your project parameters once you've defined these (more in Chapter 3). Check and recheck what is being asked of you.

- Don't give up being creative, playful, intuitive, painting your nails, listening to music – and, above all, don't take yourself too seriously!

Figure 1.2

What Turns You On?

Working Titles and Research Questions

Locating a research area – Appropriate research areas – Turning a research area into research questions – 'Open' and 'closed' questions – Working titles

A week or so after the conference, Suzie scribbles furiously in her pink notebook. She's frustrated when the phone interrupts:

'Is that Suzie? It's Franz Mozarella. I was wondering how your research was going?'

'I think I've got it,' says Suzie (thinking that, though Franz looks quite cute, he sounds rather awkward and gauche on the phone). Suzie launches into her latest idea:

'I've just been scribbling reams of notes ready for tomorrow. We have to outline our ideas and develop a title at Peter Purt's seminar. It all came last night when I was watching TV and this nun who lives in a caravan came on, standing in front of a painting and talking about why music is so important for her. She said that art was healing and how some pieces of music give her energy. That's just what I've found myself – both last year on the course when we spent all that time in the studio just making music, and also when I observe my patients playing music. In fact, I realise that's why I'm doing a music therapy training – I mean, I really believe that this is what happens – music gives people energy!

Franz thinks to himself that this all sounds very vague, and certainly not what he thinks research is. More like up-market journalism! But he doesn't want to spoil Suzie's enthusiasm. She'll find out soon enough.

Suzie suddenly stops talking, realising she's wittering. 'What about you, Franz? Are you any further with your topic?'

Franz feels that what he has to report is a lot more boring than nuns in caravans enthusing about the energy of music.

'Well,' says Franz, 'I'm a little further on — John Audit suggested I go and see Carmen Statistica in the Psychology Department in the hospital. She's a bit frightening — jet black hair, vampy clothes and topaz earrings.'

Suzie takes an instant dislike to this Carmen woman.

'She asked me what I was doing, but before I'd described my idea she was pulling out all of these rating scales and test batteries, all of which had acronyms.

"Don't worry about the process," she said, "Put all that in a nice black box — what we need to show is how something is bigger and better afterwards than before… We are scientists, Franz — always remember that!" The more she talked the more confused I became about what I actually did want to research — I got kind of mesmerised by those earrings.'

'Mm,' says Suzie, wondering which earrings to wear if she meets Franz again.

What interests you?

Anyone who has ever done research will tell you that, if you're not to some extent personally invested in your inquiry then you're unlikely to get through the slog of the research process. Rewards there are too, but the slog is undeniable. You will need to invest much time and energy into doing research, so make sure there's something in it for *you*, that you are tackling a question you want to answer for yourself.

We suggest you start by working through the following three questions in developing your research inquiry. Your answers will begin to guide the next stage of your explorations. Make notes for yourself under each question.

What is your motivation for beginning research?

Are you researching for your own personal reasons or is it imposed by others (the requirements of a course or employer)? Is it possible to 'marry' the two in some way? As an arts therapist you are in a lucky position of researching a relatively new profession, where many fascinating areas and questions have yet to be tackled. So almost anything you do will be useful in building up a more comprehensive account of your practice. It will doubtless also be helpful to others.

What do you need to end up with?

A dissertation? (If so, how long?) A report? (Again, how long?) A journal paper? Consider realistically how much time and effort you can devote to research given other commitments. Check at this stage the guidelines for course dissertations; consult with an employer on *precisely* what they are expecting from you in terms of a 'pilot' or evaluation study.

What are the obstacles to researching your possible area?

For example: ethical clearance, confidentiality, restrictions on data collection, lack of appropriate technology. Also personal circumstances such as family commitments.

Reflecting on these questions will help you to balance your own interests against other requirements and potential problems.

If you're still having trouble focusing your area of interest we suggest that you brainstorm two different possibilities, then apply the questions above to them. Make the first possibility an area or question which fascinates you in your clinical work, and the second one which troubles you.

How you go about designing your research will be closely connected with the research questions you formulate – which will in turn relate to the area you are researching. So let's look now at what, in the broadest sense, might be appropriate research areas to choose.

What are appropriate research areas?

Much research in the arts therapies falls into one (or more) of the following areas.

Practice

What therapists do in the therapy room with clients (and how clients present or react). Here research might be about *clients* – their conditions, experiences and therapeutic needs; about the *treatment* – therapy techniques and modes of intervention and client responses to these; or about *client–therapist relationship* – the nature of this in an arts therapy, how it's the same as or different from other treatment models, the influence of it on the process and outcome of the therapy.

Discipline

How a body of knowledge helps to organise what and how therapists think about practice. Here, research areas might include: assessment models (both from within and outside your discipline); theoretical models and technical vocabulary; the usefulness of various theories; therapists' case-study writing; connections between artform theory and practice and the therapeutic applications of these.

Profession

How therapists organise themselves and present themselves as a group of practitioners. Research area might include the organisation and structuring of the profession; training; employment patterns and practices; history of the profession; political and socio-economic factors that affect the arts therapies as professions.

Intra-disciplinary and inter-disciplinary research

There might be some overlap between these areas as research is seldom as neat as we'd hope. A further distinction we can make is between **intra-disciplinary** and **inter-disciplinary** research. With the former your inquiry keeps within the boundaries of your particular arts therapy. Inter-disciplinary research focuses instead on the relationship *between* an arts therapy and another practice, disciplinary or professional area (for example,

how music therapy relates to physiotherapy or how the theory of art education relates to art therapy practices). Another possibility of inter- or cross-disciplinary research might involve borrowing a research method or theoretical model from another discipline.

Turning a research area into research questions

When you've found an area of interest, the next stage is to focus this with a **research question** (or questions). There are two types of research questions: **'open' questions** and **'closed' questions** (Figure 2.1).[1]

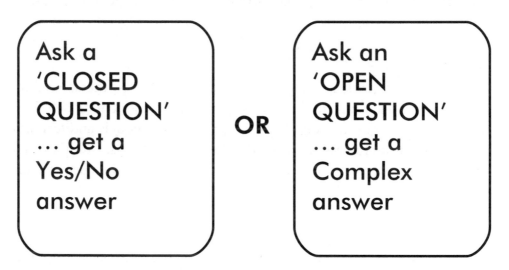

Figure 2.1 *Types of research questions*

Closed questions produce yes/no answers while open questions produce more complex discussions. Rather like the interviewer's nightmare, a yes/no answer may not get you far if your aim is to explore the 'meaning' of your work. But equally if you have a precise question you need or want to answer,

1 Here is an instance where research discourse appears insensitive. The terms 'closed' and 'open' questions do not have the same meaning as a person who is 'closed' in the therapeutic or psychological sense. Rather, closed (or open) research questions orientate you towards the kinds of answers, data collection, research methodology or methods of analysis that your research design will generate. Neither is better or worse, more or less limited than the other: more critical is that you ask the right 'kinds' of questions to get the answers you need.

developing a closed question will help you focus your research. So you need to think about whether:

- your research question(s) need to be closed and focused from the beginning

- your research questions need to *probe* your research area in open-ended ways and to develop as your inquiry takes shape.

Let's look at how Franz and Suzie's ideas work from an area of interest towards a research question.

By chance Suzie sees the nun on the television make a statement about music giving people energy. She relates this to her own experience of her music therapy placement and what she's observed happening to her patients. This becomes her 'area of interest', and if we were to categorise her interest within the 'research areas' in the previous section, we'd say it was to do with clinical practice: she's interested in music seeming to give people energy not just in an abstract or general sense, but as something she herself has observed in a clinical situation. But notice this is not quite a question yet – let alone a fully defined 'research question' which can serve as the basis of a research project.

In contrast Franz has little choice about his research area, or even the questions he will ask. As we'll see later on, Franz is getting help from Carmen Statistica (the psychologist at the University Statistical Support Service) to research the therapeutic 'outcome' of his work. As a clinician, Franz is actually interested in more than this – but he also needs to keep his job and so must not follow his personal agenda too much at this stage.

Both Suzie's and Franz' positions are a mixed blessing. Franz' research is narrower and more focused – Mr Audit wants facts and figures to see whether art therapy is economically viable at Ivory Leaves Mental Health Unit. His research question is likely to be a 'closed' one. Suzie, on the other hand, is free to research what really interests her, as a clinician. She has more scope to be individual and creative in moulding her research area, but is also

prey to ending up in a muddle. Her 'open' research questions are inevitably more complex and will tempt her towards side issues.

Refining your area of interest into research questions is a crucial stage, as the kind of questions you ask will determine what kind of answers you get (what kind of results) and how you will set about finding such answers (your methodology).

Look at the following research questions and ask yourself: what kind of questions are they? What kind of answers do they lead to? What kind of thinking have they been generated from? How would you go about answering them? Is there anything wrong – from a *research* stance – with how the questions are posed? (Hint: what does the question 'give away' of the questioner's attitude?)

- Is music therapy effective in the treatment of anorexia nervosa?

- How does co-creating a picture enhance adolescents' experiences of relationships with adults?

- Can the therapist's assumed technical skill inhibit spontaneous movement by clients in dance-movement therapy?

- What is the role of twentieth-century acting theory in the development of dramatherapy?

- Do group music therapy sessions reduce problematic behaviours in clients with advanced dementia?

These questions could also form the title of a research inquiry. Finding a 'working title' for your project is another way of focusing what you are doing. Working title means you may not quite have got your final title. It is still 'in motion' so to speak – liable to change as you proceed, up until the cut-off point when you have to submit your final title (usually with your research proposal). The next section will look at some examples of working titles in order to help you think through different ways of developing your project.

Developing a 'working title': Some examples

These examples come from dissertations we have supervised on a Master's music therapy training course.

Example 1

Working title: *Why Do We Sing? Investigating the Significance of Vocalisation for the Therapeutic Relationship in Creative Music Therapy*

The therapist's motivation for this question comes from her clinical practice as a student, when she used singing with both a non-verbal child and a verbal adult client. In both instances, singing seemed to lead to a closer relationship between therapist and client.

Notice the structure of the title. Her main question ('Why do we sing?') is an open and broad question, which is followed by a statement which further defines the context of the research by identifying the music therapy approach (creative music therapy rather than, say, behavioural music therapy or music psychotherapy). The title also states what the research intends to do: her interest is the impact of a therapeutic technique (singing) on the therapeutic relationship, and she aims not just to describe the phenomenon of singing but to 'investigate the significance' of it – that is, she will be *evaluating* a technique. Many implications are contained in this short sentence, which formulates both a research question and an agenda for the research project.

Example 2

Working title: *Discontinuous Music Therapy: A Contradiction or a Challenge? Interrupted and Short-term Relationships with Adult Clients*

Here the statement comes first – in a seemingly novel phrase, 'Discontinuous Music Therapy'. This sentence is then qualified by a subtitle which limits the project to adult clients. This study emerged from a student's experience of working with clients whose illness prevented them from attending regularly. Her 'personal question' was whether the work she was doing was 'proper therapy' and whether it contradicted or challenged the 'theory' she was getting as a student – which suggested that 'proper therapy' was continuous and developing. During the course of the inquiry she developed a new concept – 'Discontinuous Music Therapy' – and within her research design she set out to investigate other therapists' experience and attitudes towards this phenomenon.

Example 3

> **Working title:** *Is Music Therapy an Effective Intervention in the Rehabilitation of Persons Suffering from Chronic Schizophrenia?*

The therapist was not particularly motivated by this question. But she was applying for a research grant, and the grant-awarding body required 'hard' research on cost-effectiveness of services. Within the project, however, the therapist was able to structure in some of her own interests which had come from clinical practice (and which were more specifically musical and theoretical). In the title the word 'effective' instantly alerts us to the nature of this study: that it may have a cause–effect structure and addresses a specific and single issue – the rehabilitation of chronic schizophrenics. The advantage of choosing this population is that they are an easily identifiable clinical group and there is a high concentration of adults with this illness. Thus, in terms of an experimental study, the therapist could be sure, before beginning her data collection, that the research question can be addressed. Before fixing this research area and working title the therapist received a lot of advice from clinicians specialising in this patient group, as well as from a statistician working in social science research.

Defining and clarifying 'working questions/titles'

We hope that by now you understand that your research title and research question(s) are worked over many times before being settled on as the clearest they can be. At this stage you will have a 'working title' and 'working research questions'. The title is an overall statement or question that identifies your project, and your research questions are more specific pointers to what it is you want to ask. Work out for yourself now:

- a **working title** – which may initially be in the form of an overall question
- a main **working research** question
- subsidiary questions which lead on from this.

As we'll see in Chapter 5, the form of your title and research questions have implications for research methodology, design and methods of data collec-

tion and analysis. Return to your working title and questions when you've informed yourself more about these areas.

An essential part of 'working over' your title and research questions is to become 'critical' about your use of language: not just what 'vocabulary' you use, but about the thinking underlying the words you use. Let's look again at the title of one of the inquiries we presented earlier:

Discontinuous Music Therapy: A Contradiction or a Challenge? Interrupted and Short-term Relationships with Adult Clients

This title breaks up into:

- a main title and a subtitle. The main title contains a statement (which seems like a jargon term) followed by a question.

- a set of smaller definitional terms.

Looking critically at this title we would ask the following questions:

- *Discontinuous Music Therapy*: Whose term? Is it the author's? Or is she using an already recognised jargon term? If it is not in everyday usage in music therapy, is it self-explanatory (or does it need further definition and qualification)?

- *A Contradiction or a Challenge?* In what way does this question refer to the first part of the title? What does this question imply? What are the implications of the terms 'contradiction' and 'challenge'?

- *Interrupted and Short-term Relationships:* What's the difference between the two?

- *With Adult Clients:* This defines who the research will study – though you might want to ask what kind of client groups.

And finally: does this title leave anything important out? You will need to define and qualify all of the major terms in your title and questions, so for each of them ask yourself as a final check:

- Is this term mine, or someone else's?

- Whose then? From where?

- What are the other possible meanings of this term?

- What do I mean by it?

- What are its implications or associations?

- What context is this term usually found in?

Another way of checking whether your title is adequate is to imagine it on a database, and ask whether it is self-explanatory and self-sufficient, without an accompanying abstract. For the title above, the database entries might be: (i) <Music Therapy> (ii) <Adult Clients> (iii) <Short-term Therapy>. On locating the title to this research we may also want to know what *kind* of adult clients. Also, since 'Short-term Music Therapy' is not commonly used in database entries we might want to use simply 'Short-term Therapy'.

Thinking about research is also thinking about how words work. Being sensitive to the language you are using to build your ideas will stand you in good stead for the remainder of the research process. As many a fairy story cautions: *be careful of the questions you ask.*

3

Plotting, Planning and Playing Safe

Planning tasks – Time-lines – Getting organised – Backing up

Though a bright New Year's Day, a bench on the top of Primrose Hill doesn't feel quite the place to be at the moment, thinks Suzie, shivering in the icy breeze.

'I'm catching what sun I can,' says Franz, 'before going to Cape Town tomorrow for ten days – I can't look too pale! And Aunt Millie's offered me her little cottage for a reading holiday – just what I need before really getting down to my project.'

Suzie tries to hide her envy (which is tinged with longing).

'So Franz,' says Suzie, 'what did John Audit say before Christmas?'

'"Go ahead", basically. He got me my £1000 from the Trust – the scary thing is that I've actually got to do it now. And what I know about experimental research is dicey. My psychology course at college was years ago – I've forgotten most of it! But I've got Aunt Millie's cottage – I'll take a pile of books and mug up about design and all of that. And you? What did dear Dr Purt have to say about your proposal?'

'Not much,' says Suzie. 'He talked about how it was so important that I find my own way without him telling me what to do – something about the destination being on the path, or

something. Anyway, he told me to go and acquaint myself with the world of research by reading his book first of all!'

Franz and Suzie laugh. Suzie had asked Franz along to the Gamut College Christmas Party, and Peter Purt had spent quite a time chatting to Franz. Franz had found him quite fun. Suzie had felt a twinge of… (no, that could wait for her therapy when Perpetua returned).

How to do it: Planning time and tasks

You've (more or less) sorted out your title and research questions, and now need to start planning the project as a whole before you begin drafting your research proposal (more in Chapter 5).

A supervisor of Gary's had once advised: '*dream backwards, plan forwards*' – in other words, keep an eye on both end-points of your project, *both* beginning and end, while also being fully engaged in the present. At the same time, remember to keep track of what's required in 'external' terms, and what you want to get out of your study – the 'internal' factor. To do all these, you need to plan properly so that you *don't* end up:

- doing years of detailed research when what's required is a short project

- never finishing your project because you lose sight of why you're doing it

- producing the 'wrong' project (e.g. a philosophical treatise instead of a factual report).

So, before you go any further:

- **Check** your requirements: what format does the project/report/ dissertation need to be in? How long?

- **Check** whether the procedures you need to do in order to answer your research questions are possible in the time-scale you have, possible in terms of research ethics, and possible in terms of access to clients / information / material you need.

- **Check** whether you have access to the hardware you need for your inquiry or access to funding to obtain these. Equipment might

involve nothing more than a computer. On the other hand, you may need complex technology, a film crew, reams of digital video tapes, etc.

- Be realistic NOW!

Since, at this stage, your project may seem rather large, daunting and unmanageable, you need to break it up into tasks, then do some time management by anchoring these segments within a 'real time' structure. Doing this now will help you feel a lot better – and will also give you an overall view of the actual research activities.

Task planning

The basic structure of most research projects is similar. We'll illustrate this with something we've developed called the 'Bow-tie Model' – or, if you're a strict mechanist, the 'Double-funnel Model' (see Figure 3.1). This shows not only the structural segments of a typical piece of research but also something important about the logic of any research enquiry. The left-hand 'wing' of

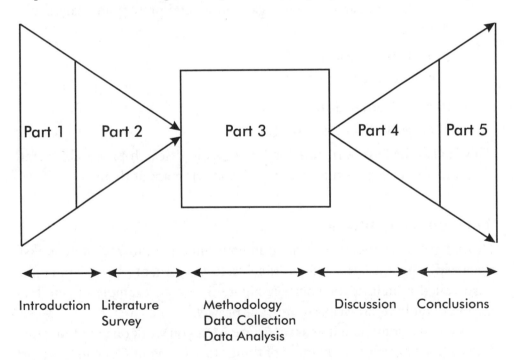

Figure 3.1 The 'Bow-tie Model'

the bow-tie represents how your Introduction and Literature Survey 'focus down' on to the bow-tie 'knot' in the middle, which is the piece of research you are doing. The Discussion and Conclusions segments in the right-hand 'wing' then serve to 'focus up' the relevance of your findings for the wider picture.

With this ideal shape in our minds we can now break down the research process into manageable tasks based on the segments of the Bow-tie Model:

- **Part 1: Introduction**
 Sets the project within a clinical / personal / academic context, defines the area of study, the background, and focuses the research questions.

- **Part 2: Literature Survey**
 Puts your inquiry into context of what others have already thought, done and written about.

- **Part 3: Methodology, Data Collection, Data Analysis**
 Justify why your inquiry proceeds as it does, document data collection, data preparation and organisation, and present an analysis of the data.

- **Part 4: Discussion**
 Compares the results to Part 2.

- **Part 5: Conclusions**
 Suggest relevance of findings.

This is also the basic structure for writing your research proposal, so start thinking about each of the steps now – and write about them!

Time-lines and lifelines

Having got this structure organised in your mind (and in your notebooks), you need to put the 'task' and the 'time' factors together to create a time-line (also called a lifeline) for yourself. Figure 3.2 is an example of one that assumes you have 20 weeks to do your project.

As you see, some activities are concurrent. As you work on your Literature Survey (Part 2), you already think of things to say in your Conclusions (Part 5). Also, even after completing your Literature Survey, you may continue to

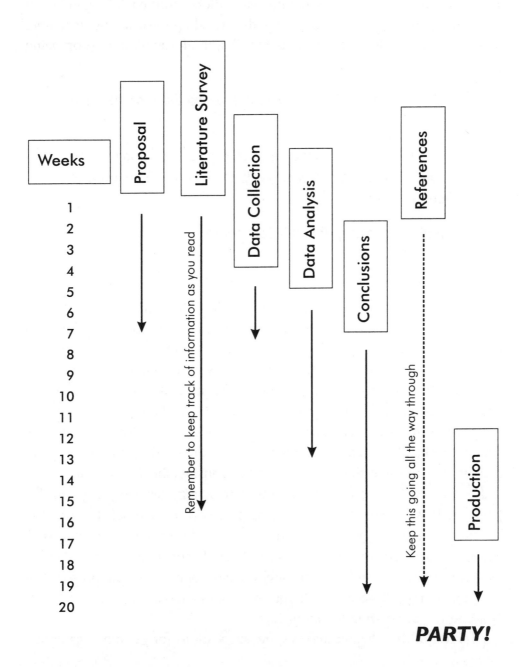

Figure 3.2 Research time-lines

find things to add to it. We've left Week 20 purely for production: all researchers have stories of disks getting lost or files corrupted, falling in love at the wrong time and getting totally distracted, photocopying machines playing up, geese developing a taste for Chapter 4, the binding shop being closed until further notice.

'I shall finish on July 13,' says Franz, showing Suzie his neat plan in his Filofax.

'Oh,' says Suzie, for whom a research project is an imaginative enterprise, not a planned one. 'Well, the Heath will be lovely to wander on by then!'

Franz almost looks up from his Sachertorte.

Get a system

Rather like the estate agent's credo of 'location, location, location', the researcher's is *organisation, organisation, organisation*. It's a wise researcher who decides at an early stage how to organise the research material, instead of leaving piles of articles unsorted and disorganised heaps of notes, quotes and references. If your strategy up to now has been to use the cat's basket we strongly recommend that you devise a system. Hours being wasted at a later stage trying to locate references and quotations, or forgetting that you've already read and made notes on the subject you're writing-up, are not good uses of your research time and will lead to considerable frustration.

So spend a few hours and pounds at this stage devising a system for yourself. It will also encourage you to *process* your material. Information becomes knowledge only once you've processed it (more in Chapter 4). A paper photocopied is not a paper read and noted; tapes unlabelled (and unlistened to) are not data useful to the ongoing development of your project. You need quick, reliable access to all your research material, i.e. to the information and to your own notes about it.

The rest of this chapter makes some suggestions for getting organised.

System suggestions

Hardware

You might consider using any of the following to contain your research material physically:

- notebooks (colour-coded – red for ideas, blue for data, pink for diversions)

- loose-leaf files with loads of dividers

- card-index boxes (large ones for subjects – write notes on articles or books on these and file under subject heading – small ones for just bibliographical information, organised alphabetically)

- box-files for photocopied articles

- lots of 'Post-It' blocks for notes on books and your own writing.

Distinguishing between 'items' and 'records'

Orna and Stevens (1995) distinguish between an *item* and a *record*. An item is a book, article, set of notes or pictures, while a record of that item is something that represents that item. You may need to store both of these types of material and to ensure easy access and cross-reference between them.

You can put *items* in their containers in two ways:

- grouping like with like (files, categories in files, e.g. autism, cubism, early psychoanalysis, etc.)

- adding items as they are collected and numbering them.

Our own preference would be the former – as it encourages you to read or at least scan an article when you first collect it in order to decide how to classify and store it. If you do this you're more likely to remember having read it. Moreover, when you need (and find) a paper, there will be others in the same section on similar topics that will catch your attention and arouse your interest.

Indexes

A key way of organising diverse material is to *index* it. An index is a tool (usually arranged alphabetically) which points to all the different places where you will find information about a given topic. The simplest way of organising an index is with *index cards*, which you keep in card-index boxes. You can have an *author index* or a *subject index* or you might have one of each, as cross-reference.

AUTHOR INDEX

This keeps a record of details of books or articles by a certain author. Make sure that you put all the relevant bibliographic information on your author reference cards. Here is a checklist:

- **author** surname and initials

- **full title and subtitle** of book or article

- **journal title** and edition, year and pages of relevant article (e.g. 13(1) 1999, pp.23–31.)

- **publisher**, year and place of publication

- if a **book chapter** record both details of the chapter and the book (including names of editors)

- always mark on your index cards a **location** for the material: it's no use later knowing that you've got a certain article or notes on a book if you can't find *where*, such as which library the book is in, which box-file an article can be found in, etc.

SUBJECT INDEX

Compile this from the **keywords** of your main topic and research questions. One problem of any categorisation system is that some material fits into more than one subject category, i.e. an article may have more than one of your keyword categories. In this case **cross-reference** it and write these additional keywords along the top of the article. And on each of the relevant subject index cards, write the authors and dates of the papers that fit under this particular subject (see Figure 3.3).

Be punctilious about keeping your indexes up to date. Keep a folder for new articles, read them on the train and after reading write keywords on the top of the article and file it as soon as you can (don't just let a huge pile build up on your desk). This fairly simple system should ensure that you keep a hold of your material.

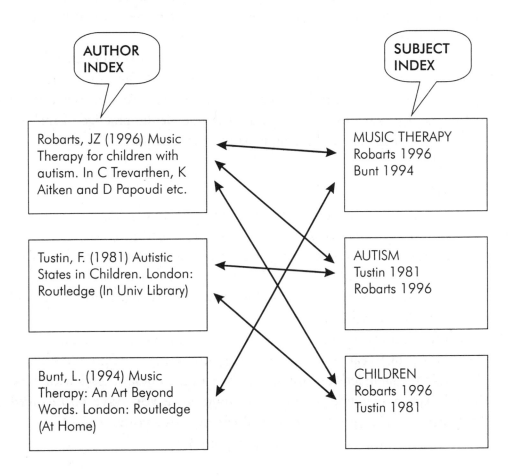

Figure 3.3 Author and subject cross-referencing

Keep full bibliographic details

It's easy to get lazy in keeping a record of the details of books and articles. Believe us, you will regret this when you come to write up your work in any way! The small time spent as you go along noting the full details and creating good cross-referencing is nothing compared to the frustrating hours you will have to spend at a later stage tracking down the publishing details of a book in a library somewhere or trying to remember the name of the other paper you've read on autism and family therapy.

As we will see in the section on referencing, this is where academics become super-pedantic – references are required to be in *exactly* the same form throughout and with all the required information. This, of course, is not just being pedantic: it's part of good overall academic practice of making your work transparent and accountable to others' work.

Play safe!

Some of the following advice may seem obvious, but is worth writing if it prevents a single person losing vital data or text at a critical moment in their research. Our caution comes from each of us having bitter experiences of accidentally corrupting disk files, with no recourse to a hard disk or a copied floppy. The only option, in both instances, was to retype reams of pages and we could tell you worse stories.

So our motto is 'Play Safe' from the beginning. Give a little thought as you begin your research to how you are going to fight the gremlins of our electronic age (and, let's be honest, our own all too human lapses with these things). The basic advice is simply to **make sure you have copies and back-ups of all important material throughout your project**.

Take note of the Hints and Tips in Figure 3.4.

Hints and Tips
Play safe – use a copy!

- **Copy** your raw data – whether audio or video tape, paintings or photographs.

- **Print out** as you go when working on drafts of chapters – before your hard disk corrupts (and mark each draft clearly – include its date).

- **Photocopy** your key 'primary data' before the dog chews it up.

- **Keep** at least two back-up disks of your analysed data and chapter drafts-in-progress before little green men press the 'trash' button on your computer.

- **Keep** your duplicate disks and photocopied material in different locations in case of flood, fire, earthquake or lightning.

- If you work on more than one computer (e.g. home and office) keep a 'pigeon disk' to transport files between them – but guard against viruses.

- **Label** everything: disks, notebooks, files, drafts. It's easy to erase your latest draft, or to hand in an old one.

Figure 3.4

STAGE 2

Catching Ideas

Your next stage is to find what others have already done on your subject and to write this up. Chapter 4 guides you through what we call the '3 Rs' of the research process: reading, writing and referencing.

4

The '3 Rs' of Research
Reading, Writing and Referencing

*Reading for academic purposes – Doing a
literature search – Sourcing information –
Converting information into knowledge – Planning
a literature survey – Writing for academic
purposes – Drafting – Referencing*

Introducing the '3 Rs'

Whether you're researching electrons or elephants there are some funda-
mental research procedures, which we've called the '3 Rs' of research. This
chapter will outline the processes of finding information relevant to your
inquiry, reading large amounts of material efficiently, and writing a review of
this as a literature survey. Though you may already be a prolific reader and
writer, we've found it common that beginner researchers often feel
unconfident about how to read and write for a specifically academic
purpose. If this is you then this chapter may help.

SECTION A: READING FOR ACADEMIC PURPOSES

Reinventing the wheel?

Arguably, 'reinventing the wheel' is a useful educational exercise. Some pro-
gressive theories used to maintain (a long time ago when we were at school),
that it's better that you find out something for yourself than be told. Like
Suzie, you may feel you've located a good research area out of your own
practice and you're developing some interesting questions. It's always

annoying (and embarrassing) when some clever person tells you that, far from being stunningly original, your ideas sound rather like so-and-so's work.

To prevent this situation, fairly early on in the research project researchers go through a process called **reviewing the literature**. This means checking whether anyone else has already done what you're planning to do, or has at least written something related to what you're interested in. Reviewing the literature will also sharpen your thinking on a subject.

It's not a disaster if there is already work on your area – or even if someone has done an almost identical inquiry. As Franz commented to Suzie, 'Nobody's entirely original!' You can use the groundwork done by others, since it's unlikely that your project will be exactly like someone else's (though it may be similar). And in some forms of research, it's necessary that some researchers attempt to *replicate* a study. Within a qualitative research approach, however, the unique factors which make up the inquiry tend to make exact replication difficult (and unsuitable). Nevertheless it's always useful to compare similar research projects, even if they have different contexts. This ensures that your readers know that *you* know about this work!

This section will give some advice on searching for literature and then writing this knowledge up as a **Literature Survey**. As a prelude to this here's a teaching story on searching from the Sufi tradition:

> Nasrudin was found searching his yard. 'What are you looking for?' asked his friend. 'My key,' said Nasrudin. They searched for an hour to no avail. 'Well, where do you think you lost it?' said the friend, to which Nasrudin replied 'In my house.' 'Why are we looking for it in the yard, then?' said the friend. 'Because it's too dark in the house, stupid!' replied Nasrudin (Shah 1983: 9).

Searching the literature

Orna and Stevens (1995) call this aspect of the research process 'going fishing' – trawling for information which will be relevant. We could extend this metaphor to suggest how we also have to search for areas in which to search. A term from the Internet revolution, the 'search engine', makes it clear how, within a mass of information, the difficult thing is actually getting

to what you need. It's hard work, so we suggest you approach the search in a logical way, as follows.

Step 1: Begin with yourself

Take a piece of paper with your title and research questions on it and draw a spidery map of associations. Start with what you know: your own field. The arts therapies are not yet vast fields of knowledge (unlike most academic disciplines), so you'll be able to start by thinking (or asking colleagues) about papers and books which are directly related to your project. But don't stop here! There will be relevant material outside your immediate discipline, in related areas. For example, if your research question is 'What role does therapist intervention play in group art therapy?' then you'll start by looking at how this issue has been tackled by other art therapists (if at all). But it would also be relevant to look at therapist intervention in group situations within other disciplines (other arts therapies, psychotherapy or perhaps even art teaching). You then begin to build up a bigger picture of ideas and research – to put your own research ideas within the context of others' work. Ask colleagues what they know, use your fellow students – often it's easier to fall upon the literature for someone else's project than it is for your own!

An important differentiation made by researchers is between **primary sources** and **secondary sources** of information. Primary sources are original documents, first-hand accounts, statements and interview material. They comprise 'raw' information not yet arranged, edited or interpreted by anyone else. If you are doing historical research such sources might provide your research data. If you are researching something contemporary you will generate data from your own primary sources in the course of the research. In contrast, secondary sources are papers, reports and books written by people who discuss facts, ideas and circumstances by presenting their reflections, selections and versions of primary material. It is secondary sources you locate and discuss as part of the literature survey process.

Step 2: Hunt further afield

When you've reached the limits of relevant books and articles on your own shelves and in a specialist library, you will need to use more systematic search processes to make sure you're not missing a key source. This is where indexes

and databases come in. But in order to use these we need first to look at the concept of **keywords**.

Step 3: Devise keywords

In a book index a name, noun or noun phrase helps you to match up the page number with the idea you're looking for. This is the principle of **keywords** (although 'keywords' is a slightly misleading term, since what you're looking for is generally a noun phrase rather than single words). Electronic databases ask you to type in key nouns or noun phrases. So before searching you need to decide in a precise but flexible way what the keywords of your project are. Let's go back to our previous example: 'What role does therapist intervention play in group art therapy?' The key bits of this are:

- **therapist intervention (role)**

- **group art therapy (therapy)**

The words in parentheses indicate a broadening of the basic keyword concepts – a kind of 'lateral thinking' is essential for this work. For example, if you type <therapist intervention> into a database for arts therapies and related therapies publications it may come up with 20 entries. If you then follow this with <therapist role> it may produce 20 more suggestions (some of which may be far from what you're looking for – but some might well be interesting). Equally, after trying <group art therapy> you might cast your net wider and try the broader <group therapy> which might direct you to allied fields. It's a matter of trial and error, but the key to the process of useful searching is to keep thinking flexibly (laterally) – thinking of synonyms of your keywords. Look sideways instead of just ahead!

Step 4: Use databases

Once you've typed in your keywords, databases will then give you 'entries' – usually the name, title and (if you're lucky) location of an existing book or journal article. But there are many different kinds of databases, so the first step is to ask a librarian to help you locate the one that's right for you. Armed with well-thought-out keywords you will be ready to use a variety of 'search engines' to find appropriate sources in various forms and locations. These might include:

- Indexes in books.

- References and bibliographies at the end of articles and books. These represent the sources the author has used – you can often use this as a starting point for a wider search.

- Library databases on paper or computer which detail books and journals (remember to hunt out small specialist libraries).

- CD-ROM specialist databases – ask your professional association for details on these.

- Internet sites – the databases of many world-class libraries, institutes and organisations are now available.

The details of each of these are too complicated to include in this book, but the principles of searching, trawling and accessing sources are roughly the same for all of them – despite the differences in technology level.

What's relevant? Too many or too few sources?

You should have now found something 'out there' that seems relevant to your inquiry. You may even have got hold of some of it, or perhaps even be staring at a list of 134 'hits' resulting from your first keyword search on a database. This is when the trouble begins!

There are two possible scenarios at this stage: either your search produces masses of references and you're not sure which (if any) are relevant, or the search produces nothing! Let's take the more likely of these for most people – 134 references staring at you. If you're working within the arts therapies this probably means that your keyword search is too broad. Your stategy with all these sources should be first to tackle the articles and books that are 'nearer home' (to give you an orientation to the ideas) and then work further out when you're ready. On databases you may also find that if you read the abstract (the brief summary of the article) which usually accompanies the title, you'll find that the majority of the 134 references are in fact not so relevant to your interests after all.

If you're in the second scenario – shocked at finding no references – then never fear! Your task this time is to look broader, at associated fields which might seem only indirectly relevant. If there really is nothing (a conclusion you come to after a decent honest time of searching) then you will need to

describe this fact in your written Literature Survey – stating why and how there's nothing (odd as this may sound). This may be the appropriate start in outlining what you want to do and why you want to do it – because nobody seems to have done it thus far.

Converting information into knowledge

Databases, articles, references – all of these can provide an indigestible amount of information at this stage. So it's worth our while stepping back a bit now, and considering the relationship between information and knowledge. The goal of doing research is to produce new knowledge, not just to amass more information. But it can feel at this stage of the game that we have much more information than knowledge, and are not certain how to separate out the sheep from the goats!

Orna and Stevens (1995) have a useful model of an information/ knowledge 'loop' (for our version of this see Figure 4.1). This is relevant to dealing with a literature survey, as well as later in the research process when you may get equally overwhelmed by your own information in the form of new research data.

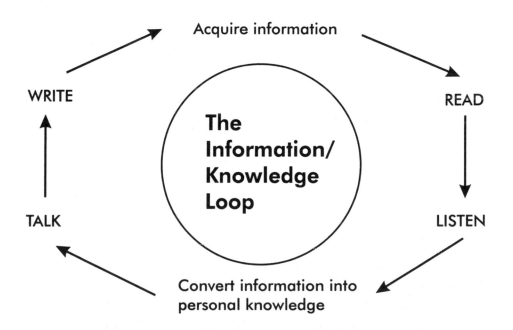

Figure 4.1 The information/knowledge loop (developed from Orna and Stevens 1995)

The temptation for us all is to store information (which is always in a form 'out there') without digesting it inside us (making it personal knowledge). Some of us underline bits in books, perhaps intending at some later point to digest these. But mostly, of course, the underlined passages stay as information rather than becoming fully digested knowledge.

Equally, when working with databases and gathering information in a literature survey, there's a tendency to copy out material parrot-fashion, intending to sort it all out later. It's actually more important to process all of the information as you go (even if this means gathering less). In short, you need continually to convert the information you find into knowledge that you own. And as knowledge (which we might also call understanding) it will develop and help the next stage of your search. As you read, evaluate and compare literature there's a quick 'learning curve' in your subject which helps you decide where to go next in the search – when to narrow it, when to broaden – to decide how many of those 134 texts might actually be relevant.

An important aspect of the 'loop' is that our knowledge in turn becomes information for others (but because, as knowledge, it is 'digested' it has our view as part of it). Reading in a particular way, and writing summaries, comments and comparisons are essential parts of the process of 'reviewing the literature'. We'll look at some of these aspects after the interlude.

> *Despite needing to finish a second draft of his Literature Survey, Franz picks up the phone.*
>
> *'Suzie? I was wondering how you were doing?'*
>
> *'Oh, I'm having great fun with Cassirer and Bachelard – it's fascinating! I'm just racing through it all.'*
>
> *'Is it relevant to your nun's idea?' asks Franz.*
>
> *'Oh, I haven't thought much about that!' replies Suzie. 'But let me tell you about energetic symbolism.'*
>
> *And she does. Twenty minutes later Franz is still listening, or rather, is listening to Suzie's nice voice, and the passion with which she talks about ideas and writers. He thinks how dull his sources are. Suddenly Suzie stops.*
>
> *'Oh, Franz, I'm sorry! I've been burbling on, I haven't even asked how you're getting on.'*

'Well,' says Franz, 'Mine's a bit more boring – there was no problem getting information from the database in the Psychology Department about client re-attendance, there seems to be loads of work on that. I've copied down hundreds of references on my new computer card-index program, which...'

Suzie interrupts. 'But are they interesting? Do they inspire your research?'

'I don't know about that,' says Franz.

'Why not?' says Suzie.

'Because I haven't read them yet!'

'Franz, you're a silly! Don't leave them without converting information into personal knowledge. Peter Purt insists on that!'

Then Suzie asks Franz if he'd like to meet her again at the end of the week.

'Let's go to a film this time,' she says, 'It'll prevent us from talking about you-know-what!'

Franz tries to enter <Suzie.research.film.friday> on his palmtop diary, but the battery has run out.

Critical reading and bedtime reading

This episode in Franz and Suzie's research adventures brings up an important issue: *how* we read for research purposes. Franz and Suzie have two different problems regarding reading – each of which may well cause trouble for them as researchers.

Suzie has found good things to read and is admirably engrossed in her Bachelard (in a way that any author would wish). This is what we could call 'bedtime reading' – the kind that we do to be absorbed, transported and entertained. Only reviewers and obsessives write notes on the novel they're reading. Suzie's approach is fine in a way – it will get her acquainted with the key texts of her research area – but, as Franz' response to her suggests, she isn't reading these texts critically in relation to her developing research questions. She's putting off this more difficult thinking stage of reading until later. But the fact is that most of us have only very limited time to complete our research, and it's unlikely that we will read whole texts more than once.

So during that single reading it makes practical (and academic) sense to make notes, mark passages of interest and actively think about how the author's ideas, data and interpretations relate to your own research area.

Franz, however, is doing the opposite of 'bedtime reading'. He's being a good researcher in one way: organising all his references into a database, but what he isn't doing is actually reading them! Again, he's missing the chance of using the literature to help him develop his own ideas as soon as possible.

Like most academic procedures, what's required of *reading* and *writing* is that they be **critical** and **comparative**. Let's take these two concepts in turn, as they are key to approaching all styles of research in the right way.

Critical reading

In the academic sense this isn't the same as saying someone is a 'critical person'. Instead it means that as a reader you actively engage with an idea, an argument or a piece of evidence (spoken or written) rather than simply accepting it at face value (bedtime reading). In other words, you *evaluate* it: you form a considered opinion as to the value of the idea, argument or data presented.

This means asking various questions about the material you read: from the simplest 'What is this text about?' to more complex questions such as:

- Where is the author coming from? (What context – historical, social, intellectual – is the author writing from?)

- Are there ambiguities, omissions or hidden traps in the argument? How does the form of the argument influence how you read it?

- Do the data or argument challenge (or support) similar material you've read on the subject?

- What do *you* think of how the author presents his or her case? Are you convinced?

Get into the habit of reading critically – your own reader or examiner will be thinking in these terms when considering your arguments. Bear them in mind when you write and construct your arguments.

Contrary to what you may have been told, you need to write on texts when reading them critically (assuming you own them or have photocopied them, of course). Someone once said that, while in the academic world you

could get a fair way without talent, you wouldn't get far without a pencil. The Hints and Tips in Figure 4.2 give some advice about devising a system for annotating texts.

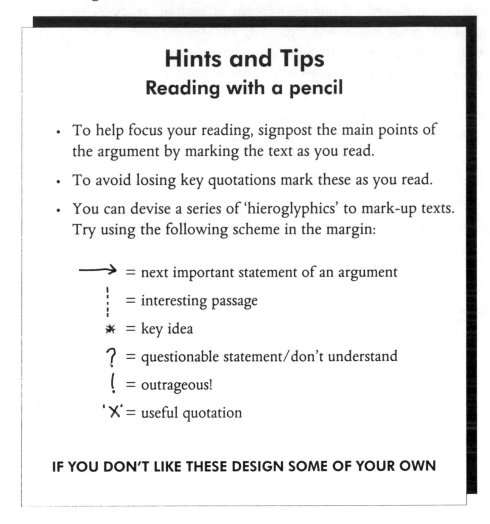

Hints and Tips
Reading with a pencil

- To help focus your reading, signpost the main points of the argument by marking the text as you read.

- To avoid losing key quotations mark these as you read.

- You can devise a series of 'hieroglyphics' to mark-up texts. Try using the following scheme in the margin:

 ⟶ = next important statement of an argument

 ⋮ = interesting passage

 ✳ = key idea

 ? = questionable statement/don't understand

 (= outrageous!

 'X' = useful quotation

IF YOU DON'T LIKE THESE DESIGN SOME OF YOUR OWN

Figure 4.2

Comparative reading

This means not reading texts 'in isolation' (as Suzie is wont to do) but constantly comparing and contrasting them (as the old-fashioned essay titles always bid us do). This relates to the scheme of reading we mentioned earlier – asking how Text B you are currently reading relates to Text A which you read yesterday on a similar subject. The two texts may contain similar data,

but draw different conclusions from it, or, alternatively, may offer different kinds of evidence for similar conclusions, and so on. As a research reader you need to make a critical comparison of the texts: don't take them at face value. All writers (however 'scientific' they may present themselves as) are actually trying to make you believe them. Your job as a **critical-comparative reader** is to subject their texts to fair and thorough scrutiny.

Notes and quotes

You cannot begin writing your (convincing and well-contextualised) proposal until you have a fair feel of the literature: what's been done, what's missing or what you might like to replicate. The process of 'fishing and trawling' will lead you to amass notes on literature both helpful and unhelpful to your inquiry. Your notes should include material about the *content* of the literature and your *evaluation* of it (as explained). If you find especially clear passages of writing, copy these out *verbatim* – they may be useful as quotations later. If you've not written academic prose for some time it might be useful to turn your notes on the literature into formally written prose, as practice. This will get you back into writing and will also mean you have something 'concrete' to show for the weeks (and possibly months) of work on your project thus far.

> *Contrary to their declared aim to work all week and socialise only during the weekend, Franz and Suzie are having a drink at the King William pub in Hampstead.*
>
> *'Did you read it yet?' asks Suzie.*
>
> *Franz looks uncomfortable. 'Yes…it was a…lovely postcard,' he says. He looks distracted.*
>
> *Suzie blushes. 'Not that, silly! I mean my Literature Survey.' Franz takes a sip of Guinness.*
>
> *'Be honest,' adds Suzie, hoping he'll have liked it and she won't have to think about it again.*
>
> *'Well,' says Franz, his tone indicating to Suzie that he didn't. 'To be honest it reads rather flowery to me – not what I'd have thought academic style exactly – there are too many metaphors*

and anecdotes, and the argument kind of spirals rather than going from A to B to C.'

 Suzie tries not to look hurt, and takes a slug of her gin and tonic instead.

 'I mean, it's good writing,' adds Franz hastily, 'but perhaps for a novel rather than a dissertation. Anyway, what about mine?'

 Suzie pauses and takes a rather larger slug of her drink. 'Well…you certainly can say with yours that it goes from A to B to C, but to me…I'm sorry, Franz, it's rather dull! I think it's because you're not in the writing yourself – the prose doesn't communicate the interesting and sensitive Franz I know and…' Suzie blushes again. They both take sips of their drinks and look around the pub. Suzie notices several men looking at Franz. Odd, she thinks.

 After a slightly awkward pause Suzie says, 'Anyway, what time's this film? We'd better get moving.'

SECTION B: WRITING FOR ACADEMIC PURPOSES

Putting pen to paper

Many people beginning research are reluctant to commit themselves to paper. Partly this is being intimidated by the idea of writing 'academic prose', which people believe to be a totally different species from a love letter (the latter they feel quite capable of writing, the former they've not done since college – if at all). While we won't deny the fact that academic writing is in many key ways different from love-letter writing, there is also at least one similarity: namely that the *process* of writing helps to develop thinking (and feeling). And that both kinds of writing are cultivated only by practice.

 The idea of *writing* as a practice is the central message of a helpful book by Gail Sher (1999) – *One Continuous Mistake: Four Noble Truths for Writers* – which we thoroughly recommend if you have 'writer's block'. Sher blends a Zen Buddhist perspective with her experience as a writer, and suggests the following 'Noble Truths':

1. Writers write.

2. Writing is a process.

3. You don't know what your writing will be until the end of the process.

4. If writing is your practice, the only way to fail is not to write.

(Sher 1999: 5)

The last of these underlines the need to *just get on and do it* – even if you don't feel ready. The following sections of this chapter aim to reduce the mystery of writing for academic purposes by going over what the expectations are in terms of style and organisation of material. We seriously advise you to get writing at this point of your inquiry. Why not write a love letter too!

'Academic prose' and writing style

To call someone's prose style 'academic' is not necessarily a compliment. What we mean, however, by 'writing for academic purposes' is not a style which is dry as dust, impersonal and tedious (Suzie's impression of Franz' draft), but one which is clear, logical *and* vibrant. It doesn't of course mean that just because you have a good prose style then the content is necessarily good (or vice versa), but you should aim to be conscious of *how* you are writing up your research.

But writing is not just presentation, or just style. Writing about a subject can be as good a way of learning about it as reading. Writing requires that we order the facts and our thoughts about them, and then structure arguments in order to communicate something effectively. There's a real connection between good thinking (or at least *clear* thinking) and good writing. As with most things, perhaps, there is probably an 'innate talent' factor at work in making some people write more naturally than others, but there are also approaches and tricks which can help improve how to style and structure written work. Our view is that it's certainly worth *working* on writing in an academic style as part of your developing research skills.

Primarily this involves giving attention first to *style* (asking what's appropriate to a dissertation or research proposal/report) and second, to the *organisation* and *structure* of a review, argument or discussion of research material.

Styling writing

Franz' and Suzie's styles (as reported in the pub) represent two polarities – neither of which is desirable for their purposes. They need to communicate their ideas and information in a clear, concise and interesting way. But Suzie's 'novelistic' style is too elaborate, while Franz' 'objective' style is too dull. What they (and we) are looking for is a happy medium. These days, both science and arts departments in academic establishments tend to prefer a style of academic prose which is 'transparent but personal'.

While the old impersonal style never used 'I' and took the passive form ('A bunsen burner was lit'), it's now usually fine to use the first person in most contexts. But this does not, however, mean steeping your prose in personal opinion and characterisation. We do not need to know in a case study, for example, that 'John wore unfashionable glasses that offended my sense of taste'. Note, however, with both this and the earlier 'a bunsen burner was lit' style, that a certain prose style automatically involves a certain form of thinking – what's appropriate, relevant, 'allowed'. This itself is a lesson in the ways of research!

Think carefully of the *function* of your project before writing it. How you write it will depend on who it's for. You may, for example, be writing a research report on behalf of a research team and know that it will be read by a manager who expects to dedicate half an hour to reading it. Alternatively you might be writing a 15,000 word manuscript which will be examined by an academic. The style requirements for these two are different – though the central principle of clarity and elegance of writing is common to both.

It's easy of course to say what *not* to do in writing, but less easy to suggest exactly what to do. Our advice is to take a good model and to analyse why it's successful. The twentieth-century philosopher Karl Popper was said to have modelled his clear style on the seventeenth-century philosopher John Locke. So find something not only clear and accessible but also interesting to read, and analyse how the writer has achieved this. Look for example at:

- the balance of information to comment
- how much of the writer is 'in' the prose
- how long the sentences and paragraphs are
- how the text is organised into sections and subsections.

A final thought here is that the challenge for us as arts therapies researchers is to relate clinical material to more theoretical issues. For a classic model of how to do this we need look no further than Oliver Sacks (1985). Freud's work is also exemplary in terms of style and blend of case material and theory. Get reading!

Structuring writing

The poet Philip Larkin remarked that the model for a classic novel's structure is 'a beginning, a muddle and an end'. But while the obscure plot of a novel may intend to frustrate the reader's expectations of a logical ordering of events, if you do the same in an academic paper your examiner may take your *thinking* to be as unclear as your writing.

'Plotting' academic prose is as vital in an article as it is in a novel. The plot of academic writing, however, aims to set out, as transparently as possible, its evidence, argument and conclusions. A structural plot of an academic piece

'Sonata form' structure

EXPOSITION	Introduction of themes
DEVELOPMENT	Argument = Varying treatment of themes
RECAPITULATION	Reminder of original form of themes
CODA	Concluding section

Figure 4.3 'Sonata form' structure for prose

of writing could be as simple as the essay plan we were taught at school: Introduction – Argument – Conclusion. Or it could be more elaborate than this – Suzie would probably think at this point of 'sonata form' in music (see Figure 4.3).

These kinds of structures can be used for the whole of a piece of writing, or in terms of particular sections such as a chapter. Overall, the point we want to make is that whatever the form, the internal logic of a piece of academic prose needs to be transparent to the reader. As Franz comments about Suzie's prose, there's a kind of spiral movement to her argument, instead of the logical progression of a well-structured piece of writing.

Micro-structuring

If you have trouble writing a logical argument we suggest you try a 'micro-structuring' approach. This helps to create a logically evolving writing style for academic purposes (though revert to your instinct when writing love letters!).

Micro-structuring involves four stages as follows:

1. Write a paragraph on the material you're working with (whether summarising other literature or commenting on your own data). Rewrite it until it's 'transparent'.

2. At the end of the paragraph, separated from it (and possibly in another typeface if you're word-processing), write a one-sentence *summary* of the paragraph.

3. Then write a *link* sentence which says how the next paragraph will *logically follow on* from the last (and why you're writing it). Only *then* write the next paragraph.

4. When you're happy with the draft of a whole section (that it fulfils the requirements of clarity and logical follow on) eliminate the summary and link sentences if necessary.

Let's take as an example the first paragraph of this section, and see how we may have planned the logic of it:

• **Summary paragraph 1:** Writing for academic purposes entails being conscious of style and aiming for clarity – but does not necessarily mean being tedious.

- **Link sentence to paragraph 2:** Good writing implies good thinking – expand on how style and structure in writing has implications for 'thinking through writing'.

You don't have to use this technique all of the time of course, but if you have difficulties providing a logical structure to your argument this approach might help you improve it.

Writing a literature survey

Let's apply the advice in this section to a real task you will need to tackle now: writing your literature survey. We will address aspects of both style and structure.

The style of a literature survey aims to reflect the kind of 'critical-comparative' thinking outlined earlier. Here's an example:

> The use of fruit juice as an energy source is well documented (Bloggs 1968), but a central dilemma has polarised the field since Blockhead (1984) suggested that blackcurrant was more effective than orange. Drivel *et al.* (1995) further maintain that dark blackcurrant tends to be more effective than light.

Your prose doesn't need to be this dull, but we hope you see the logic of this example. It both **cites** (with name and date reference) the key texts on the subject and sketches out the ongoing argument which researchers are having on the subject – in this case from 1968 to 1995 (see how stubborn and dogged researchers can be). (Section C of this chapter, on referencing in academic work, will explain the concept of citation more fully.) The reader should finish a well-written literature survey with both an outline of the subject you propose to research and the main arguments and evidence which represents the 'history' of this subject. They should, consequently, understand where you are coming from, and at what point you come into the debate on your research topic.

It will be useful at this point to revisit the 'Bow-tie Model' of the typical shape of a research project which we presented in Chapter 3 (see Figure 4.4). Following the Introduction, the Literature Survey of Part 2 aims to focus the literature down to the particular significance of your inquiry (Part 3). Thus Part 2 puts Part 3 into a context so that people reading it know why you're doing what you're doing and what its significance is within your discipline.

Parts 4 and 5 then 'focus up' – using the conclusions you draw from your data analysis to put the results into the wider context of your discipline again, stating its significance and recommending action if appropriate.

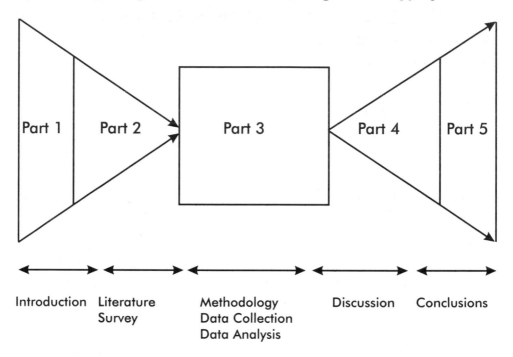

Figure 4.4 The 'Bow-tie Model'

A well-organised literature survey is rather like a good gâteau – in slices. Part 2 thus consists of vertical 'slices' which present and discuss different parts of the relevant literature under subheaded sections in your text, with clear and logical links between them (see Figure 4.5).

Here are some guidelines on organising the 'slices':

- Use the keywords of your research title to organise the slices of the literature survey – you need to cover all of these logically. Start the survey nearest to home – stating how much (or little) people have written in your own discipline on your research area.

- Then branch out to other sources. Be careful not to lose focus when reviewing literature that is only indirectly relevant (going off on a tangent!). Any area has relevance only so far as it relates to

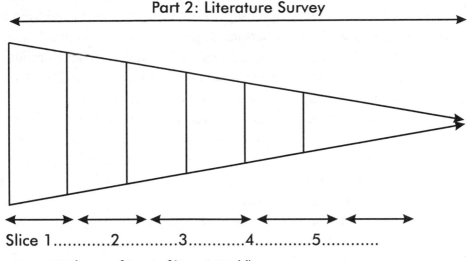

Figure 4.5 Blow-up of Part 2 of 'Bow-tie Model'

your own inquiry. So keep the focus 'down' on this (as in Figure 4.5).

- Finally, summarise your review, explicitly relating your conclusions about the current literature, and its relationship to your research questions and the inquiry you're about to do. The reader should end this section saying in effect: 'Oh yes, I see why Suzie/Franz decided to investigate this idea further, put this hypothesis to the test, or whatever.'

Drafting

Your first version of your literature survey is unlikely to be perfect. Or the second. This chapter you are now reading took three major rewrites before reaching its present form. An important part of writing for academic purposes is *drafting* – by which we mean making several provisional versions of a section, chapter, whole report or dissertation. Whatever you do, *don't* wait until an advanced stage of your research before you write it up – in the hope that a magically perfect version will just happen. Most prose of any clarity has been arrived at through the classic '10 per cent inspiration, 90 per cent perspiration' method. Your final manuscript is simply your final draft – the culmination of a long process of refining and tinkering.

Label all your drafts clearly so as to prevent confusion later (e.g. <Chapter 2 – Draft 3>) and give them to your supervisor, or to colleagues and friends for critique. Cultivate a 'writing partner' to give you honest feedback. Gail Sher (1999: 93) calls them 'writing parents', 'who must be tender, enthusiastic, extremely interested, nurturing, visionary and knowledgeable'. A tall order perhaps, but you may find somebody with some of these!

When you have a critique of your work, go back again and write a further draft, looking again at style, clarity of content and transparency of argument. When writing an earlier book we asked a friend to read drafts of chapters and to mark *anything* which struck her as ambiguous or jargon-ridden with a red mark in the margin. Though our hearts sank at the sight of page after page of red, this actually made for much better readability in the long run.

Any reader of your drafts will need to know both *where* and *how* a particular draft fits into the overall picture of the work. So what we ask our students to do is to *signpost* their drafts – by which we mean that they preface their draft with an opening paragraph completing the following two statements:

1. **'This draft is…'** (describe where it fits into the report or dissertation as a whole).

2. **'The purpose of this section is to…'** (describe what the section is trying to do in terms of the progression of your argument).

And remember to **label** and **keep** all drafts – *sometimes* aspects of the first draft are the best (as Beethoven's sketchbooks testify).

Organising and presenting writing

A final aspect of writing well for academic purposes is how you organise and set out your text. While when reading a novel most of us are happy enough with pages of text interrupted only by dialogue, a dissertation or research report in this style will guarantee to lose most readers. Instead what you should be trying to do in academic writing is to break up the text into clear sections and subsections (as we've tried to do in this book). This will help the reader to follow your material and argument.

Hints and Tips
Styling writing

1. **Emphasising?** <u>Emphasising?</u> *Emphasising?*
 Here are three possible ways of stressing a word in a text.
 Ask yourself what the point of the emphasis is: to <u>stress</u> a
 word? To indicate a title of a book in the main text, e.g.
 Beginning Research, or to show an unusual or non-standard
 use of a word or noun phase, e.g. *transitional space?* On a
 word-processor you have at your disposal *italic,* **bold** or
 <u>underline</u>. As a rule underlining is usually the least
 effective, and can look quite amateurish. Whatever you do,
 be careful not to **over**-*do* it – Or your **text** can end up
 looking quite **ODD!!** Above all, whatever you do be
 consistent in your approach throughout the text.

2. **Indicate special or jargon uses**
 Another option is to put words or terms to which you are
 giving a special or theory-specific use in single inverted
 commas – e.g. 'transitional space' – but again be careful
 you know *why* you are doing this.

3. **Label everything!**
 Use page numbers. Number all figures and tables.
 Cross-reference them with the main text.

4. **Explain yourself! Use a footnote**
 Read through your text critically and mark any words or
 phrases which are non-standard or profession-specific and
 ask yourself whether a 'cold' reader from another
 discipline needs these to be defined and/or explained. It's
 usually better not to clog up the main text with this, but to
 use a footnote – where you can give a clear definition and
 explain clearly how it fits into the text.

Figure 4.6

Organising your writing into separate **sections** and **subsections** helps readability. Break up the manuscript into logical chapters or sections and within this use subsections to organise the text further. Label the different sections with perhaps a different typeface for subheadings or a numerical ordering system (e.g. section 2.1 = the first subsection of Chapter 2). Overall, make it obvious to the reader what is a main section, what's a subsection, what are data and what's commentary.

Now look critically at your own drafts and ask yourself:

- Are the 'chunks' of my text too long or too short?

- Is the layout clear or unclear?

- Is the structure of the text 'signposted' or confused by the layout?

When you're confident that the organisation of the text is fine, read it again with the same 'outside eye' with regard to its content, and ask yourself:

- What things am I taking for granted that the reader will know? (In terms of the background to my question, the context or tradition in which I work and to which my research is relevant.)

- Have I taken for granted that the reader knows both my practical and theoretical orientation – both in terms of my clinical work and the angle of the research investigation?

- Are there any terms or jargon which are included but not explained or defined?

Finally, Figure 4.6 gives some Hints and Tips on styling your manuscript.

SECTION C: REFERENCING

Academic courtesy: Referring to others' work

For the Suzies of this world the requirement of fully **referencing** academic work is the height of pedantry. But, take our word for it, if you *don't* tackle this area now, and establish for yourself a consistent referencing and citation system, you will regret it. Within academia, the devil's in the detail, and you'll create a lot of work for yourself later if you don't sort this out now.

Referencing simply means the process of referring to others' work. You will hear people talk about **citation** as well as referencing – these terms

being somewhat synonymous. Technically, you cite a reference – a citation being a marker within a text – e.g. (Ansdell and Pavlicevic 2001) – which indicates to the reader the sources you are using at this point. A reference is also needed at the end of quoted text to indicate where the quotation comes from (and at which point in the author's text). Your reader can then look in the References section at the end of your text to find the full publishing information for this source. Only put sources you have cited in the text into the References section. Any other texts you have used should be placed in a separate Bibliography or Further Reading section.

Contrary to the view that using citations is a way of showing off how many books you've read, referencing is an essential part of fair academic practice. It entails presenting your ideas with reference to the ideas of those who have preceded you and have influenced your thinking, or whose work bears a similarity to your own. Referring to other people's writing allows a reader to see which sources you used and to trace these if necessary by looking them up in the References section at the end of your text. By doing this a reader can check the accuracy of your representation of other writers' work.

There are several different formats for referencing or citing according to which house-style the academic journal or university dissertation regulations require. Make sure you know what the requirement is for *your* project before doing any work on this. But the principle is the same for whatever style, so in the remainder of this section we'll set out the logic of the one we've found the most useful (and user-friendly) – a generic version of the Harvard System. This is an 'author/date' method and has the advantage of ending up with an alphabetical bibliography (which is the easiest to change as your literature survey expands). Though it needs some attention to detail to get this right, it's worth it in the long run as there are positive gains for you as a researcher at this stage in establishing a coherent referencing system. It will:

- ensure you keep track of all of your sources along with their bibliographical information (needed for your References section)

- help you compile an academic text in the right style – referring to others' work and discussing their ideas in relation to your own.

Talking about Music Therapy
A Dilemma and a Qualitative Experiment

by Gary Ansdell

Abstract

This paper is designed as an introduction to a projected series on aspects of the meta-theory of music therapy. In common with pyschoanalysis (Mitchell 1993) and art therapy (Henzell 1995), music therapy inquiry is seeing an evolving reflexive trend which examines in several ways the nature of theory in the discipline — in order to clarify, contextualise and critically evaluate past and current trends (Aldridge 1990, 1993b; Aigen 1991, 1995; Ruud 1988). In the case of music therapy, meta-theory typically seeks to uncover the relationships between three domains: what music therapists do (praxis); what they say (discourse); and what they know (epistemology). This paper takes discourse as the starting-point and makes an introductory study of the nature of talking about music therapy. It centres its investigation on a simple qualitative-style experiment in which a group of listeners (of varying musical and music therapy experience) identify and describe a taped excerpt of music therapy. The results of this experiment are used to form the basis of a discussion about several commonly expressed 'language problems' in music therapy: the need for a 'common language'; the verification of clinical data; describing musical behaviour and the boundary between description and interpretation.

1. Introduction

The experience of music is not, in itself, problematical at all: it is, in a sense, the one thing we can be sure of. The problem lies in correlating what we hear and what we think, know and imagine. (Cook 1990)

'Seeger's dilemma'

Talking about music has always been a problem. Music therapists are revisiting, in their problems with language, a path well-trodden by musicologists, ethnomusicologists, music theorists, critics, instrumental teachers and performers the world over. The difficulty affects anyone trying to breach the word-music divide; anyone who attempts to use verbal strategies to describe musical processes.

Whilst there have been eras when the rhetoric of a musical discourse has flowed more freely (Osmond-Smith 1989), the situation for some time can be summed up by Stravinsky's remark that 'verbal dialectic is powerless to define musical dialectic in its entirety' (1947:123). Musicologists sometimes refer to problems of the verbal description of musical process as 'Seeger's dilemma' — named after the ethnomusicologist Charles Seeger (1977) who spent a long life tirelessly attempting to clarify the relationships between music and verbal language, and the 'dilemma' inherent every time we cross what he called the 'musicological juncture' and use verbal strategies to talk about musical processes. Seeger developed a useful terminology for representing this situation, referring to our *music knowledge* which operates 'within' musical practice, as opposed to our *speech knowledge* which is 'outside' it and about it (as an object of our 'musicological' attention). The problem, whether we are musicologists or music therapists, is that the knowledge inherent in each of these modes (and the tools for their articulation and communication) is not always isomorphic. Seeger comments that:

The immediate aim of musicology is (a) to integrate music knowledge and feeling in music and the speech knowledge and feeling about them to the extent this is possible in speech presentation, and (b) to indicate as clearly as possible the extent to which this is not possible. (1977: 47-8)

What Seeger calls 'speech presentation' is for music therapists the dilemma of a *discourse* of music therapy, which I characterise as 'music therapists' dilemma'. This concerns the attempt to reconcile the practice of music therapy (which largely operates within Seeger's 'music knowledge') with the need for a coherent system of verbal representation (a 'speech knowledge') in order to communicate this practice and to develop theory — in teaching, research, or simply in everyday clinical communication within the discipline or between professionals.

'Music therapists' dilemma'

This situation has not gone unnoticed by music therapists, who have increasingly shown an awareness of language issues. At the First Arts Therapies Research Conference (City University

Figure 4.7 An example of a referenced academic text

How to reference

Take a look now at Figure 4.7, which is a page from an article in the *British Journal of Music Therapy*. We can see two types of referencing here:[1]

- **Citation** within the abstract and main text of both others' ideas in general and of specific books or articles – indicated by the author's name and year of publication in parentheses.

- **Referencing** of direct quotations from other published texts (either in the main text for quotations of up to a sentence, or in small type for longer quotations) – again indicated by author's name and year of publication in parentheses.

The conventions for referencing seem rather complicated initially, but it's worth taking the time to learn them – referencing is of value only if all the details are *exactly* right. Also, be warned – there's a certain breed of professional academic who takes great joy at circling in red pen on your final manuscript every single referencing misadventure!

The Hints and Tips in Figures 4.8 and 4.9 give a summary of how to use the Harvard System to **reference within a text** and to **compile a bibliography**.

Also ensure that your method of laying-out **quoted text** is both consistent and accords with the house-style required by your institution. We suggest the following guidelines for a general style:

- Place only short quotations (of up to one sentence) in the main text.

- Place them in single inverted commas followed by a reference.

- When the quotation is longer than a sentence place it in an indented paragraph without inverted commas.

- Try not to have a string of quotations littering your text – it actually creates the opposite impression than you might suppose (especially if they all come suspiciously from one source). Try instead to **paraphrase** (summarise in your own words) the material, using appropriate citation of the sources.

1 Our editor spotted a mistake in this – see if you can too!

Hints and Tips
Citations in texts (Harvard System)

References are cited in your text by author's surname and year of publication, e.g. (Ansdell and Pavlicevic 2001). Citations are not always this simple! The following lists the complications:

• Citation of an idea within text	**(Blair 1997)**
• Same idea, several authors	**(Blair 1997; Wilson 1965)**
• One author, several sources	**(Blair 1995, 1997)**
• One author, several papers, same year	**(Blair 1995a, 1995b)**
• Second (or more) citation of same author within the sentence	**(1995)**
• Mention of name in sentence and citation of author's main text	**Blair (1995)**
• Referencing a quotation with a page number	**(Blair 1995: 123)**
• Referencing a quotation obtained from another text	**(Aristotle in Blair 1995)**

NB Don't use 'ibid.', 'Op.cit.' etc. – people can mistake them for prolific authors! Just repeat your basic citation.

Figure 4.8

Hints and Tips
Compiling a references section
(Harvard System)

In the references section at the end of your text list all references cited in your text – with authors' surnames arranged in alphabetical order, chronologically. The following styles pertain to the different kinds of references:

Book
BLOGGS, J. and SMITH, T. (1997) *On Pedanticism.* (London: Flabber).

Article
SMITH, J. (1999) The influence of the swanee whistle on the development of headaches in music therapists. *British Journal of Music Therapy 12*(1): 32–46.

Article or chapter in an edited book
JONES, D. (1997) On deconstructing pedanticism. In: *Popular Deconstuctions*, ed. D. Smith and F. Craddock. (London: Duck Press).

Thesis
DRY, V. (1997) Bongos and cultural process. PhD thesis: Bognor University, Dept of Music Therapy.

NB There are many variations on the above. Check the exact style of the institution or journal you are writing for before compiling references sections.

Figure 4.9

And finally

We won't include an interlude from Franz and Suzie's progress at this point – it might depress you! Suffice to say that both are having problems with the nitty-gritty of academic practice. Franz isn't particularly keen on reading around his subject, preferring just to get straight into the research. Suzie loves reading around, but hates the detail of referencing. Her comments when her supervisor returned her first draft of her Literature Survey covered in red rings around most of the citations and referencing are not printable!

We realise that this has been a rather long and involved chapter. Like Franz and Suzie you may be impatient to get on with your research, and feel that all of this academic practice is getting in the way. But you know (as artists yourself) that, as in any other practice, the craft must precede the art. We are ready now to approach the actual research process of Stage 3.

STAGE 3

Work-in-progress

Enough preparing! It's time to start your research – beginning with writing a proposal (Chapter 5) and choosing a design (Chapter 6). We then follow Franz and Suzie's work-in-progress (Chapters 7–10) and consider other research methods (Chapter 11).

5
Making a Proposal

Structuring research proposals –
Franz' proposal – Suzie's proposal

Franz isn't quite sure how far to go. He is at his computer, late at
night, typing his thoughts on to the blank screen. He remembers
the taste of cappuccino and of Sachertorte, and his meetings
with Suzie. There's no time to lose. His proposal needs inspiration
if it is to succeed.

In Chapter 2 we discussed research titles and questions. Before launching
into Franz and Suzie's research proposals, in this chapter, we give some brief
pointers about the various sections of a research proposal. Incidentally, this
will not differ too much from the structure of your *actual* project. We then
present Franz and Suzie's proposals in some detail.

Structure and content of research proposals
Title

Sally French (1993: 40) writes: 'The title should be no longer than necessary,
but long enough to give an exact idea of what your proposed research is
about.'

Think carefully about the title and your choice of words. Also, as you
work through constructing your proposal, your title is likely to change – a
few times. (It happened to us while composing the studies for these chapters.)

Don't panic: keep your title open until the last moment – i.e. let it be a
working title for as long as you can – and make sure it 'fits' the other sections
of your proposal.

Background and purpose

This includes:

- Why you are doing your project. Say why you think that this project is relevant: why and how it is useful to your profession, and/or to your professional colleagues.

- Where you will do it (and why there and not elsewhere).

- A short review of relevant literature to show that you are not just inventing the need for this project. You want to show that there is a gap in the literature to be filled, a topic to be developed, or a next step to be taken in existing research literature.

Here, Colin Robson (1993) warns against showing off or simply displaying that you have read a lot of the literature that may have no relevance to your topic; or assuming that, as an experienced clinician, your research proposal will automatically be fascinating and rigorous. He writes:

> Your aim is to lead the reader inexorably towards the conclusion you have reached: that this is the work that must be done, with these aims, in this way. (Robson 1993: 466)

If you're applying for funding, this section needs to be especially convincing!

Research question(s)

As we saw in Chapter 2, closed or open questions signal to readers rather different research approaches. Think about how you're going to word your questions – and about what sort of answers you want – and need. Bear in mind what research methods you will use, what data you will collect and how you will analyse it in order to address your questions. In other words, think holistically, not only mechanistically. Don't think of only one proposal section at a time: you need to think forwards, backwards and sideways at the same time.

Structure of the inquiry

Here you go into some detail about how you will answer your research questions. Where and how you will collect data: e.g. you need to set out

where and how you will record sessions and collect interview data, which clients will be involved, how many clients you intend to study, and what permission and ethical clearance you have obtained in order to do this. Also include any cooperation or involvement you have enlisted or negotiated from your college, school, clinic or university prior to submitting your proposal. This shows that you are serious and committed – and not just 'hot air'.

You then need to indicate how you will analyse your data. Robson (1993) says:

> You should, again, convince the reader that you have thought through the issues…guard against the impression that you are going to gather the data and then think about analysis afterwards.

> (Robson 1993: 467)

You may also need to signal that there will be several steps to your data analysis: a primary analysis may lead to a synthesis and necessitate a secondary analysis.

Ethical implications

Most research projects involving human beings need ethical clearance, so make sure that your study falls well within ethical codes of practice. By the time your proposal is written you should have written approval from whichever institution you are collecting your data, and state this in your proposal. You usually also need to include a sample form asking clients for informed consent to take part in your study. This would form part of your proposal appendix.

Conclusions

Finally, state something about what you hope to find through this project, and what your results will show, who your study will help or interest; how this might further the cause of your profession or a particular client group; what gap in the literature you hope to contribute to, and so on.

Let's begin with Franz' proposal.

Franz' proposal

While reading Franz' proposal, remember that he has a specific remit: to justify his practice and the funding of his post at Ivory Leaves Mental Health Unit. In contrast to Suzie's proposal (for her Master's dissertation) he is in no position to follow his personal interests in designing this project. (We've interspersed the proposal with a commentary, to guide you through the thinking that underpins the text.)

RESEARCH PROPOSAL: JANUARY 2000
FRANZ MOZARELLA, ART THERAPIST
IVORY LEAVES MENTAL HEALTH UNIT
LONDON

Title

Is art therapy effective in supporting the multidisciplinary treatments (and/or monitoring) of persons living with chronic mental health problems? An inquiry into the role of art therapy in community mental health programmes

COMMENTARY

This title is a bit longwinded and not very clear. It seems to go in two directions at once: Franz hasn't decided whether he means 'treatment' or 'monitoring' at this stage. However, even if he decides to use the word 'treatment', the title does not claim that art therapy itself 'treats' mental illness – but that it may have a critical role in supporting multidisciplinary treatments. The context for his project is community mental health programmes. There is also a hint of economics in his title, in terms of the viability of art therapy. He's inquiring about the role of art therapy in community mental health programmes. Finally, this is a closed question: Franz is going to find an answer that is 'yes' or 'no'.

Background

Government policy for mental health sufferers in the community presents challenges for both carers in the community (usually families and relatives of mental health sufferers) and for mental health units, which have clinical responsibility for the well-being of mental health sufferers. At the same time, though, mental health units are reporting dif-

ficulties in monitoring the well-being of chronic sufferers (Smith and Adams 1998),[1] due to their erratic keeping of appointments with unit support staff.

COMMENTARY

Franz makes it clear that he intends addressing issues that are bigger than just art therapy. This stands him in good stead in terms of getting his proposal accepted by the board. He refers to a recent study (Smith and Adams 1998) that has already reported a problem with mental health sufferers keeping appointments, so Franz is on firm ground. Also, he knows that John Audit and the Hospital Board need to show that a good proportion of mental health sufferers do, in fact, attend Ivory Leaves Mental Health Unit in order to receive the various treatments offered, failing which the unit may be closed. We now begin to detect a subtext: that it may, in fact, be more than art therapy that stands to benefit from this project.

Although art therapy is reported to be successful in helping chronic mental health sufferers to sustain personal and social motivation in long-term hospital psychiatric wards (Smith and Cowan 1989; Wonder and Smiley 1992), no study has yet addressed the effectiveness of art therapy in the context of community care.

COMMENTARY

There is a gap in the literature, so Franz is not reinventing the wheel.

Moreover, the constant need by mental health teams to monitor the well-being and medication of mental health sufferers in the community is dependent on their willingness and commitment to attending mental health community centres regularly. However, a preliminary audit suggests that clients' attendance of weekly group art therapy sessions at Ivory Leaves Mental Health Unit has bettered the average attendance records of non-art therapy clients to other appointments at the unit, although this has yet to be systematically monitored and tested.

COMMENTARY

Franz makes it clear that if patients do not attend they cannot be monitored and may be in difficulty without anyone knowing about it. As a result of his two years' work at

1 The references in Franz' project are fictitious.

Ivory Leaves, Franz is fairly confident that the clients do, in fact, keep their weekly group art therapy appointments. He's recorded their attendance and already done a preliminary 'audit' – which we could also call a pilot study. He hopes to show, therefore, that weekly group art therapy sessions may well be pivotal in improving clients' attendance of the unit – giving staff the opportunity to see clients and monitor their well-being at the same time. Hence his title stating that art therapy may be 'effective in supporting the [treatment]'. He is not claiming, for this project, that art therapy is itself a 'treatment'.

Now go back and read his title: how does it read now? What would you change in it?

It is proposed that (a) weekly group art therapy (WGAT) sessions motivate mental health sufferers to come to the mental health unit, thus ensuring that at the same time they are seen by their mental health workers, and (b) that WGAT sessions are themselves (highly) effective in monitoring and maintaining the emotional and social well-being of chronic sufferers.

This has long-term economic implications for the ongoing support and care of chronic mental health sufferers, and for the place of art therapy groups with adults who have chronic mental health problems.

COMMENTARY

The outcome of this project will be of interest not just to art therapists lobbying for more jobs in mental health units, but also to the medical and paramedical professions involved in mental health care in the community. It is hoped that the outcome will persuade Franz' manager that paying for an art therapist is a good investment: it may help reduce the enormous costs of following-up patients who do not attend units and need hours and hours of follow-up work, as well as the costs of increased medication when clients relapse due to not being effectively monitored and supported. Note that, for the time being, Franz is choosing to bracket the word 'highly' in 'highly effective'. He needs to discuss this with Carmen Statistica at the University Statistical Support Services – since the amount of improvement in clients' condition may be rather small – in which case the word 'highly' will need to be deleted.

Research questions

1. Can weekly group art therapy (WGAT) sessions help improve chronic mental health sufferers' attendance at community mental health units?

2. Can WGAT sessions be useful in stabilising or improving chronic mental health sufferers' sociability and personal motivation?

COMMENTARY

These questions are specific: more specific than the title. These are essentially the questions that Franz will answer through his data collection and analysis. He needs to be sure that the research questions and the title 'fit' together. In fact, this may be the time when he makes a final decision about the wording of his title. He might want to change it to: 'Is art therapy effective in improving attendance of mental health sufferers at mental health units? Etc., etc.'

Structure of the inquiry

The project will be based at Ivory Leaves Mental Health Unit in South East London. The unit currently has 172 chronic mental health sufferers on its books, and a mental health team of 22, comprising 3 (part-time) and 1 (full-time) social workers, 3 psychologists, 11 community nurses, 2 consultant psychiatrists (part-time), an occupational therapist (part-time) and an art therapist (part-time). The unit is funded by the National Health Trust, and is also part of the University South East Psychiatry Department. The unit is open daily from 08h00 to 22h00, and from 10h00 to 20h00 on Sundays. The unit has a well-equipped art therapy room large enough to accommodate groups of up to 8 clients, and art therapy has been part of Ivory Leaves' programme for the past 9 years.

The viability of this project was discussed at two staff meetings, and Dr Bill Saunders (consultant psychiatrist) and Mr Michel LeBain (clinical psychologist) have indicated their willingness to identify clients for the study, and to undertake assessments as necessary. Mrs Pam Cook (head social worker) is willing to help obtain clients' informed consent for the project, as are Mr White and Ms Smith, community staff nurses.

Statistical support will come from Dr Carmen Statistica of the University South East's Statistical Support Services, and Mr John Audit has approved a grant of £1000 in support of this project (budget – Appendix X subject to the board's approval of this proposal). The Friends of Ivory Leaves Unit will underwrite the cost of art therapy materials – part of their ongoing funding of art therapy materials. The University Ethics Committee application for approval has been submitted, and a response is due by the end of May (sample form – Appendix Y).

COMMENTARY

Franz has done his homework. The staff at the unit are alerted to the project and ready to support him. In addition he has obtained statistical support from the University Statistical Support Services, as well as financial support for the project. Most important, he has the support of the university Psychiatric Department as well as the mental health unit's consultant psychiatrist. He is ready to roll.

Methods

Franz' proposal will have only one design. However, since there are multiple ways of answering a research question, we present two alternatives below (Design 1 and Design 2), and talk you through each. Also, this makes an important point: you do *not* first think of what research methods you'd like to use and *then* decide on your questions. Rather, first think through what you want to ask, and *then* work out how you are going to do it – familiarising yourself with existing possibilities. As you begin this process of formulating your proposal, you will probably find that your title and perhaps even your research questions need revisiting. This is part of the feedback loop of doing research. And it happened to us several times while designing Franz' and Suzie's projects for you!

Design 1

See Figure 7.2, Chapter 7.

Data collection

(a) Records of all clients' attendance of the unit for the past three months will be perused by Mr LeBain (clinical psychologist) and 48 clients with the poorest attendance records will be selected

by Dr Saunders (consultant psychiatrist) and Mr LeBain to take part in the study.

(b) All subjects will be tested for Social Motivation (Sandler *et al.* 1993) and for General Moodstate (Johnston and Carlton 1985).

(c) Of the 48 subjects 24 will be allocated to the experimental group, which will have weekly group art therapy for a period of three months. The other 24 members will form the control group and will have no art therapy during the same three-month period. The two groups will be matched as closely as possible for age, duration of illness, attendance record, and for their Social Motivation and General Moodstate scores.

(d) All subjects' attendance will continuously be monitored during the three-month period, in order to gauge for any changes in attendance patterns.

(e) At the end of the three-month period, all subjects will once again be tested for Social Motivation (Sandler *et al.* 1993) and for General Moodstate (Johnston and Carlton 1985).

Data analysis

Statistical methods will be used for within-group and between-group comparisons for frequency and regularity of attendance at the unit, and for Social Motivation and General Moodstate scores.[2]

COMMENTARY

Franz has a clear idea of how his project will proceed. He has a time-frame for the 'treatment' period – although he hasn't mentioned how long the data analysis will take. Rather disappointingly for art therapists, perhaps, is that he doesn't seem to be interested in what goes on during the weekly group art therapy sessions – but perhaps we need to remember that he is under pressure to show 'facts and figures' within a limited time-span – six months in fact. Having thought through his proposal, he will be ready to begin as soon as the project is approved by the Hospital Board.

2 We'll go into much more detail in Chapter 7, but if you want a quick preview, look at Figures 7.2 and 7.4.

Design 2

Remember we're offering an alternative scenario – so don't get confused with Design 1. (Also, have a look at Figure 7.4 in Chapter 7 if you want to.)

Data collection

(a) Records of all clients' attendance at the unit for the past three months will be perused by Mr LeBain (clinical psychologist).

(b) All unit clients will be allocated to one of three groups: 'low', 'medium' and 'high' attendance, according to accepted defining criteria (Smith and Redfern 1984).

(c) Nine clients from each of the three groups will be randomly selected by Mr LeBain to take part in the study, and the existing three-months records will form a baseline measure for the 27 subjects' attendance.

(d) All 27 subjects will be tested for Social Motivation (Sandler *et al.* 1993) and for General Moodstate (Johnston and Carlton 1985).

(e) The 27 subjects will then be randomly assigned to three groups of nine subjects each – Groups A, B and C. Group A will have 24 weekly group art therapy (WGAT) sessions, Group B will have 16 WGAT sessions and Group C will have 8 WGAT sessions.

(f) All subjects will be retested for Social Motivation (Sandler *et al.* 1993) and for General Moodstate (Johnston and Carlton 1985) at the end of each of their WGAT periods, and again at the end of the project period – week 24.

(g) All subjects' attendance records (AR) will continue to be monitored for a period of two months after the completion of the project.

Data analysis

Statistical analysis will compare all subjects' attendance records for three months prior to the study with attendance records during and after the

project period. Comparisons will also be drawn between the three groups to establish whether the length of WGAT influences subjects' attendance.

COMMENTARY

This design is more complex – there are more conditions than in Design 1, where the study simply compared the effects of art therapy versus no art therapy. Here, the duration of WGAT is introduced as another factor to be taken into account – and the organising of the actual project will be more complicated. (More about this in Chapter 7.)

Conclusions

This study hopes to show that weekly group art therapy sessions may help to support mental health sufferers in the community, who have been shown to be erratic in their attendance of community mental health centres. It also hopes to make a case for weekly group art therapy sessions as being economically viable, in alleviating staff pressures and in reducing the time and cost of needing to 'follow-up' clients with poor attendance.

COMMENTARY

By now we all have an idea of what Franz is proposing. Don't irritate readers by repeating.

Suzie's proposal

Suzie's proposal is different from Franz' – a fact largely to do with the reason why she's undertaking her research in the first place. Suzie, as we know, is writing a dissertation as part of an academic requirement. She does not need to justify her work to an employer. She is being guided through the research process by an academic supervisor (in her own discipline) and needs to end up with a manuscript of not fewer than 12,000 words. All of these factors influence not just the choice of her research area, but also the way she goes about the research process and the way she writes up her research. This will be reflected in how she structures and expresses the proposal.

As with Franz' proposal, we present Suzie's section by section with a commentary.

DISSERTATION PROPOSAL: SUZIE KAFTAN
MASTER OF MUSIC THERAPY, GAMUT COLLEGE, LONDON
January 2000

Title

> Music Therapy and the 'Life in Music': An inquiry into 'moments of quickening' in clinical work

COMMENTARY

The title is far less specific (and rather more 'poetic') than Franz'. The main part of the title is a statement relating to two things – her realm of practice and something about music (which we assume will be elaborated as the proposal goes on). The second half of the title clarifies this slightly – though it too has an unusual phrase in it. Overall this title hints rather than defines. It promises the reader not the answer to a defined question, but an exploration within a defined area.

Background to the inquiry

> Both my own experience of music as a performer, and my recent work as a music therapy trainee, have suggested that what I understand as the 'life in music' is a vital aspect of how it benefits people. The 'life' or 'energy' that music and music-making can bring seems more than just a physiological effect – indeed is quite different from that achieved by physical therapies. Instead music seems to generate an energy which concerns inner motivation and the 'will to act' (though I have also noted clear physiological effects in my clients). Ansdell (1995) calls the phenomenon *quickening*. I shall borrow this term but reduce it to the form 'moments of quickening' for this inquiry. In the two areas I have worked in as a trainee (neuro-rehabilitation and dementia) I have considered the motivating effects of music in my clinical work to be amongst the most important (though perhaps the least easy to articulate) – and consequently it is to this area which my thinking about music therapy has most been drawn.

COMMENTARY

The style of Suzie's report is what might be called 'academic informal' – she writes in the first person. This is appropriate to the style and content of her research, which proposes

to start with her own work. She can do this because as an academic thesis her research is intended as self-inquiry, and aims to develop her skill as a practitioner-researcher, and deepen her thinking about her own clinical work. Consequently, in the proposal she doesn't try to define everything or pose a closed question but sets up an open-ended inquiry. In defining this she borrows terms and ideas from other sources which suggest what she has experienced in her practice. She indicates these special uses of words by putting them in inverted commas ('life', 'energy'), indicating a non-standard use – which the reader will expect her to discuss subsequently. Taking the concept of 'quickening' she then reduces this to the smaller area of 'moments of quickening' – something perhaps more easy actually to investigate. Suzie gives her motivation for this investigation as the fact that the phenomenon she has chosen is not easy to articulate. This gives both a feeling of integrity and expectation for the reader.

Aims of the inquiry

I would like to further investigate this phenomenon of quickening within the context of music therapy: both within my own clinical work, and by exploring whether other music therapists consider this aspect of their work to be important and, if so, how it has manifested itself in different client groups. For this inquiry a qualitative research perspective is most appropriate as my aim is to produce a 'close description' of the phenomenon of 'quickening' in order to encourage further thinking about this aspect of music therapy.

COMMENTARY

Having centred on the concept of 'quickening' notice how the progress of the proposal leads on by starting with this concept. Suzie then heads off the possible criticism that her inquiry is too narrow by enlarging it to include other therapists' views. She nails her colours to the mast at this point, stating her choice of methodology – a 'qualitative research perspective' – but notice that she starts with the project, not the methodology. A qualitative design is appropriate because of the aims and area of the inquiry (more about this in Chapter 7). For Suzie, it's her supervisor Peter Purt who will approve (or not) this proposal: perhaps this is suggested in the way that a jargon phrase ('close description') pops in here. Were she not addressing an expert reader in her own discipline it's possible that a misunderstanding might result from use of unexplained terminology. A reference might help here.

Context of the inquiry

The main part of the study will concentrate on the clinical work I have done during my training with clients with brain injury and dementia. I will compare my close study of this material with the work of music therapists who have more extensive experience and who have worked with other client groups. The inquiry will attempt to blend detailed study of examples from a limited context with broader discussion of the phenomenon of quickening.

COMMENTARY

Suzie outlines which clinical areas she has developed her research ideas from, and where she will be obtaining data. She has designed the project to have both a narrow and a broader focus – working with her own clinical material, but also obtaining, as comparative data, other therapists' perceptions on the phenomenon.

Research questions

1. Can 'moments of quickening' be located in clinical music therapy?

2. If so, how can these be defined and described?

3. What is the significance of these moments for accounts of music therapy process?

COMMENTARY

Though Suzie's basic research question is an 'open' one she nevertheless intends to subject her concept of 'quickening' to empirical inquiry. Her research question 'tests' the idea by asking whether it has any grounding in reality – by asking whether Suzie or other therapists can locate such moments. As we shall see, Suzie allows the question to lead into a way of investigating this. The second research question follows on logically from the first. If found, how can 'moments' be described? The third question brings the research back to music therapy practice.

Previous writing about the subject

Descriptions of music as having or imparting energy are common in writings on musical aesthetics, such as those by Kant and Schopenhauer (Lewis 1981; Schofield 1964). A musicologist whose writing has been

influential on music therapists, Zuckerkandl (1956), writes of the 'life in music' and states that 'to hear music is to hear motion'. Many music therapists write of the motivational powers of music (Aitken 1996; Belladonna 1997; Blanche 1995), and Aitken (1995: 87) writes in a chapter about the phenomenon of quickening that 'For many of our clients music therapy is often the best way of finding access to this "life in music".' Finally, outside music therapy, Oliver Sacks (1986) and the conductor Karajan have given interesting personal accounts of this phenomenon.

COMMENTARY

As we wrote in Chapter 4, literature surveys (even brief ones like this) need to be logical and focused. Suzie does well here. In a single paragraph she grounds her project in a 'lineage' of thinking on the general subject of 'life in music' within musicology and aesthetics literature, then relates this to music therapy and any writing she's found on the subject by music therapists. Finally she suggests that it has a broader reference in personal accounts outside of music therapy. From this paragraph we can feel confident that Suzie has done her homework and will be aware of the context her research has grown out of.

Structure of the inquiry

The inquiry will be in two parts. The first will address research questions 1 and 2 through a close examination of case studies from my own clinical work, using descriptive and musicological analysis to attempt to locate, describe and define 'moments of quickening'. In order to expand my own perspective on the case material I will also include 'listening tests' on colleagues to determine whether they locate and describe similar moments from short audio-taped examples. The second half of the inquiry will tackle the third research question by surveying the experiences and views of other more experienced therapists on the subject. For this I will make six semi-structured interviews with practitioners working with a range of client groups.

COMMENTARY

Note that the design of Suzie's inquiry follows directly from her research questions. This will help prevent her research 'wandering' and should ensure that her 'results' answer the questions she initially asked. She states what kind of analysis she will use to examine her data and proposes two specific methods – a 'listening test' and a set of semi-structured

interviews. Again, Suzie's proposal gives us confidence not only that she has thought through what she wants to know but also how she can practically go about investigating this. When this proposal comes up before Gamut College's Research Ethics Committee she may be asked some questions about preserving the confidentiality of client material, as well as how she will present her research to her interviewees.

Projected conclusions and benefits of the study

The study is a descriptive and open-ended one, which will not aim to reach definitive conclusions. Rather its aim is to elaborate on, and stimulate thinking about an area which, while often mentioned as a vital one in music therapy process, has so far been given little sustained inquiry. I hope that that my small study into this area will encourage further research.

COMMENTARY

Suzie's aims are appropriately modest and realistic. She has also considered how her research may be useful to the profession.

References

Aitken, G. (1995) *Music and Strife*. London: Jessica Kingsley.

Blanche, A. (1997) 'Psycho-affective formation and proro-narrative modules in early infant interaction studies'. *Journal of Proto-Narration 36*(2) pp. 1–2.#

Lewis, E. (1981) Kant for Cooks. BBC Publications.

Schofield, D. (1964) 'Dialectical fingers and Schopenhauer's toes' *International Journal of Aesthetics 13*(2)

Zuckerkandl, V. (1956) *Sound and Symbol*. New Jersey: Princeton University Press.

Sacks, O. (1986) *A Leg to Stand on*. London: Picador.

COMMENTARY

Peter Purt is quite pleased with Suzie's proposal overall. He has a few words to say about the referencing, however. His red pen finds several mistakes in this section. See if you can spot them! If you're handing in a formal proposal, make sure every detail is correct (see Figure 5.1).

Hints and Tips
Don't panic!

You read all this and think...HELP!!!!

Remember that those reading (and approving) your research proposal will gauge:

- whether your proposal is realistic in terms of time constraints and size of project
- whether your research questions are being answered by the process that you have set out
- whether the ethical considerations for your project are satisfactory.

Figure 5.1

6

Designs and Ethics

Clarifying research concepts: Methodology, design, methods – Ethical considerations – Introducing Franz' and Suzie's projects

Introduction: Behind the proposals

Now you have read through Franz' and Suzie's proposals in Chapter 5 we'd like to discuss some of the methodological and ethical considerations they had to take into account as part of designing their research. Until now in this book we've encouraged you to approach research from the angle of developing *what* it is you want to know, and *why*, rather than beginning with the *how* of a specific research methodology, design or method. We now need to look at these areas and at the area of **research ethics**,[1] which considers how your research impacts upon other people, situations and institutions. Section A deals with methodology, Section B discusses ethics, and Section C introduces Franz' and Suzie's research projects, which will take up most of the rest of the book.

SECTION A: METHODOLOGY, DESIGN, METHODS

When you start thinking and reading about this area it can get quite confusing – partly to do with the different terminology used. So let's spend a while looking at the following key concepts:[2]

1 The thoughts in the ethics section are drawn from Banister *et al.* (1994), French (1993), McLeod (1994), Maranto (1995) and Robson (1993).

2 Silverman (1993) and Wheeler (1995) have been helpful in building these definitions. Read these texts, or others, to make sure you fully understand this area.

- **Methodology:** the overall approach (paradigm) to research, which has roots in a research tradition or philosophy. Examples of methodologies are quantitative, qualitative, positivist, naturalistic, phenomenological, hermeneutic, etc. There is a strong relationship between the kinds of research questions you ask and your research methodology.

- **Design:** the way a research study is structured in order to answer the research questions. Your design will depend on your methodology, with different designs being identified with specific research methodologies.

- **Method(s):** specific research devices or techniques such as interviewing, surveying, experiments, transcribing, categorising. Research methods are also identified with traditions of methodology.

For your own inquiry the trick is to make sure that your methodology, design and methods match up. This will ensure that your research is logical and self-consistent and that your results will in fact answer your research questions.

Now that you know what you are interested in, you need to see which methodology will work best for you – or, to put it another way, under which methodology 'umbrella' your research logically stands. It's no good thinking 'I want to do a study like Sally's because it sounds interesting and I like the way she didn't tell the people what she was doing to them' and so on. More critical is to understand the options that various methodologies offer you. Be clear about what you want and need to do, and then make the two fit together.

The choice should be a totally pragmatic, rather than an ideological one. As we mentioned in the Preface to this book, many arts therapists have become embroiled in recent years in what David Aldridge (1996) calls the *methodolatory* debate: that is, the worshipping and defending of a research methodology for its own sake. This can take almost moral dimensions, with researchers identifying themselves, 'Hello, I'm John, and I'm a qualitative/quantitative researcher'.

We think this trend rather unfortunate, in that it unnecessarily polarises the debate and can lead inexperienced researchers into thinking about what

they *should* do methodologically instead of selecting a methodology on the basis of what the project needs. So although we recommend that you read as much of the 'methodology in the arts therapies' debate as you can manage, we suggest that in the end you take a more pragmatic line and ask: *What questions do I need or want to answer?* and consequently, *Which methodology will best allow me to answer these questions, such that others will take my research seriously?*

In order to answer these questions effectively you will need to inform yourself about the various methodology options and also seek advice from an experienced researcher in your field. We hope, however, that the remainder of this book will give you a perspective on these options, as we follow through Franz' and Suzie's projects. Each of them will discuss methodology in the following chapters.

Being informed involves knowing where the different traditions have evolved from, and how these have developed in relation to the arts therapies and their particular research requirements. Browse any book on research or any research paper and you will find implicit or explicit mention of methodology, design and methods. As a beginner researcher it can be tempting to skip over these difficult bits and head for the conclusions. But if you are seriously interested in learning about research skills then discipline yourself to attend to these sections, look up terms and concepts you don't understand, try to work out where the research is coming from – whether it's quantitative or qualitative, an experiment or survey, a descriptive or case-study method. Then read up some more on any of these.

This subject is clearly a vast one, and we make no apology that our book is too brief to cover all of these. Use it, however, as an 'orientation' and then follow-up as much other material as you have time for.

Another area to consider carefully is the ethical debate which surrounds much medical and social research. As an arts therapies researcher you will almost certainly be researching people. Essential to planning your design will be the consideration of the potential impact of your research on other people. The next section considers some aspects to do with ethics in research, some of which overlap with the question of ethics in clinical practice.

SECTION B: RESEARCH ETHICS

Ethics in research is a tricky area, and you need to think through the ethical implications of your project, for your client(s), for yourself as researcher, and in some instances, for yourself as therapist. Here are some guidelines to help you to think through the various aspects of ethics. As with other parts of the book, we don't pretend to cover all aspects of this complex topic, but rather, to help you to begin considering it.

Research design: Answering your questions

Your research design needs to be appropriate for what you are trying to elicit. A poor design may yield false data or poor results, and these may undermine not only the client group in question, but also the profession as a whole.

> For example, you are attempting to show that movement therapy sessions result in improved social skills in people with Alzheimer's disease. Your design includes a test for social skills, but the results show no improvement in the patients at the end of your movement therapy 'treatment period'.

A poor experimental design, weak research methods or using the 'wrong' test may result in flawed results. Here, the study shows no 'improvement' in the social skills of Alzheimer sufferers, and this may undermine the profession directly and indirectly. For example, hospital managers may be reluctant to set up a movement therapy programme based on this study. However, if you had selected the appropriate test, the sessions may well have shown improved social skills.

Another related scenario is that although the patients show a significant change in social skills after the sessions, you have not established whether this test is, in fact, accepted within the medical or psychological establishment. Here again, hospital managers might well query your research and its results: you've used a non-validated test.

In scenarios such as these we are looking at the content of your research design from an ethical perspective. Ethics here is broader than whether or not the research intervention (in this instance movement therapy sessions) puts clients at risk. A poor research design is ethically questionable, and ethical issues pivot around whether you are making the best possible use of resources, of your own time, of that of hospital patients, and so on.

As well as consulting texts on research ethics, you do need to consider the best possible way for your design to answer your research questions. To return to the beginning: *who* is the research for; what *benefit* does it hold for the profession; what *influences* will the results have, and on *whom*; are your *procedures* robust, and so on.

Research methods: Acting and not acting

Some research methods involve withdrawing 'treatment' for a while, to see, for example, whether there is any change in clients during periods when they're not having therapy.

Ethical considerations include thinking about whether it is really in the best interests of these clients not to have sessions for a period of time. Might there be any other way of obtaining the data we need – for example, when there is a natural break during Christmas or summer holidays? Another ethical complexity presents itself when you need to have sessions in order to generate data when this is, in fact, of doubtful clinical value: for instance when a patient is in the throes of an acute psychotic episode, or is not feeling physically well. We have to consider what is in the person's best interest – and reconcile this with our own interest(s) as a researcher.

Selecting research participants

While thinking about your research topic, you need to think about how to select participants for your project. Let's consider some questions.

Can anyone take part in research?

Theoretically yes, so long as you obtain informed consent. But think about it for a minute: what if a client is in a vulnerable state? Would you feel comfortable asking someone who is in temporary crisis, or who is acutely ill, to take part in your study? Would it be ethical practice to ask them to take part? Can your project wait for them to get better, or are you under time constraints? Can you afford to leave them out of your study?

What about clients who are a 'captive audience'?

Clients who are in prison, elderly people in a residential home, or children in a school or home, may have no choice about whether or not to participate (setting aside the issue of whether they or their families or legal guardians give informed consent). They may, however subtly, experience group or peer pressure to be involved in your project. How can this be managed ethically?

What about clients who don't understand what you are asking them?

Your clients may not have the cognitive ability or emotional capacity to grasp fully the implications of taking part in research, or they may be too young to do so – what then? Here you need to ensure that the client's legal guardian gives written informed consent, which we'll talk more about below.

Cornerstones of ethical research

Each of these scenarios has its own kind of complexity. Here we discuss four cornerstones of ethical research practice concerning your research participants. These are:

- informed consent
- confidentiality and anonymity
- the dual relationship: therapist as researcher
- the dual relationship: client as participant.

Informed consent

This means ensuring that you have the full consent for your client to take part in your research project, and this needs to be written and signed, rather than a verbal OK from the client or their family. Obtaining informed consent means that the client or their family is told as much as possible about:

- *why* you are asking them to take part
- *what* your research entails
- what possible *risks* it carries to them
- what *benefits* the study holds for them

- how and why this study may be *helpful* to your profession (and to them in the longer term)

- what *your* involvement is as researcher/therapist

- how many *other* participants you are asking to take part

- what you will do with the *information* you collect about them

- how you will ensure *privacy* and *confidentiality*

- what will happen to the material *after* your study is written up

- whether you hope to *publish* the study after your project is ended

- whether you will present some of the material at *conferences* or professional meetings.

Clients need to know that they can withdraw from the study at any time, and not be made to feel embarrassed or guilty for letting you down, should they decide to withdraw. They also need to know that there is an avenue for complaints, should they feel unhappy about an aspect of your project.

All of this makes it obvious that obtaining informed consent from clients needs respect and trust between you and the research participants, and as we'll see later, you may also need to specify what you'll be doing with the data after the completion of your project.

Finally, informed consent is a written contract drawn up and signed by yourself, the director or head of your institution or department, and by clients or their family or legal guardian, should the clients be unable to give it.

Confidentiality and anonymity

These are two different things. *Anonymity* means keeping the identity of your participants unknown: here, clients' identity is disconnected from the material. In the case of a large data corpus (especially in the case of statistical analyses), numerical codes are usually assigned to names: for example, 'Anne' becomes number 23, 'Jason' becomes number 24, and so on. In single case-study designs or with a small data corpus, clients' names are usually changed.

Concealing identity, however, raises another ethical problem: the deception of readership or audience. Ethically, they need to be informed that the names being used are not 'real'.

In contrast to *anonymity, confidentiality* means keeping intimate, private or sensitive material within certain boundaries, rather than disseminating information to the general public.

> *For example, as part of your data collection, you discover that your client has a fairly serious (and fascinating) criminal record.*

First, as a therapist you'll reflect on how this impacts on your clinical relationship. As a therapist-researcher you want to consider whether or not this information is pertinent to your project. You may feel academically or theoretically tantalised by this particular client. What happens to your decision-making process? Apart from possibly getting sidetracked (and deciding to change your research to the arts therapies in prisons), how do you ethically manage this situation?

In terms of confidentiality: what will you leave out of any report? Or how will you present this material in a way that respects the nature of the material, as well as both your client's and your own feelings about sensitive or private issues?

The dual relationship: Therapist as researcher

Being both therapist and researcher is complicating to both roles, and at the very least sets up a dual relationship with clients. Each role can create different priorities at different times – and may interfere with the other in ways that are both enhancing and tricky for your project. As a researcher, your emphasis is on collecting data and contributing to knowledge and understanding about arts therapy. As a therapist, your emphasis is on your client's well-being, in whatever form this takes. The dual relationship is also rich relational ground, with each relationship enhancing and complementing the other, both inter- and intra-personally (Figure 6.1).

Ken Aigen (1993) has placed particular emphasis on how the dual role can enhance the research process. He suggests that the researcher's personal and professional qualities as a therapist can render the research process all the more 'consonant' with practice. He cites the qualities of intuition, insight, capacity for spontaneous analysis, emotional reactions and intellec-

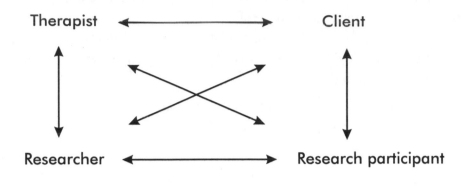

Figure 6.1 Intra- and inter-personal relationships between therapist/researcher and client/research participant

tual judgements as especially helpful to 'knowing' and 'sensing' what needs to be emphasised in research. These qualities can help you to exercise sensitivity and subtlety in all stages of your project.

It is also worth bearing in mind that as researcher-and-therapist, you too are under the research spotlight, not only your client! Think about how *you* feel about taking part in the project. Do *you* feel pressurised to take part as therapist-and-researcher? Would you like to consider, for a moment, whether *you* want to give your informed consent to take part in this study? Would you rather research someone else's work – or have someone else research yours?

Finally, remember that as therapist-and-researcher, you are *both* the observer of the research process and the participant within it. You take full responsibility for the clinical relationship with clients, as well as for the quality, accuracy and trustworthiness of the research material. This contrasts with positivist research, which encourages the researcher to be a detached observer.

The dual relationship: Client as participant

It is not only you as therapist-and-researcher who has a dual role. The client too is now a participant in your study as well as being your client. Let's revisit some of the issues facing the client in such a research scenario.

TAKING PART

- The client may feel coerced or compelled to take part in the project, by virtue of already being in a therapeutic relationship with you.

- The client may feel exploited and, because of your being perceived as being powerful, may not feel able to say so.

- As the therapist, you may be exerting implicit pressure on your client to take part in the study.

WITHDRAWING FROM THE PROJECT

- The client may feel too embarrassed to withdraw from the research study, and may feel that this will affect your therapeutic relationship.

- As therapist, you may feel irritated with a client who wants to withdraw, especially when you are well into the sessions or data collection. (Don't judge this statement too harshly: Mercédès has had this experience several times, and the time and energy invested in collecting data can result in frustration and aggravation when clients decide to withdraw.)

- As therapist-and-researcher, you may yourself be wanting to withdraw from the study, but feel pressurised by external demands of your project to see it through in its present form.

THE THERAPEUTIC PROCESS

- You may feel anxious that the client 'performs', in order for you to collect the data you need, and this can interfere with the therapeutic process.

- You may feel pressurised to perform well as a therapist, to come across as competent in any recordings for your data collection.

From clinical material to research data

We've offered some ethical pointers to do with the *people* involved in research projects: both the researchers and the participants. We now consider the data themselves.

There are two possibilities regarding the use of clinical material as data. Either you need to generate data by having arts therapy sessions *as part of* your research project, with the specific intention of collecting clinical material as research data; or else you want to research clinical material that already *exists* – e.g. as tape or video recordings, photographs or paintings. Common to both situations is that the clinical material 'doubles up' as research data: let's look at some ethical aspects.

Using existing clinical material

The existing clinical material you want to use for your study may be your own material, or that of your colleagues – already recorded in some form as part of clinical practice. This material will become research data.

One ethical implication is, whose material is it anyway: yours? The client's? The institution's? (This issue is obviously about more than converting clinical material into data.)

One complication with using existing material is that informed consent may have been obtained from the client (or their family) to record sessions as part of clinical training or practice. To use this material as research data, you now need ethical clearance – usually by the appropriate ethics research committee – as well as informed consent by the client or their family, if at all possible. Where material was collected many years ago, the latter may not be possible. It is critical that you familiarise yourself with the guidelines of the research ethics committee you'll be approaching for your study, or get advice from an ethics expert.

Here are some pointers:

- You need clearance from the client or their family or legal guardian, if you or your institution still has contact with them.

- You need clearance from the appropriate senior person in the various institutions involved with your study. This includes written approval for your study from the director of your programme; from

consultants or medical superintendents at the hospital or unit or
prison; from the head teacher at the school; and so on.

- You need clearance from the hospital, university or institution
 ethics committee.

Using other therapists' material

When using other therapists' material, that therapist potentially becomes
both a research subject, and your collaborator. Issues around using others'
material include that the therapist may know the material very well, may feel
sensitive about it, and may want or need to be consulted by you during your
data analysis. Here you need to consider at which stage you want the
therapist to be involved: you might need to do data analysis on your own
first, and draw them in afterwards for insights and comments. They may feel
sensitive about being viewed 'negatively' in the data analysis, and you need
to be open and sensitive to discussing this. The therapist may feel the need to
protect the client, and may still feel emotionally involved with the material.
In both of these instances, you need to negotiate the boundaries between
yourself as researcher (who is also a therapist) and the therapist (who may
also be your collaborator and/or research participant).

You need clearance from the therapist, who will consider:

- how sensitive is the material
- how vulnerable is the client group
- how appropriate is the material to the project
- how vulnerable the therapist feels.

You need to discuss with the therapist the best way of obtaining informed
consent: do you see the client together? For example, does the therapist
approach the client first and then you? What is the most appropriate way of
doing this, with that particular client?

You also need to obtain ethical clearance from the various bodies or com-
mittees, for using this material as research data (as we've discussed above).

Collaborating

You may wish to invite the therapist whose material you are using to give their insights into the material, and you may want to use their contribution as part of the data collection or data analysis. The therapist may make their collaboration a condition of your using the material. Remember that you hold the reins! Keep focused on what you want to do.

Also your research supervisor or other professionals who help you with your project may suggest (or request) that any publications from this project include their name. How do you feel about this?

What happens to the data

Your project is complete, your data analysed, your conclusions reached, the work disseminated. What happens to your data? Generally, your informed consent form will need to specify that after the research you intend storing the data securely for *x* number of years (usually seven years), after which it will be destroyed. However, you may want to negotiate with clients to use some data for other purposes. For example, you may find that some data would make a good case study for teaching purposes, or you may want to keep some excerpts or photographs for public presentations. If this was not part of your original request for permission to collect research material, then you need to obtain informed consent from the parties involved, much as we've suggested above.

Research that flops

Not all studies are successful and not all yield what we hope to find. In terms of your own integrity, and your responsibilities to your profession, it is ethically important to be up-front about the shortcomings of your study. Remember that by being open about the flaws of your work, you're showing integrity in your work, and at the same time helping others to avoid those pitfalls.

Integrity in reporting

We saw earlier that in writing up your research, either for your degree, for your institution or for a publication, you may need to omit information to

protect the client's identity, or you may need to shape or select information for your report for the same reasons. Each of these has ethical resonances: on the one hand you risk deceiving your readership, but on the other you want to safeguard the privacy of the client. Your report needs to state that you have changed names and that, for ethical reasons, you have omitted certain information. You also need to state that you have informed consent from clients – and include a sample form in your report appendix – as well as ethical clearance from the appropriate research ethics committee.

In terms of presenting your research viva voce at gatherings, rather than only in written form, you need to consider what ethical clearance you need in order to do this.

At this point, it should become clear that obtaining informed consent from clients needs some thinking through. You'll save yourself an awful lot of hassle if, from the beginning, you make clear to clients, to the professionals with overall responsibility for the clients, as well as to the research ethics committees, that you may want to use the data in various ways. As well as for data analysis and your project report, you need permission also to include some data in professional publications, presentations at conferences, inter-disciplinary research meetings, professional meetings and so on. You need to make it clear that you are not seeking permission to present data at public meetings or via the media (we're not going into the use of clinical material in the media, but focusing on research uses of clinical material).

Coda

There are never straightforward answers to ethics in any research practice that involves human beings, and we assure you that the pointers we've offered you here are tiny tips of large icebergs. Each issue needs consideration, it probably needs some research in existing texts on research ethics, or some advice from an ethics expert. You need to weigh up how best to remain faithful to the integrity of your work as a researcher, your practice as a therapist, and the confidence that the client has placed in you.

Complicated!

SECTION C: INTRODUCING FRANZ AND SUZIE'S RESEARCH PROJECTS

With all of this in mind, let's now turn our attention to Franz and Suzie's research proposals.

We have designed the following chapters of this book as a journey around research design, data collection and organisation and data analysis by working through Franz and Suzie's projects. Chapters 7 and 9 follow Franz' project through the two main stages of his research, while Chapters 8 and 10 do the same with Suzie's. It will be clear to you once you've read some more about methodology that we've styled Franz and Suzie's projects as quantitative and qualitative ones respectively. If you are really only interested in quantitative designs, or only in qualitative ones, you can skip the appropriate chapters – but remember our suggestion that the contemporary arts therapist researcher needs to be informed about both.

We hope you'll bear with both Franz and Suzie – so that you fully understand the logic of *why* they are doing what they're doing, *how* they are doing it, and *when* they need to do and think certain things. There is, however, a slight difference in the two projects or methodologies in terms of what the level of advice giving in these chapters enables you to do, and we'd like to sound a note of caution at this point.

With Franz' essentially quantitative project, our chapters can characterise how he develops his project from the needs of his research and from the types of questions he poses. This will help you to understand the principles of a quantitative inquiry. However, the necessary use of statistical procedures and experimental set-ups means that the information we can provide in a small book like this is unlikely to equip you enough to go and do this kind of research just by yourself. Even quite experienced arts therapies researchers will need to collaborate with colleagues to do research such as Franz': using, at the least, the help of a statistics specialist to make sure that the most effective instruments are being used. Collaboration can of course be vital to making a project effective, and for team-building in an institution. But it also needs more planning (and financing).

Suzie's project is essentially a qualitative one, and one advantage (for a student or lone researcher) is that its demands from other specialists are arguably less (though expert supervision by someone skilled in your area is

essential). However, the guide contained in Chapters 8 and 10 should be enough for most arts therapists to begin a small-scale piece of research, with only modest financial resources (time here being the key resource).

We hope, however, that both projects will give you an overview of some of the details of how to go about research, and that Franz and Suzie will communicate something of the culture and spirit of research – its ins and outs, ups and downs.

Haven't heard from him for a while, Suzie thinks, trying to choose which earrings to wear, heading for the phone.

'Hello, Franz? It's Suzie.'

'Suzie! How nice… I was thinking of you, I saw a wonderful film last night.'

'A film!! What's happening to your research? I haven't been out for weeks.'

Why didn't he ask me to go to the film, thinks Suzie. She changes her earrings as she's speaking. Yes, the 'Jungian' ones!

'Oh Suzie, there's more to life than research. And anyway I'm at the data collection stage so all I can do is do my weekly group sessions. And what are you doing?'

'Reading Guba and Lincoln on Internal Validity, or is it External Validity, or whatever. Oh, let's not talk about that.'

'Sound fascinating,' says Franz unconvincingly. 'When are we going to meet then? We're research buddies after all!'

Suzie notes that changing earrings has clearly done the trick. Could you research that kind of thing? she ponders.

7

Franz' Project: Part 1

Quantitative research methods – Three
designs – Data collection – Data organisation

Franz has to fulfil requirements set out by Mr John Audit and the Board of Ivory Leaves Mental Health Unit. He has to justify his job to Mr Audit (himself under pressure from the Board) by showing that art therapy is 'effective' as a therapy – in other words, that it 'works'. This immediately positions Franz' research within a specific research paradigm: one that underpins outcome-based research. **Outcome research** methods traditionally evaluate the effectiveness of practice, and usually there is less (or usually little) interest in what happens 'inside' the arts therapy group sessions, e.g. how arts therapy happens, how arts therapists make sense of this, how the significance of the practice is understood, and so on. These kinds of questions (like Suzie's project) usually belong within the framework of **process research** (more of this in Chapter 8).

Franz' research questions situate his project within a scientific research paradigm, which is based on **positivist** thinking. This methodology demands conclusions from direct observation (in other words, conclusions are **empirically** based), rather than making interpretations and inferences based on analyses of written or musical or artistic texts. The positivist world-view understands truth as objective (rather than subjective), and studies within this paradigm attempt to 'prove' (or at least, to show beyond reasonable doubt) that results are generalisable – i.e. that they would hold true for all conditions that are similar (known as the study having **external validity**).

Franz thus needs to be able to make an objective statement that might well be true for all weekly group art therapy sessions within community mental

health centres. What gives his project external validity is the secure and logical combination of his research design, and the methods he uses for collecting and analysing data. His design needs to ensure that his research sample (the number of subjects or research participants) is large enough, and representative enough of mental health community centre clients, to be able to apply his findings to mental health community centre clients generally. It is essential that Franz have ongoing advice from Carmen Statistica for his project, since the design of his study requires in-depth understanding of statistical concepts that most arts therapists (and many other professionals, incidentally) simply do not have.

Also, Franz' project results need to be accessible to a range of colleagues – including accountants, medical consultants, his line manager, social workers and psychologists – as well as being of interest to his fellow art therapists. His results thus need to be presented in a way that makes sense across a range of disciplines. By drawing from standard and pre-existing research methodologies, Franz is dipping into a pool of language, concepts and methods that is accessible to readers from many disciplines. In other words, scientific research methods may be thought of as a template, or a formula that is adaptable to a range of situations and subjects, and also accessible to researchers from other disciplines.

What is fairly obvious from Franz' proposal is that it has to do with *measuring, observing* and *verifying* the effects of art therapy, rather than describing weekly group art therapy sessions. The rest of this chapter takes you through various issues to do with research designs, some drawn from Franz' proposal.

To begin with, let's remind ourselves of his research questions:

1. Can weekly group art therapy (WGAT) sessions help improve chronic mental health sufferers' attendance at mental health units?

2. Can WGAT sessions be useful in stabilising or improving chronic mental health sufferers' sociability and personal motivation?

Design 1: Two-group, pre- and post-test design (the experimental study)

This corresponds with Franz' Design 1 in his proposal (see Chapter 5). As well as talking you through various aspects of Franz' design, this chapter introduces some general concepts underpinning quantitative research methods.

Dependent and independent variables

In Franz' Design 1 (Chapter 5), he seeks to show the *effect* of one condition (art therapy) on another (attendance record). In other words, the relationship between the one and the other is *causal* – and the **experimental design** is usually a good way of testing causal relationships. Using quantitative research discourse for Franz' study, we would call 'attendance record' (AR) the **dependent variable** (since it is *dependent* on the weekly group art therapy sessions), and the WGAT is the **independent variable** (which Franz manipulates in order to check its effect on 'attendance record', the dependent variable). However, if you look at the project design plan, you'll see that there is another dependent variable: the measures of General Moodstate (GM) and Social Motivation (SM). In research question 2, Franz slips an 'extra something' into his study: he also wants to see whether there might be a causal relationship between art therapy (independent variable) and the subjects' General Moodstate and Social Motivation (dependent variables): see Figure 7.1.

Figure 7.1 Dependent and independent variables

Matching subject groups and controlling for variables

In his Design 1, Franz compares two groups of 'subjects': the *experimental group* has weekly group art therapy sessions, while the *control group* has none. In other words, Franz is 'testing' the independent variable (WGAT) on the two groups by applying WGAT to one group and not applying it to the other. Apart from the independent variable (WGAT), the groups are as similar as possible to one another: they are *matched* for age, gender, age at onset of illness, duration of illness, socio-economic status, as well as for their attendance record (AR), Social Motivation (SM) and General Moodstate (GM). This is to prevent a situation where, as a result of *random allocation* of clients to the two groups (more of this later in this chapter) the clients in one group happen to have different dependent variables from the other group to begin with. For example, one group might happen to be younger, better educated and have a better attendance record than the other. This mismatch between the two groups might well influence the results of his study, and Franz can then not convincingly report that the relationship between the *independent* and *dependent variables* is a causal one. This is because the group with 'better' pre-test scores – let's say it is the *experimental group* – might greatly improve. However, they are the 'better' group in the first instance (e.g. better educated, more motivated, more sociable, etc.), and this might make them more responsive to WGAT than a group with lower pre-test scores. By matching the two groups as closely as possible *before* he begins WGAT, Franz hopes to avoid unnecessary distortions of results: i.e. he wants to be able to say that improvement in AR is the result of WGAT and nothing else. We hope that the need for pre-test scores is beginning to make sense. Not only do these scores provide a baseline against which we can measure any change, but also they enable Mr LeBain to allocate clients to the two groups in a way that makes the groups as similar as possible.

At the same time, though, we need to remember that in real life, it may be very difficult to match groups completely in terms of all variables.

Finally, we should remind ourselves that Franz wants to show that as a result of art therapy, the attendance of the *experimental group improves* (and here, in terms of statistical methods, we think of a **one-tailed test**, since he is postulating that the scores will shift in one direction only). However, he might also posit that the attendance of the experimental group changes (and

here, in terms of statistical methods, we think of a **two-tailed test**, since 'change' means that the scores might shift in any direction – up or down).

Remember that Franz is not interested in what happens inside the sessions (or rather, John Audit is not interested) – which is implicit in his design (Figure 7.2).

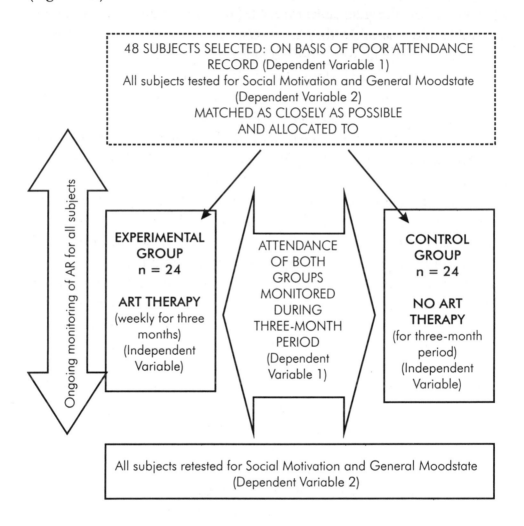

Figure 7.2 Design 1: The experimental study

Internal validity

Franz needs to be sure that his research design has *internal validity*, i.e. that his choice of *dependent variable* is suitable for what he is trying to find out. If we look once again at research question 1 (Can weekly group art therapy

sessions help improve chronic mental health sufferers' attendance at community mental health units?), then it makes sense to use the frequency of attendance (i.e. attendance record) as a *dependent variable* – since subjects' erratic attendance is a focus area of this project.

If we look at research question 2 (Can WGAT sessions be useful in stabilising or improving chronic mental health sufferers' sociability and personal motivation?), then in terms of internal validity, Franz needs to be sure that the scales for General Moodstate do, in fact, measure what he needs, and that the scales for Social Motivation are the appropriate ones for measuring 'sociability'. If these are not appropriate, he could go to an awful lot of trouble and end up with unreliable results, because of having chosen incorrect measuring instruments for his study. This is ethically dubious research practice incidentally, as we saw in Chapter 6.

Pre- and post-test scores

Pre- and post-test scores are a repeat of the same tests (Social Motivation, General Moodstate and attendance record). It is simply the *timing* of them that determines whether they are **pre-test** (i.e. before the WGAT period) or **post-test** (i.e. after the WGAT period).

- *Pre-test*: all subjects (i.e. from both groups) (n=48) are tested for SM and GM and their AR is noted (scores Ea and Ca, Figure 7.3). This should show that the two group scores are similar, and well matched.

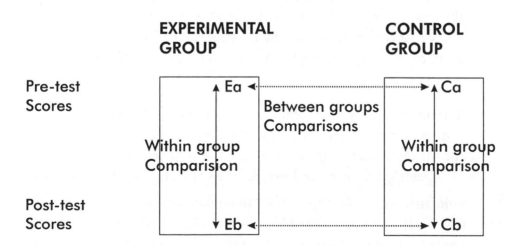

Figure 7.3 Pre- and post-test scores

- *Post-test*: All subjects (n=48) are once again tested for SM and GM, and their AR is again noted (scores Eb and Cb, Figure 7.3). This should show that the two group scores are now different (in contrast to the pre-test scores).

We see that the pre- and post-test procedure is identical, which eliminates the possibility that testing itself affects the results.

In order to maximise objectivity and eliminate **researcher bias**, the person administering the tests should, ideally, not know which of the groups any of the subjects belong to. (Think about it: if they know that 'Johnny' is about to have WGAT, they might be more careful in testing him than in testing 'Alan', whom they know is not going to have WGAT. Even without necessarily giving Johnny 'better' scores than Alan, the tester's researcher bias – also known as the **Hawthorne Effect** – may in some way interfere with the 'cleanliness' of the data being collected.)

Outcomes

The scores are then compared, as follows:

Between groups comparisons

- Between the experimental and the control groups, Franz compares the pre-test scores (Ea and Ca in Figure 7.3). Here he wants to show that the scores for the two groups are similar to one another.

- Between the experimental and the control groups, Franz compares the post-test measures (Eb and Cb in Figure 7.3). Here he wants to show that the scores for the two groups are different from one another, since one group has had WGAT and the other not.

Within group comparisons

- Within each group, he compares the pre-test scores with the post-test scores (Ea and Eb) (Ca and Cb). He wants to show that for the experimental group, the pre- and post-test scores have changed significantly, and that for the control group they have not.

The results that we would expect from these comparisons would be that if WGAT is effective in 'improving' SM, GM and AR, then this will be reflected in changes on the *post-test* scores both within and between the groups. Let's recap:

- We would expect the pre-test measures between the experimental and control groups (Ea and Ca) to be similar (remember that the groups are matched as closely as possible, so it would figure that the scores would be close to one another for SM, GM and AR).

- We would expect the post-test measures between the groups to be different (Eb and Cb): (remember that the experimental and control groups differ in experimental conditions, so we would expect a change – we hope for the better – in the SM, GM and AR scores for the experimental group, and little or no change for the control group).

- Within the experimental group, comparing the pre-test scores with the post-test scores (Ea and Eb) would show a change in scores for Social Motivation and for General Moodstate – as well as for general attendance record.

- Within the control group, we would expect to find little or no change in comparing the pre-test scores with the post-test scores for Social Motivation and for General Moodstate (Ca and Cb) – as well as for general attendance record. This is the group that has had no WGAT.

At first glance, all of this makes sense and we might think that of course WGAT is a good idea, and Franz' design is logical and therefore the results will be in his favour. Would that life were that simple! Remember that Franz' study needs to fulfil certain requirements, in terms of statistical procedures, to ensure that any changes in SM, GM and AR are not only significantly so, but also due to WGAT, and not to anything else. His results needs to be **statistically significant**, i.e. not just any change will do. (More about this in the data analysis section in Chapter 9.)

We now present you with another possible design scenario for Franz' study – to give you ideas about how you might play around with designs in your own study, before you begin collecting data.

Design 2: Three-group, pre- and post-test design

Were Franz to follow Design 2 in his proposal (Chapter 5), the structure of his study would be much more complicated.

More on selecting subjects for research projects

To select clients for Franz' project, psychologist Michel LeBain divides all the clients at the unit into 'low', 'medium' and 'high' attenders. These three **categories** use selection criteria already established in a previous (fictitious) study, that of Smith and Redfern (1984) (reread Chapter 5 if you need to remind yourself). Why use their study, you might ask yourself; why not simply have Mr LeBain or Franz define their own categories of 'low', 'medium' and 'high' attenders – after all, they know the set-up at Ivory Leaves, etc.

One answer is that by using Smith and Redfern's study, Franz is being academically rigorous: Smith and Redfern have already done the groundwork in setting out general criteria for what constitutes 'low', 'medium' and 'high' attendance and, moreover, they have certainly 'tested' the soundness of their criteria. However, Mr LeBain needs to be careful. He needs to ensure that these criteria are, in fact, appropriate for the client group and the clinical context of programmes at Ivory Leaves Mental Health Unit. If he does not check this first, but simply assumes that Smith and Redfern's study is appropriate, then Franz' study might be in trouble (in fact, he'd better check this out with Carmen Statistica before going any further).

Having selected 27 clients for the study on the basis of their attendance record, Mr LeBain randomly allocates all 27 clients to WGAT – Group A (24 WGAT sessions), Group B (16 WGAT sessions) or Group C (8 WGAT sessions). At the end of their respective WGAT periods, all clients are retested for GM and SM. Also, in this design, all subjects are again retested for AR and GM after a further two-month period (Figure 7.4). This is to see whether the effects of WGAT on GM and SM are short or longer term. (Careful here: first of all, Franz does not have that much time for his project, so that this idea of retesting all clients after two months may be unrealistic. Also, in terms of research ethics, this design means that none of the 27 will have WGAT for a two-month period.)

Before continuing, let's think about how Mr LeBain might check whether Smith and Redfern's criteria are appropriate for Franz, and how Mr LeBain might himself design the categories of 'low', 'medium' and 'high' attendance for Ivory Leaves.

We now work through various ways in which to create categories for a study such as Franz'.

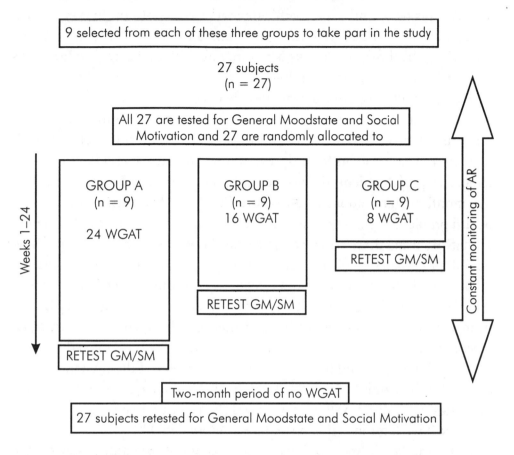

ALL CLIENTS AT IVORY LEAVES MENTAL HEALTH UNIT: DIVIDED
INTO 'LOW' 'MEDIUM' 'HIGH' ATTENDERS

9 selected from each of these three groups to take part in the study

27 subjects
(n = 27)

All 27 are tested for General Moodstate and Social
Motivation and 27 are randomly allocated to

Weeks 1–24

GROUP A
(n = 9)

24 WGAT

GROUP B
(n = 9)
16 WGAT

GROUP C
(n = 9)
8 WGAT

RETEST GM/SM

RETEST GM/SM

RETEST GM/SM

Constant monitoring of AR

Two-month period of no WGAT

27 subjects retested for General Moodstate and Social Motivation

Figure 7.4 Design 2: Three-group, pre- and post-test design

Creating categories

If we take an average of 30 days per month in the year, then we would agree that clients who attend Ivory Leaves for 30 out of 30 possible days have 100 per cent attendance per month. We might then agree that up to 10 days per month might be 'low' attendance, 11–20 days might be 'medium', and 21–30 days 'high'. In other words, we are dividing the 30 days into three 'equal' sections.

NB: the three categories are *mutually exclusive*. Thus, 0–10 days is 'low' attendance. We cannot have 10–20 days as 'medium' attendance, as this would

create confusion as to whether 10 days fits into the category of 'low' or of 'medium', since '10' appears in both. Thus, the 'medium' attendance is 11–20 days per month, and 'high' attendance is 21–30. In this way, a neat demarcation exists between 'low', 'medium' and 'high' attendance. At the same time, the three categories include all possibilities: i.e. they include 0 as well as 30 days for every month – not just the days between 0 and 30.

However, although this demarcation between 'low', 'medium' and 'high' attendance appears to be logical in terms of dividing 30 days into three equal sections, when Mr LeBain applies these categories to the attendance records of all Ivory Leaves clients for the previous three months, he finds that, in fact, almost none of the clients fit into the 'high' category (attendance 21–30 days per month). Think about it: do you really think that clients with mental health problems are likely to attend a community health centre as frequently as that? By using these criteria to demarcate 'low', 'medium' and 'high', how would Mr LeBain find sufficient clients from the 'high' group for the study?

Mr LeBain has to redefine the categories according to more appropriate criteria. One way to do this is to rank all 172 clients attending Ivory Leaves from lowest to highest attenders, and then divide them into three equal groups of 57 + 58 + 57 clients in the order that they are ranked (total = 172). Each group would then represent 33.3 per cent of the total number of clients. He then finds the point (in terms of number of days per month) which identifies the division of the Ivory Leaves clients into three equal groups. (In Chapter 9 we'll go into this procedure in more detail.)

Here, the 'low', 'medium' and 'high' categories are still based on the number of days that this group of clients attend Ivory Leaves, but they might end up looking like this:

- 'low' = 0–6 days' attendance per month (57 clients) (clients ranked 1 to 57)

- 'medium' = 7–16 days per month (58 clients) (clients ranked 58 to 115)

- 'high' = 17–30 days per month (57 clients) (clients ranked 116 to 172)

Although these three categories are not even in terms of numbers of days, they are more representative for defining low, medium and high attendance records at Ivory Leaves. According to the previous 'logical' criteria for the

categories 9 or 10 days' attendance per month would have been 'low' atten-
dance figures, but for Ivory Leaves, this is, in fact, 'medium' attendance: a far
better position from which to select subjects for Franz' study.

The point being made here is that Franz needs to be clear that the criteria
he uses to create his **data collection**, as well as the measures he will use, are
appropriate for the group that he is investigating. He needs to think this
through before beginning to collect his data.

Random sampling

In Franz' Design 2, there is no 'treatment' or 'control' group as such, since all
clients have WGAT. However, we have three different conditions: Group A
has 24 weekly group art therapy sessions, Group B has 16 and Group C has
8. Moreover, unlike in Design 1, where the experimental and control groups
are matched as evenly as possible in terms of age, duration of illness, and at-
tendance record, the three groups in Design 2 are *randomly* allocated. This is
not to be confused with the fact that Mr LeBain will already have all the in-
formation about all the subjects, such as their age, gender, age at onset of
illness, socio-economic status, attendance record, SM and GM scores, and so
on. But here, this information does not feature in deciding which clients are
in which of the three groups. Here the clients will be allocated to groups A, B
or C randomly.

In order to ensure random allocation, Mr LeBain might do something like
this.

1. Identify all 172 clients as belonging to either 'low', 'medium' or
 'high' attenders groups and place their names into one of three
 appropriate hats – called 'low', 'medium' or 'high'.[1]

2. Pull nine names from each of the three hats: 27 subjects.

3. Put the 27 selected names into another hat.

4. Pull out each name and put it into one of the three piles in
 sequence: Groups A, B and C.

1 Putting something 'in a hat' means that we can't see what is inside the hat (think of magicians
 who pull surprises out of their hats). Imagine, therefore, bits of paper with clients' names written
 on them all in the 'hat'. Mr LeBain pulls names out of the hat, unable to see what names he is
 selecting. This is a common way of ensuring random sampling.

This is *random sampling*: Mr LeBain allocates clients to Groups A, B or C on the basis of the order in which names are pulled out of the hat.

Also, whereas Mr LeBain knows whether the subjects are 'low', 'medium' or 'high' attenders, he will not tell Franz, who will be *blind* to that condition. Think about this: if Franz knew which subjects were 'low', 'medium' and 'high' attenders, this might influence his attitude to them in the sessions, i.e. his project results might be affected by **researcher bias**. He might (in spite of himself) pay more attention to 'low' attenders, because of wanting them to improve.

Before considering other aspects of Franz' data collection, let's detour briefly to one other design possibility.

Design 3: One-group pre- and post-test design

This design does not correspond to either of Franz' designs in his proposal; we are offering you an alternative, but using the same setting, number of clients and protagonists – in case you're getting rather fond of them.

48 SUBJECTS SELECTED: ON BASIS OF ATTENDANCE RECORD
(Dependent Variable 1)

All subjects tested for Social Motivation and General Moodstate
(Dependent Variable 2)

ALL HAVE WGAT
(Independent Variable)

Attendance record monitored

All subjects retested for Social Motivation and General Moodstate
(Dependent Variable 2)

Figure 7.5 Design 3: One-group pre- and post-test design

Instead of having two groups, Franz might consider putting all the research subjects into one group; i.e. all 48 clients who have WGAT for the same period, and pre- and post-test measures applied, as well as their attendance records monitored during WGAT (Figure 7.5). This single-subject or single-group experiment (sometimes known as one of the quasi-experimental designs) is not unlike a case-study design, with the 'case' being the entire group.

Ethics

We might say that, in terms of ethics, this design is preferable to Franz' other two designs since no client is deprived of weekly group art therapy. However, we might also argue the opposite: that in view of the amount of time, energy, costs and people involved in the study, the one-group design is *less* likely to give us reliable results. Here there is no other group to 'control' for the effects of WGAT. This raises different kinds of ethical issues. Whereas in the short term (i.e. for the duration of the research project), more clients at Ivory Leaves have WGAT, in the longer term, if Franz' study does not reliably and convincingly 'prove' that funding an art therapy post can be justified in terms of economics and efficacy of the practice, then its ethics are debatable in terms of time, energy and funding spent on it.

Controlling for the effects of the *independent variable(s)* is generally sounder experimental practice, in terms of delivering 'results' that are uncontaminated or 'clean' – although research ethics always rears its head whatever design we use – and you do need to be alert to the ethical pitfalls of your designs.

Time-series analysis

One other kind of analysis that Franz might consider in this design is *time-series analysis*. Here, if we think in terms of ongoing events (WGAT and AR monitoring) over a period of time, we may want to analyse the way these scores might change over time: for instance, whether there are patterns and changes of patterns over time. If Franz were to do an analysis of attendance record (AR) during the WGAT period and, let's say, the use of primary colours in weekly WGAT, then time-series analysis would explore whether (and how) a change in pattern on one set of data (e.g. the WGAT) might

coincide with a change in another (e.g. attendance record). The emphasis, here, is on the temporal nature of the relationship. As you've gathered, here we're moving into looking at what happens *inside* WGAT, in contrast to our initial emphasis that Franz' designs are looking at pre- and post-test scores. This is a scenario where you might think not only in terms of either positivist or post-positivist methodology, or of quantitative or qualitative research methods. There is absolutely no reason why measuring cannot be part of qualitative data analysis, and vice versa.

Other aspects of data collection

Implicit – or rather, explicit – in this chapter is that Franz is collecting information specific to his project – i.e. he is collecting data according to set criteria and for specific purposes. He is not collecting data in a random manner – or because it seems to be interesting information that he might use one day.

Franz needs to collect data that enable him to answer his research questions as follows.

General information about all subjects

Age, gender, socio-economic status, age at onset of illness, duration of illness and diagnosis data need to be collected. Although these data are not directly needed for answering his research questions, this information may be critical in doing primary analysis of his data. He may find, for example, that those subjects whose AR scores (*dependent variable*) do not improve are, in fact, younger than those who do improve, they may have been ill for a longer period, may have suffered from depression rather than from mania, or might be from a certain socio-economic status. It would be a pity for Franz to lose these peripheral and possibly critical findings (through omitting to collect these data), since they might provide pointers to WGAT for other groups of clients. For example, he might find that people suffering from mania might be more amenable to WGAT than those suffering from depression, and so on. In his research report, he will discuss this unexpected finding, suggesting that more research needs to be done in this area.

For the pre-test and post-test measures

Attendance record, Social Motivation and General Moodstate need to be recorded. Remember that the *pre-* and *post-test measures* are the *dependent variables*: Franz needs these data in order to be able to compare what happens before to what happens 'after' the WGAT period whether or not subjects are having WGAT. Also remember that the *pre-* and the *post-test measures* are the same tests, but applied at different times – before (pre-) and after (post-) the WGAT period.

Data organisation

We conclude this chapter with three more aspects of data collection you need to consider; these are to do with data organisation as well as data collection, including the use of standardised testing procedures, and the scoring and coding of data. Each of these straddles both data collection and data organisation – as we'll explain in a moment. Let's first consider collecting data by using standardised tests.

Standardised testing procedures

Some of the data – specifically the SM and GM scores – are collected by administering *standardised 'tests'*. In other words, there is a predetermined and validated format for collecting this information that has been used in many other studies. For example, a test may have a total of 20 questions which are all pre-set and asked the same way, as well as a specific format for organising the answers. Thus, the question 'how often do you get up before 0800h?' may provide answers that fit into a numeric value between 1 and 5, where 1 = never, 2 = rarely, 3 = sometimes, 4 = often, and 5 = always. Here, there is also a format for presenting and interpreting the final scores. For example, the final score could be the sum of the number selected for each question, and an interpretation of the final score might compare that final score to a table showing standardised scores by large groups of clients with similar mental health problems, in similar community health contexts (assuming these tests had been tested over a large and diverse sample).

Someone (other than Franz) needs to be 'trained' to administer these rating instruments. They need to ensure that for each subject, the procedure for administering remains consistent: e.g. that the whole test is administered

in one sitting, that it takes no longer than 30 minutes, that the same warm-up questions are asked every time, that each client gets the same explanation as to why this is being done. This will ensure that the data are collected in a consistent manner, and according to standard procedures.

Many of Franz' data have to do with numbers, for example, ages of the experimental subjects, the duration of their illness, their scores for the Social Motivation and General Moodstate tests, their attendance records and so on. Whereas some of the numbers will be determined by standardised scoring – like the GM and SM scores – Franz needs to think about how to organise the scoring and coding of other data, e.g. the gender of his respondents, the nature of their illness, their age, and so on. It is best that he thinks through this before he begins his data collection, even if the actual coding and scoring will happen after his data collection.

Next we consider that numbers can mean different things – and not all numbers represent quantity!

Numeric values and scoring

Some of Franz' data will be **nominal** data, i.e. representing one or other category, rather than representing a 'quantity' as such. For example, the gender of his subjects can be coded as follows: 1 = male or 2 = female. Their mental health problem could equally be coded, e.g. 1 = depression, 2 = substance abuse and 3 = mania. Here, the numbers literally have nominal value.

Other data may be **ordinal**. Here, numbers do represent quantity, although its exact value is inexact. Thus, 1 = 'low' attenders, 2 = 'medium' attenders and 3 = 'high' attenders. We know that 2 is more than 1, and that 3 is more than 2 or 1, but we do not know by how much. Here, the space or distance between 1 and 2, and between 2 and 3 is likely to be different (unlike a ruler which shows equal spaces between numbers).

Ordinal and nominal values require *non-parametric statistical tests.*[2]

Other data may be **interval** data. Here, numbers have fixed value in the sense that the distance between 20 and 10 is the same as that between 30 and

2 We're not going into details here about parametric and non-parametric tests, but are alerting you to their distinction on the basis of the kind of data you collect. As always, we urge you to consult statistical manuals and speak to statisticians when undertaking a project such as Franz'.

20, but the numbers themselves do not refer to a fixed quantity – there is no fixed zero point. The usual example here is that of a thermometer, where the distance between degrees of temerature is fixed, but the zero point is not (think about the zero in Celsius and in Fahrenheit).

Finally, **ratio** data have a fixed zero value, such as age, distance, weight, etc.

Interval and ratio numeric values usually require *parametric statistical tests.*

Coding

Franz needs to ensure that his data are coded properly – especially if he is using computer software for his statistical tests. Some codings are predetermined by computing software used for statistical analysis or even for descriptive statistics, but others he needs to develop himself. Much of this section will remind you of our discussion about creating categories, but the emphasis here is on how to code the different categories. For example, he might need to code subjects' gender, as well as their medical diagnosis, according to a numeric value. Here, he decides that all numeric values to do with mental illness begin with a '2':

21 = depression

22 = schizophrenia

23 = mood disorder

whereas all neurological-based illnesses begin with a '3':

31 = aphasia

32 = disphasia

33 = diskinesia.

The ages of subjects he codes with a figure beginning with '4', so that:

20 years old will be coded as 420

21 years as 421

34 years as 434, and so on.

Alternatively, he may create subgroups (or categories) of ages:

41 = 20–29 years

42 = 30–39 years

43 = 40–49 years

44 = 50–59 years

45 = 60–69 years

46 = 70 + years.

Note that the codes 41, 42, 43 etc. do not represent 41 years old, 42 years old, etc. but are simply a way of coding or of representing age groupings in a format that is more accessible for computing.

In terms of arts therapies research in general, some of the data may not fit easily into numeric values. The answer is simple: Get advice! We do – constantly!

For example, in wanting to convert the qualities of a painting into 'numbers' to do with quantity or proportion, you might decide to create three categories with regard to 'movement'. These are:

(a) static

(b) some movement

(c) lots of movement.

You might then consider assigning what proportion of the painting fits into each of the three categories, e.g.

(a) = 55%

(b) = 30%

(c) = 10% of the painting.

Remember that, as with creating categories, you need to cover all possibilities. In Figure 7.6 the three categories do not total 100 but 95 per cent. You therefore need to create another category, but since you may not be sure what quality this has, you can decide to call it (d) = not sure (Figure 7.7). This ensures that you've covered all the possibilities – totalling 100 per cent.

(a) Static	(b) Some movement	(c) Lots of movement
55%	30%	10%
		(Total 95%)

Figure 7.6 Painting: Movement 1

(a) Static	(b) Some movement	(c) Lots of movement	(d) Not sure
55%	30%	10%	5%
			(Total 100%)

Figure 7.7 Painting: Movement 2

Conclusion

We've discussed various aspects do to with research design, data collection and data organisation for Franz' study, hoping that this has alerted you to thinking about how to collect information, how to manage and organise it. Do remember that these are all tips of icebergs – and at this stage, the critical thing is for you to be aware of the icebergs' existence. This should help you to think through the hows and whys of collecting data – before you even begin your study.

Remember what we said at the beginning: that you need to think through possibilities carefully while writing your proposal, to see whether what you are intending to do is realistic in terms of time, facilities, resources, funding and the demands of your institution.

In Chapter 8 we take a break from Franz and have a look at Suzie's study. Remember that if you want to continue with Franz' project, then go directly to Chapter 9, which takes you through his data analysis.

Suzie's Project: Part 1

*Justifying a qualitative methodology – Characteristics
of qualitative reseach – Qualitative methods –
Collecting data – Organising data*

Suzie's choice

Suzie has made a series of choices in developing her research up to this point.
Her research proposal (see Chapter 5) presented an initial design which
involved certain methods for collecting data and which reflected the stance
of a qualitative research methodology. This chapter will follow through the
first stage of Suzie's project, looking at the nature and characteristics of a
qualitative research perspective (Section A), and at how these lead to partic-
ular methods of data collection and organisation (Section B).

SECTION A: QUALITATIVE METHODOLOGY AND DESIGNS

Research as cooking

A research methodology is rather like a cuisine. It has a tradition, an identity
and varying degrees of rigour. The overall cuisine (**methodology**) and its
recipes (**designs**) influence how ingredients are collected (**data collection**),
prepared (**data preparation**), served (**data presentation**) and cooked
(**data analysis**). Then the proof, as they say, is in the eating. We won't force
this analogy any further, but you get the idea.

Look again now at Suzie's proposal and we will trace in more detail in this
chapter how these concepts and procedures are relevant to Suzie's research.

She states in her proposal that:

For this inquiry a qualitative research perspective is most appropriate as my aim is to produce a 'close description' of the phenomenon of 'quickening' in order to encourage further thinking about this aspect of music therapy.

Her criteria for her choice of methodology are as follows:

- She is researching for an academic purpose, intended to deepen her understanding of her practice, and to link this to theory.

- She is not required to demonstrate that her practice works, nor is her dissertation intended for anyone else except her examiners and fellow music therapists.

- She is clear what she wants her inquiry to achieve: a detailed investigation and description of an aspect of the *process* of her clinical work – the phenomenon she calls 'quickening'.

- She realises that she already has data which could be used for this research – her own clinical work, and the thoughts of colleagues about this phenomenon. Unlike Franz, there's no need to set up an artificial experiment to investigate it.

- Though not sure quite how she will organise and analyse these data, she is sure that she has already got quite a bit of the research material she will need.

- Importantly, Suzie is motivated to spend six months on this project. She is convinced by her clinical work, but realises that she has yet to understand it fully, especially when she attempts to match a theoretical understanding to her intuitive grasp of the work. She believes that detailed examination and thinking around the concept of 'quickening' will be a way of developing her 'clinical thinking' about music therapy – it is hoped it will help her to talk about the clinical process with more confidence and focus.

As to naming her methodology 'qualitative' Suzie realises (from Peter Purt's 'methodological perspectives' lectures) that this provides the nearest 'fit' to her project. In particular, the following quotation from Grainger's book caught Suzie's attention:

Quantitative approaches are powerful ways of determining *whether* a particular result was causally related to one or another variable, and to what *extent* these are related. However, qualitative research is often better at showing *how* this occurred.

(Maxwell in Grainger 1999: 19; emphasis in orginal)

In the light of this distinction it is clear to Suzie that it is indeed a *qualitative* perspective that her inquiry comes under. She knows that the phenomenon of 'quickening' occurs and knows that it is causally related to the creative musical relationship (and she had no need to 'prove' this to anyone for the purposes of her dissertation). What she does want to investigate is *how* the phenomenon shows itself within the music therapy process – to understand it better by looking (and listening) more carefully. What's more, Suzie knows from her study of quantitative methods that any attempt to study 'quickening' from this perspective would in fact actively prevent her from understanding more about it – as it would prevent the study of individual cases. And only within individual cases is she likely to find the *uniqueness* or *essence* of the phenomenon.

Suzie also knows, however, from Peter Purt's lectures that qualitative research is not just something you do when you can't do quantitative. It has its own history, logic and designs. Suzie decides that she is rather vague about exactly what the 'qualitative paradigm' implies. She does some more reading.

Qualitative research in brief

Whereas Franz' methodology follows a tried-and-tested and preset procedure, Suzie's will evolve (successfully or unsuccessfully) as her project develops. As Forinash and Lee (1998) write:

Qualitative research has an *emergent focus or design*, in which the research methodology evolves, rather than having a preset structure or method, thus allowing the process to determine the direction of the investigation. This particular concept is appealing to many music therapists because of the parallel emergent focus found in the creative process. In qualitative research the aim is not to produce predictive generalisations, but rather a

more concentrated and in-depth application of the findings. Results generated are
context bound.

(Forinash and Lee 1998: 143; emphasis in original)

The heading for this subsection is something of a joke – there being no brief
way of covering all of the possible variants of what people take 'qualitative
research' to be. The remainder of this section gets a bit philosophical at
times, but we feel that it's necessary to present qualitative research as having
its own history, logic and rigour – not, as is sometimes hinted, simply a 'soft
alternative' to experimental work.

The origins of qualitative research lie in social science investigations into
human behaviour, where the aim was to understand *how* things are (their
qualities) and not only to what *extent* things are (their *quantities*). This involved
developing methods of observation, studying texts and conversations,
documents and interactions – studying the 'between and amongst' (Grainger
1998: 17) by being, as a researcher yourself, *between and amongst*, as opposed
to 'away and apart' as the quantitative experimental method tends to en-
courage. As the sociologists Kirk and Miller write: 'Qualitative research is a
particular tradition in social science that fundamentally depends on watch-
ing people in their own territory' (quoted in Silverman 1993: 29).

We will now characterise qualitative research and some of its methods by
working through Suzie's project – and how this develops in the data collec-
tion and data representation processes.

Nine characteristics of qualitative research

Suzie's project illustrates nine characteristics of qualitative inquiry, as
follows.

Process-centred

Suzie is interested primarily in the **process** of her clinical work rather than
its **outcome**. Her research focus has evolved from her involvement in her
own work. This focus does not pose a 'closed question' (a **hypothesis**)
which needs to be answered with a yes/no answer, but instead asks 'open

questions', while also defining and limiting a **research area** within which she will inquire.

Personal

Suzie is a **practitioner-researcher**, studying her *own* work (and to an extent herself), not keeping detached from it (she's a 'field' researcher rather than a 'white-coat' researcher). Qualitative researchers sometimes refer to the fact that the researcher is the 'data-gathering instrument', as it's from Suzie's own perceptions and conceptions that the focus of her research (the 'quickening' phenomenon) has developed. The advantage of this situation is that her sub- jective perceptions yield rich, informed data. The disadvantage is the accusa- tion (and real possibility) of distortion of these data (or *bias* – a concept that we'll discuss in more detail in Chapter 10). A useful basic stance on this issue is that, in qualitative research, subjectivity should be treated as a *resource* rather than a problem.

Natural or contextual

Many of Suzie's data come from work not designed as research (her tapes of completed clinical work) and from a **natural setting**. Another formulation of qualitative methodology is called **naturalistic inquiry** (Lincoln and Guba 1985), meaning that it takes place in real-life settings rather than in a laboratory. The belief attached to this methodology is that to place human events and interactions in a laboratory setting distorts them. As Grainger (1999) states, the qualitative researcher studies the 'between and amongst' by himself being 'between and amongst'. This fieldwork attitude sees human phenomena as irretrievably attached to their *context* and it is the fullness of this context which must be studied. So Suzie's focal phenomenon of 'quick- ening' will make sense only 'in the field' – a music therapy session in her case. Put it in a laboratory and it will disappear. Which brings us to another con- textual issue. Suzie outlines her concept of 'quickening' in the brief literature survey in her proposal as having something of an intellectual history to it. Her understanding, and subsequent investigation of it, can't be taken out of this intellectual and cultural context. A similar situation is true of all qualita- tive (and ethnographic) reseach: it consciously takes a wide **cultural context** as part of its research remit – not something to pretend is not there.

As a music therapist Suzie is studying an aspect of practice within an acknowledged theoretical and philosophical context. She acknowledges that however she tries she can never step outside of culture. As someone once said, there's no 'outside' outside.

Explorative

Suzie comments that her project 'is a descriptive and open-ended one'. She is not trying to confirm or disconfirm an already established statement, but rather intends her inquiry as an exploration of a complex aspect of the music therapy process that, in her opinion, has yet to be described adequately. Her research design progressively focuses as the focus of the inquiry itself clarifies. She finds out what it is that she's 'really' researching by *doing* it. The methods can be adapted, expanded and changed as the research develops. In experimental research it is not possible to reconceptualise your research half-way through. In qualitative research, however, your data analysis may lead you to revise what is central to your inquiry. This reconceptualisation is seen as part of the research, a finding rather than a crisis. Methods are *tools*, not strait-jackets. This improvisational aspect of qualitative research in many ways matches the artistic process, and leads writers to characterise qualitative research as 'creative' (Aigen 1993), 'holistic' (Ruud 1998) and 'organic and ongoing' (Forinash and Lee 1998).

Descriptive or comparative

Suzie aims to *describe first* – to establish (as her research questions state) whether 'moments of quickening' can be located in clinical music therapy and, if so, how these can be defined and described. It will not be a case of simply counting them – like counting how many black swans are left on the river. A qualitative approach looks instead at *qualities* – at *how* things are as they are – using observation techniques borrowed from other disciplines such as anthropology, ethology and social science. Observations produce **close descriptions** of phenomena. Instead of counting the swans we *observe* them for months on end and describe the qualities and characteristics of their behaviour. Closer to home for Suzie, she might use procedures from musicology to describe and redescribe the sounds, gestures and qualities of interactions within her clinical sessions. A cousin to description is *comparison* – es-

tablishing what something is, and how it is, by comparing it to something else. The process of making fine distinctions leads to putting things into **categories** – a common qualitative method. Suzie will use her fine subjective judgement to make good descriptions, although she also builds a comparative process into her inquiry. She will compare her own version of 'moments of quickening' to that of colleagues. Do they perceive the same thing, and if so is it in the same way? Can their descriptions enrich Suzie's? There is a rigour in close description and comparison. Read how Grainger (1999) argues for the scientific status of **causal inference** based on description.

Interpretative

It is a moot point whether there can be any such thing as description without implicit interpretation. As the joke goes, there's no such thing as an immaculate perception: all of what we know comes filtered through our subjectivity. Qualitative research takes this as a given, and works on ways of using (and qualifying) subjectivity. We might say that qualitative research works with the subjective, but tries to control the purely *personal* – whereas quantitative designs spend much energy attempting to eliminate subjectivity completely from research. One way in which Suzie's design attempts to work with subjectivity is in how she aims to base her inquiry both on her own perceptions and on those of other people. She enlarges subjectivity to the realm of the **intersubjective** – where perceptions and conceptions within a culture can be shared and validated (and the risk of perception being illusion can be controlled).

Arguably Suzie is already working at an interpretative level when identifying the phenomenon of 'quickening' – as this is a concept she has built upon her ideas and her sense perceptions. It can't be measured but it can be perceived and made sense of (interpreted, that is). But as we saw in the last section, it *is* important to make at least an artificial separation between description and interpretation – for as King, Keohne and Verba state, 'It is pointless to explain what we have not described with a reasonable degree of precision' (quoted in Grainger 1999: 96). Our opinion is that good descriptions lead to good interpretations – but that we must always discipline ourselves really to locate the evidence for an interpretative (explanatory) account of phenomena. Unlike the novel or love story, when it comes to research nobody cares what we *imagine* – they are interested only in what we

can *demonstrate*. Suzie's research aims not to prove the 'truth' of her views but to demonstrate a **valid perspective** that will be useful to others' thinking and practice.

Idiographic

A useful characterisation of qualitative research is as **idiographic** – meaning that it aims to make a 'deep but narrow' understanding of individual situations and phenomena – which might or might not be generalisable. In contrast a quantitative methodology is **nomothetic**, in that its research uses a 'shallow but broad' approach in order to construct general laws. As Gadamer describes, the prime concern of an idiographic study is: 'not to confirm and expand general experiences in order to attain knowledge of a law, e.g. how men, peoples and states evolve, but to understand how *this* man, *this* people, or *this* state is what it has become' (quoted in Smith, Harré and Langenhove 1995: 59). Clearly Suzie's project is an idiographic one; she believes that if she follows the 'deep but narrow' path she will likely find (but not 'prove') something which is useful for other situations – on the basis that people and their responses in real-life situations are often very similar. She has, in any case, seen the phenomenon of 'quickening' in many of her patients, in several different situations. Through her research she wants to find out *more* about it.

The idiographic approach has consequences for the **validity** of qualitative research, a topic we shall revisit in Chapter 10. As King, Koehne and Verba state, qualitative research involves 'a trade-off between a case study with additional observations internal to the case, and twenty-five case studies each of which has only one observation' (quoted in Grainger 1999: 84).

Intra-disciplinary

In her section on 'Projected conclusions and benefits of the study' Suzie is modest, claiming only that it aims 'to elaborate on, and stimulate thinking' about her research area. She targets her research at colleagues in her own discipline of music therapy and possibly at other professionals for whom the music therapy process is sufficiently similar to their own work for her findings to be generalised. In other words her research is primarily *intra*-dis-

ciplinary – in contrast to Franz', which aims to be *inter*-disciplinary, in having to explain the efficacy of art therapy to non-art therapists.

Reflexive

In keeping with the researcher's involvement in her research process, and the principle of treating subjectivity in qualitative research as a resource rather than a problem, is the notion of **reflexivity**, which means that the researcher cultivates an ongoing self-reflective and 'critical' stance on her own research activity. The aim is to control the possibilities of excessive bias, and also for the self-reflection to be a positive aid to the research itself. Questioning, for example, how your training and its theoretical stance influences how you go about researching, selecting and analysing data and so on, gives a further layer of richness and **trustworthiness** to your study. Good supervision will help with this, in challenging preconceptions and too-hasty interpretations. But Peter Purt will also be encouraging Suzie to develop her own reflexive procedures within her research (such as a research journal or 'peer debriefing' with fellow students).

If, having made it through this section you realise that your inquiry takes a qualitative perspective, test out your understanding of this material by writing a draft methodology section for yourself. The Hints and Tips in Figure 8.1 will help you.

Hints and Tips
Justifying a qualitative methodology

Your final dissertation or report will need a methodology section. Why not write a draft of one now – it will help settle some of the ideas you now have on methodology issues. Write briefly:

- A justification of why you've settled for a particular methodology – why is it appropriate to your design as set out in your proposal?

- Place your work in a methodology *context* by referring briefly to other projects and to more general thinking and writing on methodology.

Figure 8.1

SECTION B: QUALITATIVE DATA COLLECTION METHODS

The tools of the trade: Suzie's method choices

There's a frustrating tendency for writers on research endlessly to debate methodology without telling you what to *do*. So without further delay we now look at **qualitative methods**: the actual research tools which will enable you to select and collect data, to organise and present them. The remainder of this chapter will tackle these stages.

Continuing the analogy a little further, it is of course important that you use the right tool for the right job. So it's worthwhile examining both what methods are available, and for what jobs they are best suited. The trick is to match your research questions to the best methods for investigating them. We'll work through Suzie's project – not with the aim of covering every possible qualitative method exhaustively, but to show the principles and then to refer you to other authorities.

Data in qualitative designs will be of two sorts:

- **Naturally occurring data:** products derived from the therapeutic process (tapes, pictures, sculptures from therapy sessions, notes on conversations with the client and other professionals, etc.).

- **Research-generated data:** descriptions, commentaries, judgements derived from situations set up during the research process and stipulated in the design (e.g. a 'test', interview or survey).

We'll see how Suzie's research uses both naturally occurring data (her case material) and research-generated data (her listening tests). But whatever the source, her data must relate specifically to her three research questions:

1. Can 'moments of quickening' be located in clinical music therapy?

2. If so, how can these be defined and described?

3. What is the significance of these moments for accounts of music therapy process?

Question 3 should develop later from her analysis of her data, so for the time being we'll concentrate on questions 1 and 2. For Suzie to start answering these questions two further questions present themselves:

1. Where are the data coming from?

2. What is she going to do with the data?

From these questions you will need to provide a rationale (stated clearly in your methodology section) based on three aspects:

1. How were the data selected?

2. How were the data collected?

3. How were the data prepared?

Method 1: Working on case material

Suzie has already stipulated in her proposal that she will attempt to address her research questions 'through a close examination of case material from my own clinical work', stating that she has worked as a trainee with two client groups: people with brain injury and people with dementia. She therefore has the option of researching her own work (not a problem for qualitative approaches, as we saw in the previous section), and is fortunate that the approach she works within as a music therapist encourages taping of clinical work. Suzie has a combination of both video and audio tape of her clinical work from both placements, a good source of data for her project.

The case study

This is one of the key methods in qualitative research (Aldridge 1996). Case studies can be used to focus discussion in a clinical team or in training arts therapists, but they can also be formalised as a research tool (it depends in a way what you do *with* a case study as to whether it qualifies as research or not). As a research method it is an **idiographic** approach, aiming to find a lot about a little, looking deeply into the characteristics and process of a single event, condition or person. A case study is designed not to establish the general but to characterise the individual; to demonstrate existence not incidence. Within research case study methods are often called **single case designs** (Aldridge 1996). Smith *et al.* (1995) point out that the case study as

research takes a judicial logic, in that the aim is to develop a 'case law' within your discipline as single cases are written up, studied and considered in relation to each other. Cases show precedence, and build up a body of evidence on which to build theory.

Case study research does not of course always involve studying your own clinical work; you could investigate the cases of colleagues, though it may be harder to produce 'rich descriptions' of someone else's work. Both provide naturally occurring data.

Suzie worked with several clients in her two placements, but the two cases she learned most from, and which were the focus of her clinical supervision, were Betty (who had dementia and was in a nursing home) and Jack (a young man who'd had a road traffic accident and was in a neurological rehabilitation unit). Suzie wrote up both of these cases in a narrative form when on the placement and made detailed written commentaries on the tapes of the sessions. The work with these clients led her to develop her first ideas on 'moments of quickening' so she quickly decides in her initial discussions with her colleagues at Gamut College that she will use these two cases as her 'primary data' for Part I of her design.[1] These data are naturally occurring material, and while not a *single* case study, she will take a case study approach to examining the two clients' case data *comparatively*. But what data should she include?

Data selection in case studies

> Peter Purt's research lectures have now become a 'research seminar' where he and occasionally his friend and colleague Dr Porschia Tutoria, who jets in from Monaco, help the students to develop their inquiries. The task for everyone at this stage is to find data examples which fit with their research questions, and to justify these to the others. Suzie brings a problem. She's decided to use excerpts from both Betty and Jack, and has a combination of audio and video examples. She asks the seminar whether this

1 By 'primary data' we mean the main data for the research (or for one stage of the research). 'Primary data' could be either 'naturally occurring' or 'research-generated'. (Not to be confused with 'primary' and 'secondary' sources in the Literature Survey.)

*will make her data analysis too complex. 'Play them through –
we'll see,' says Peter Purt, and after they've seen a video excerpt
and heard three audio excerpts they discuss it.*

*Porschia doodles in her pink notebook during this process and
asks Suzie some sharp questions: 'OK, you've selected these
examples, but on what basis, my dear?' Suzie expected this one.
She talks of how she is already tackling her first research
question in the process of selecting the excerpts – on the basis
of what to her are the most obvious 'moments of quickening' in
the two cases. Her selection gives the clearest examples which
she hopes will demonstrate the existence of the moments.
Additionally her examples are designed to form a contrast: the
first shows a sudden change of energy, the second a gradual
gain in energy, and the third an initially high energy that flags.
The class express their agreement that the selection makes sense
logically, and that, on a first hearing, they identify similar
phenomena. Porschia (for once) looks satisfied.*

*On further discussion the class agree that, although Suzie's
one video excerpt certainly adds something to the data, if she
has only one (the remainder of the data being audio) this could
confuse the rest of her inquiry, and she would do best to stick to
just the audio examples.*

The fundamentals of the case-study approach can apply to most situations
where an arts therapist is researching clinical process. Some case designs
require that you collect specific kinds of data, some that you collect as much
as possible from different angles and sources as possible (a process sometimes
called **triangulation**). Read if you can some other accounts of case design
which go into more detail about it. If you do choose this method you need to
ensure the following:

- If you're researching completed work, that you have enough of this
 preserved (on whatever format is appropriate to your practice) and
 that it provides adequate data in terms of your research questions.

- A case study design will probably need you to relate details of the client and medical history to the phenomena you're studying in their arts therapy process. Make sure you have enough information.

- You have ethical 'clearance' to use that work from that institution for that purpose.

Write something about your data selection and collection procedures now (see Hints and Tips in Figure 8.2).

Hints and Tips
Data selection and collection

In a draft of your data analysis section include an account of:

- **WHAT** data you selected and from…

- **WHERE** you selected it, and…

- **WHY** you selected it.

And finally:

- **HOW** you selected it.

Such an account is part of the validating process for qualitative inquiry. It builds up the *trustworthiness* of your project.

Figure 8.2

Method 2: Observing – describing – interpreting (the O-D-I cycle)

Observe first: this is really the central principle of qualitative research; not deciding what you will find out beforehand, but finding evidence through sustained inquiry and building theory on the basis of controlled observation.

Observing first is natural to case study research where client change is the centre of attention. It is not exclusively tied to this, however. It is equally possible to do observational work on more abstract aspects of an arts therapy

process or product. Usually, however, it makes sense to put such work within the context of a client's case, so make sure that you have this perspective at least potentially available (background information, clinical notes, etc.).

We've developed a model called the **O-D-I cycle** (see Figure 8.3), a version of a principle common to many observational approaches. In this the researcher follows a cycle of activity, working with the primary data and developing an emerging theory. It aims to help you form an argument about the phenomenon you're studying which is *systematic, logically progressive, coherent and convincing.*

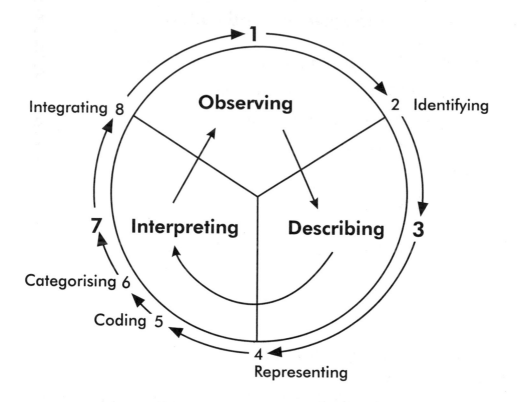

Figure 8.3 The 'O-D-I cycle'

Looking at Figure 8.3, we can see the three key activities: Observing (1), Describing (3) and Interpreting (7). Subsidiary activities are Identifying (2), Representing (4), Coding (5), Categorising (6) and, finally, Integrating (8).

Regard the cycle as a guide rather than a recipe! Use it in the way that seems appropriate to your project. You will typically go around the cycle several times during your research process – not always following it round in a linear fashion. Sometimes the different stages of the cycle interact and circle back on each other. Let's look at the logic of the activities one by one.

Observing

In order to find something, you have to look. *Observing* is the practice (and discipline) of maintaining what Freud called an 'evenly suspended attention', from which we get subjective data about the world through our senses. Observation for research purposes is just a more focused and systematic use of our everyday faculty of paying attention to the outside world.

As a researcher one of your first hurdles is therefore gaining access to the situation you want to observe. For Suzie this is not a problem as she is observing her own work, supplementing her in-session observations by recording the session on audio and video tape and observing these (the latter remaining, however, naturally occurring data). An important consideration for researchers at this stage is to decide what kinds of things you need to preserve in order to observe. If your research questions suggest you need to look at facial gestures, you clearly need more than audio taping! There are also practical and ethical questions to bear in mind. Were Suzie instead observing a colleague's work she would need:

- permission to observe
- to ensure her observation was not unduly influencing the situation (e.g. she may need to observe behind a one-way mirror, or sit somewhere where she isn't interfering with the process)
- ethical clearance to observe the client(s).

Refer back to our ethics section in Chapter 6 if you're unsure about these areas.

Identifying

Focusing your attention by observing allows you to *identify* certain things and events which emerge as significant and, if appropriate, to identify *when* they occurred. Suzie's research aims to identify her 'moments' – which she

does by listening to the tapes of her music therapy sessions and locating as exactly as possible where her attention is caught (she also remembers from the actual sessions where the moments happened). She then notes these exact moments using the tape counter. Of course, as she listens to her tapes she observes other interesting things but she makes herself keep to her main research interest – the 'moments'. In the terms of her research questions, she has *located* the moments, found *examples* of them for study purposes and *preserved* them on audio tape. Let's leave for the moment whether other people locate and identify the same 'moments': that question is also part of her design, but for the moment she's concentrating on her own perceptions.

For the first stage of her project the process of identifying 'moments' from her many tapes is useful for the research seminars where she will need to justify her observation by saying *why* the examples illustrate what she says they do.

Observing leads us to identify certain phenomena, which in turn need to be communicated to others by processes of *describing* – the second key operation of the O-D-I cycle.

Describing

Describing is the process of putting into words or other symbols what we've observed and identified in another modality (what we've seen, heard, etc.). The point of description is to preserve and share knowledge so that individual perceptions can be integrated into the larger framework of a story or theory. The art of good description is to find the most accurate way of conveying the form and qualities of something *before* interpreting it (comparing it to something already existent). The *describing* stage of the O-D-I cycle intentionally 'brackets' interpretation in order to describe a phenomenon fully first.

Description needs a medium, a form of translation from one mode to another, and is therefore usually dependent on representing.

Representing

Representing (as the word implies) is the process of *re*-presenting your data in another mode. Typically this involves transcribing it into another sense modality, as when we notate speech, music or dance into a visual system. This

can allow you to see the material from a different angle and usually in more detail. However, no description is innocent – there are inherent problems for researchers in any mode of representation or transcription. This is illustrated by the story of Picasso being challenged as to why his pictures of women were so distorted. 'Do you have a photograph of your wife?' Picasso asked the man, who duly took one from his wallet. 'Surely,' said Picasso, 'she is rather small and flat here!' A representation is a map, not the territory.

When Suzie first presents her case excerpts to the seminar she uses only a spoken description, which is rather vague. It's difficult, after playing the excerpts through, to refer to the bits she wants to talk about. From the ensuing discussion it becomes clear that Suzie needs to transcribe her excerpts into musical notation. This will give a visual form to the aural data and allow closer analysis. In the next seminar, with the aid of an overhead projector, Suzie's discussion is far more precise, as she can point to certain areas and features of the excerpts on the transcriptions. Her verbal descriptions and comments are tighter too. The transcriptions will also provide a visual form to these data which can be pasted into her final dissertation manuscript where necessary.

Most of the artistic disciplines from which the arts therapies derive have evolved well-developed transcription systems which the arts therapist researcher can use to aid close analysis of artistic and interpersonal processes. Suzie uses (for the first time ever) her hard-won transcription skills from her undergraduate ethnomusicology course (her dance movement therapist friend Lydia is using Laban movement analyis in a similar way). But Suzie also remembers Peter Purt's warning that one needs to be informed about the problems associated with transcribing material.

Transcription is like any form of translation – it can *transform* meaning as well as 'transport' it! So decide *why* you are transcribing and the implications of doing it for your analysis. There's no point taking ten hours to transcribe ten minutes of music or movement if your research questions do not ask for this level of analysis. Read up about transcription in your discipline and make your decisions rationally. Look at other research studies in your discipline which have used transcription as a descriptive method.

Forewarned, Suzie nevertheless decides that it is probably necessary that she transcribes her three excerpts, since she is going to need not only to look at the musical process (including micro-seconds of interaction) in order to

examine the musical characteristics of the 'moments', but also a visual representation of the examples to help in her 'test' aspect of the project (more about this in Chapter 10). Just in case, however, Suzie decides not to dedicate the next three weeks to transcribing *all* of her excerpts, but to do the first, try out the method, show it to Peter Purt and her colleagues in the seminar, and assess what she's doing from there.

Be clear, however, that representing your data by transcribing is *not* in itself analysing it – it is still *description*. The task for this stage is to get the material into a form where closer analysis is possible. To return to our culinary analogy: you've got to prepare the food before you can cook it, but preparation is *not* cooking. Having a transcription or detailed verbal description of your data does however mean that you can go on to the third major operation of the O-D-I cycle: **interpreting** (generating meaning from) your data. The first step of this is coding.

Coding

Suzie has one example transcribed (it took ten hours and several bars of Toblerone!), and she's ready to **label** aspects of her data representation (the transcription) in some way. **Coding** is a technical term for analytic labelling. At this stage Suzie is going beyond pure description and venturing into analysis proper, as her coding aims to break up the data into meaningful chunks so that comparison and other analytic procedures are possible. Texts on qualitative analysis often call the procedure from this point onwards **content analysis**. Edwards and Talbot (1999) liken it to passing a comb through your data, where the comb is shaped by your research aims. Sometimes a broad comb will do, sometimes you need the fine-tooth comb of a detailed analytic method. Sometimes, as Edwards and Talbot write: 'like tangled hair, the text fights back, resists the comb and may even alter its shape and hence the research question' (1999: 121). It's part of doing qualitative research that there's an interplay between the data and the emerging study. As we've said before, both data *and* study should ideally *emerge* – not one beating the other into a set shape.

To code her transcription of Excerpt 1 Suzie listens to it again, follows it in the transcription, studies the score and begins to label aspects or events *that are relevant to her research questions*. In her first rush of enthusiasm she tries simply to label her 'moments' immediately on the musical score. It doesn't

take her long to realise it's not as simple as this: even within her first excerpt the 'moments' are not so obvious on the score. Suzie remembers reading that often musical transcription is like eating soup with a fork – the very thing you're after slips through. You have to find more indirect ways of catching your fish!

Thinking this over Suzie remembers that the 'moments' are to do with the way in which the therapist musically supports the client's playing. She looks again at the transcription and codes who initiates a phrase, how long the client's phrases are, how the therapist supports these phrases (rhythmically, melodically, harmonically). For all of these she will need to find a code for marking up these features on the transcription. Given she suspects the key features are 'initiations' and 'speed changes', Suzie labels therapist initiations **Ti1**, **Ti2** etc. and client initiations **Ci1** etc. She then works on a different parameter of coding: **SC(f)** (= speed change, fast) and **SC(s)** (= speed change, slow), working through the excerpt.

Notice that this level is often very simple (if laborious). With initial coding you are beginning to make sense of the data by identifying and labelling the kinds of things you (think you) are looking for. This should help to build up a more subtle view of your data. The example we've discussed here has been coding a musical transcription, but of course you could do a very similar procedure for a transcribed verbal text – it too has **themes** or **meaning units**. Both of these terms are used in texts of qualitative analysis and mean the 'chunks' into which coding breaks down the data. In Chapter 10 we will revisit this area in relation to textual data.

Having labelled the data the next stage is to stand back from it and look at it (or perhaps look *down* at it from a higher level). Now you are beginning to know *what things* you have in your data. The next stage of data analysis asks: *what* **types** of things are these? That is, you move on to categorising.

Categorising

Let's say you've labelled the objects on a table in front of you: 'apple', 'orange', 'kumquat'. These can also be categorised as *fruit* – a higher-level organisation of your description (though you may need first to research what a kumquat is). A category is a mutually exclusive 'meaning box'. By definition an apple as a fruit cannot also be a vegetable. Categorisation allows detailed definition and logical comparison. In the same way, Suzie might have quite a

complicated system of labelling on her three transcriptions, but is soon going to need to organise her coding at a higher level (if she's wise she'll already be thinking of what her categories are as she's labelling). After much experimentation with category systems for her excerpts she finds that the most pertinent are:

- <degrees of therapist support> which can be subcategorised further into <high support> and <low support>

- <close musical contact between therapist and client>

- <speed change> with subcategories <change: faster–slower> and <change: slower–faster>

Within her transcription there are many events that come under these higher-level categories. But this is not to say that Suzie arrived at the categories instantly. It is a part of doing this kind of analysis that you must play around with categories, experiment, revise and recategorise on the basis of a new idea. As Edwards and Talbot (1999) advise, the process of establishing **robust categories** is progressive. The following scheme is based on their advice:

1. Develop possible categories.

2. Code your labelled data according to them (as many data as possible).

3. Test the robustness of the categories (do they apply to enough of the data you're interested in – or does too much 'fall out' of them?).

4. Firm up category boundaries by looking for 'overlaps'.

5. Discard 'weak categories' (those that apply to too few of the data).

6. Create new categories if necessary.

7. Go back and start again if absolutely necessary!

Luckily Suzie didn't have to resort to advice no. 7, but she spent a surprising amount of time working with the others. She emerged, however, with a better picture of what was in her data, and through the category-making procedure had begun really to analyse the data and find what she was talking

about. It was satisfying for Suzie to see how her meticulous analysis had meant that her categories genuinely *emerged* from the data, changing her initial view of it. In the next research seminar she could also *demonstrate* (with her taped excerpts and transcription on acetates) that she was not speaking off the top of her head. When she next spoke about her work she realised that she was beginning to see the wood as well as the trees, and had some **emerging theory statements** about her data. Her project was shaping up and she saw that she was now within the next stage of the cycle: interpreting.

Interpreting (theory-building)

You may remember in Section A of this chapter that we talked about the difficulty in qualitative research of really separating out description from interpretation. In coding and categorising we've seen how progressive levels of describing and defining phenomena are also to an extent interpretative – that is, we are making higher-level meanings from presented evidence.

Interpretation is the process of making meaning from a situation: *seeing-as, hearing-as,* a gestalt-level understanding of *phenomena-in-context.* As such, interpretation is subjective. It cannot be either true or false, but only a version of events – a truth-within-a-situation. Its value is also precisely this: subjective interpretation is a vital part of discovering what's happening in real-life human events and interactions. The human data-gathering instrument is also an interpreting instrument.

In research, however, both subjectivity and interpretation must be controlled – which is why qualitative researchers caution '*describe* first, and only then interpret'. Leaping straight to an interpretative level can lead you to false conclusions. There was a commercial for an insurance company on British television some years ago which showed a scenario in a thick black frame, where a punk runs up behind an old lady and violently pushes her sideways. Instantly most viewers leap to the interpretation (based on their prejudice) of 'what punks do to old ladies'. Then the thick frame around the shot is taken away, the scenario is repeated and you see in the larger picture that rubble is falling from a building site, about to hit the old lady before the punk pushes her to safety.

Suzie had realised this danger after she'd coded her transcription. She'd taken the idea of 'moments of quickening' from a source which suggested that these could be explained on the basis of 'empathic resonance' (a shared

moodstate) between therapist and client. Before she looked closely at her data this seemed a fair enough explanation. The more Suzie looked at her evidence, however, the more she realised that this was not a good enough interpretation of the phenomenon. She needed to let go of her borrowed interpretations and let her data guide her to her own explanations.

The O-D-I cycle helps to decrease the possibility of 'leaping to interpretation' – and thus weakening the trustworthiness of interpretative work. It was the 'prejudice' of the viewer in the TV ad example which led to a false interpretation. Prejudice as pre-judgement brings us back to one of the key characteristics of qualitative research – that it relies on *good judgement*. What you *infer*, and the theory about events and phenomena which you build, needs to be *demonstrated* up to the point of making a decisive interpretation – even if the judgement (interpretation) itself cannot be proved. This final leap is, as Grainger writes, a 'judgement of experience by experience' (1999: 72). We are back here to the legal analogy with the logic of qualitative research. Our research requires us to show the evidence, to make a case (argument), which will be judged plausible – or not. Technically this form of logic is called **analytic induction** or **inference**. This, as Edwards and Talbot (1999) explain, works from the particular to the general, building 'grounded theory' on the repeated occurrence of the particular.[2]

We encourage our students to keep their hands on the ropes of description for a long time before they leap to interpretations of their data. We talk of there being an intermediate level of the **musically grounded inference**, where you make statements about the therapeutic process which, though they cannot be directly perceived in the data as such (that is, they are *subjective judgements*) can nevertheless be backed up by 'circumstantial evidence'. That is, you have left the safety of pure description, but still have not leapt to an interpretation proper – where you have to take your hands off the rope – and hope!

Suzie has gone through the stages of describing her data, and is aware that she has been cautiously **theory-building** at the same time: she has her 'hunches' which labelling and categorising have begun to firm up. When she discusses her work with Peter Purt and her colleagues at the seminar she's

2 See also Grainger (1999; Ch.6) and Robson (1993; Ch.12) for an account of the role of inference in qualitative research.

aware that she knows more about her data and, when pressed, can put forward a tentative 'musically grounded inference' which interprets her data at a more inclusive level. 'My hunch', says Suzie at the seminar, 'is that what's happening in the moments is that it is points of tempo flexibility which allow the therapist to get into a musical fit with the client – and it's here that you can feel a change in energy of the music as a whole'. Peter Purt and the colleagues spend quite a lot of time asking her what exactly she means by 'tempo flexibility' and 'musical fit' but she can actually *show* some of these things with the aid of her transcription – her interpretation is to a large extent 'musically grounded'. She feels satisfied she's on to something.

Integrating

It's quite easy to follow the logic of your analysis but forget *why* you are doing it in the first place. Suzie got into this state when she became fascinated by 'tempo flexibility' after her colleagues had challenged her about it. She read some papers on tempo adjustment in improvised music in the music psychology literature and tried to apply some of these ideas to her ongoing data analysis. She was rather disconcerted when, at her next supervision, she spent 30 minutes explaining this material but could not say clearly its significance for her project. After the supervision she went home and revisited her research questions and, in the following week, made another loop around the O-D-I cycle, looking more closely at each example of tempo flexibility in relation to her 'moments'. From the second 'cycle' she developed the thought that tempo flexibility preceded the moments each time, but that equally a change of dynamics was there each time as well. Suddenly it clicked – it was the *joint change* that was significant, not that it was tempo *or* dynamics.

As part of the cycle it's vital to bring your mind back to the research questions which guided the first cycle of O-D-I. Reorientate yourself by *integrating* your evolving analysis, evolving theory and research questions. This part of the cycle is a way of going back to the shape of the wood after you've spent a lot of time staring at individual trees.

Taking stock at this point might lead you to a number of scenarios:

- You might decide that the first cycle has changed your research focus. You may even need to rethink or refine your research questions as a result of this.

- Your research questions still focus the inquiry well, but the data are too thin to show what you want – you need to collect more, or more varied, data.

- Your methods of analysis are not specific enough (or are too specific). You need to look for other forms of analysis and go around the cycle again.

- You've gone through the cycle but have missed some of the significance of what's there. Now you've done it once you're more orientated and focused, and need to revisit the data a second time and further develop your evolving theory.

These are all usual scenarios for the qualitative researcher. Remember the Chinese adage: crisis is opportunity! Go around the circle as many times as you need – but never mechanically. The principle of **progressive focusing** is the key here. You need to find what you are looking for by looking.

Riding the bicycle of qualitative inquiry

Potter and Wetherell give the following advice to the qualitative researcher:

> Analysis [of qualitative data] is like riding a bicycle, compared to conducting experiments or analysing survey data, which resemble baking cakes from a recipe. There is no mechanical procedure for producing findings.
>
> (Potter and Wetherell 1987: 175)

If you're a beginner this scenario can be anxiety-making, as can the other main characteristic of qualitative research that we've examined in this chapter – the fact that your project evolves as you do it. Not knowing exactly where your research is going is part of the challenge, but also part of the anxiety. But, to paraphrase the line in Stephen Sondheim's musical *Into the Woods*: If you knew where you were going you'd have got there! A good way of dealing with the anxiety of sorting out what you're doing and where you are going in a qualitative inquiry is to use others well: your supervisor,

colleagues and friends. The fundamentally non-technical nature of qualitative research means that any intelligent person can spot a good or bad argument in your work!

The next chapter which follows Suzie's project (Chapter 10) looks at how to move from the logic of this chapter – researching your own work by using your own subjective judgements – to its next stage: using others as part of the research process.

It's March and the final seminar of the term. Suzie presents her project having gone through the O-D-I cycle several times. Even Porschia Tutoria seems pleased, commenting only that Suzie's nail polish doesn't match her dress. But it's clear from the discussion of other people's projects that Suzie is rather behind in her research plan: she still has two other stages to go (her 'listening test' and the interviews). As people reassure her, however, for her project there was no use doing those until she had done her transcriptions and analysis and that has been especially time-consuming.

'Take a break, my dear – we don't want to get data-overload in that pretty little head of yours, do we?' says Porschia. 'But do research your nail-polish, OK?'

Suzie rings Franz to tell him that the seminar went well, and what was he doing during the Easter break?

'I'm going to Vienna actually,' says Franz. 'My cousin Georg invited me – and I've virtually done all my data analysis now. At least quantitative data analysis is quick!'

Suzie feels a bit crest-fallen at Franz zipping off again, so decides to phone her parents and arrange to spend next week at their 'community' in Dharma Manor, Devon. She always has a relaxing time there – and can have a quiet week contemplating where next to go on the bicycle of qualitative research.

Managing Your Supervisor (and Yourself)

We all need help with research. None of us is sufficiently an expert in all aspects to go it alone. This is why we've emphasised that your work needs to be supervised – whether this is formal or informal, regular or intermittent.

Supervisors will ideally give advice based on their experience of doing research and teaching it; they will give you practical and emotional support to carry through your project, will challenge your developing ideas and evaluate your ongoing work and they will give you feedback on the research process. Ideally all of this will be given in a wise, neutral and unthreatening manner. Your supervisor will be as wise as Solomon, as impartial as a confessor, as compassionate as Mother Theresa.

But you've spotted the problem, of course: supervisors are *human*! As a therapist you will be more aware than most of what can happen in charged relationships (particularly teaching or therapeutic ones). 'Transferential' aspects can distort a situation when a supervisor–supervisee relationship happens to replay past key relationships (especially authority ones). You may want to please, to rebel against, to become compliant, all at a cost to your research ideas and imagination. Or, alternatively, a supervisor (or supervisee) can simply be difficult, careless, inexperienced, defensive, malicious or plain incompetent. If you can, choose carefully. The person whose writings you admire or whose clinical work inspires you is not necessarily the ideal supervisor. If you have no choice, then you need constantly to revise the balance between what you want and need, and what your supervisor is able to offer.

A supervisory relationship in research is, however, between two consenting adults, and both parties need to take responsibility for making it work. It's true that the supervisor will typically have more experience of the situation, but equally you as a supervisee can help to 'manage your supervi-

sor' (and yourself) by being aware from the outset of the pitfalls and possibilities. The following are some notes on this, based on our experiences as supervisees and supervisors of research work.

- Some supervisors forget that it's *your* work that they are concentrating on – not *theirs*. Be careful they don't lead you off your track of research and into theirs (using you as an unpaid research assistant for their latest project). Politely but firmly remind them of your agenda and research aims.

- At higher levels of academic work it's unlikely you'll meet very often for supervision, but you do need to meet regularly. Some supervisors are elusive, so make it your responsibility to suggest a realistic timetable for meeting. If necessary, challenge your supervisor if meetings are becoming too erratic.

- Critique of work (in the way we've discussed it in this book) is natural to supervision: you submit your ongoing project, thinking and writing to a supervisor for accurate feedback on its quality and relevance. A good supervisor will challenge and correct your work forthrightly, but this shouldn't feel too personal. You should feel that it's your work being criticised, not you personally. If you continually feel the latter there are two possibilities: either your supervisor is *making* criticism too personally or you are *taking* criticism too personally. Either way, we advise that you speak directly about the problem at once with your supervisor, as you would in clinical supervision. Do not leave it until the end of your research to voice your discomfort. By this point it will have affected your work (possibly seriously).

- No supervisor can be an expert on every angle you might potentially need (especially past Master's level). You may need to consult several experts, using your main supervisor to 'oversee' your project. But arrange this diplomatically – we all have our professional pride!

These are some of the potential pitfalls. But let's not end with problems. Both of us have had some wonderful research supervision which has been a model of its kind and a testimony to the generosity and disinterest of the academic

world at its best. A good supervisor is more like a mentor: not only someone who you learn *from*, but also someone who sees the potential in you and your research, and who has the skills to elicit this. In short, someone who gives you the confidence to believe in your work and yourself.

We hope you find this experience in your research journey. But remember, you *too* share responsibility in making research supervision successful.

9
Franz' Project: Part 2

Data analysis – Descriptive statistics –
Inferential statistics

*Franz is still feeling tanned, and full of sachertorte even though
he's been back from Vienna for a while. He wonders whether to
call Suzie and tell her, but first he needs to do some reflecting
and analysis of how he feels about all this.*

Franz' data are collected and organised; he is ready to roll. What now?

In order to answer his research questions (Chapters 5 and 7) he needs to
do more than just collect interesting information, and also more than just
organise it in a logical way. He needs now to make sense of the information,
keep control of it and process it, so that he can ensure that his conclusions are
rigorous, generalisable and based on fact rather than assumptions. Because
his study is based on measuring, evaluating, quantifying (remember?) he
needs to find a reliable and valid way of working with his data and pre-
senting his results.

In this chapter, we present basic concepts to do with data analysis, and
introduce some statistical concepts. The emphasis is on *introducing* these, and
by no means is this a comprehensive text. Also remember that statistics is
simply a way of thinking about facts; a way of conceptualising and trans-
lating events into numbers. This enables us to do with these facts or events
what words cannot do (a bit like the arts therapies). Contrary to what anyone
says, you don't need much more than arithmetic skills: adding, subtracting,
multiplying and dividing in order to do statistics. You do, however, need
imagination not to be put off by some of the Greek symbols, charts and
formulae that enable us to make inferences about the hidden meanings of
data.

If you need more on statistical analysis, then you need to consult some textbooks and your college or workplace equivalent of Franz' Carmen Statistica. In other words, a statistician who is familiar with social sciences research methods. Be careful of assuming that psychologists are necessarily statisticians (unless they are research psychologists). Also, as we said in Chapter 1, don't hand over your project to a statistician or researcher just because they know about something that you don't! And don't let them get away with talking to you in statistical jargon: it will confuse and frustrate you. Make clear what you need from them and be assertive (gently, of course) in ensuring that you get it – in the way that *you* need for *your* project.

We're great believers in learning from *empathic* experts (make sure you find someone who knows how to teach: not all experts know how to put things coherently and simply). One encouraging aspect of familiarising yourself with this chapter is that you will be in a far better position to *read* scientific papers and, what's more, you'll be more confident about deciding whether what you read is, in fact, sound research. Another is that some concepts here are equally useful and applicable to qualitative research. In fact, some measuring and quantifying may do wonders for your process research.

Finally, we want strongly to suggest that if or when you undertake a study such as Franz', you'll do the following:

- Get ongoing and critical advice from experts about your project.

- Set aside your anxieties about counting and measuring, and any mental blocks you night have about 'not being mathematically minded'.

- Exorcise the voice in your head that constantly says 'statistics is too difficult for me and why should I use these tests?'

- Develop an openness to, and interest in, basic statistical concepts.

- Use appropriate software to carry out statistical tests.

- Avoid being hypersensitive about certain words in statistical discourse: as an arts therapist, you might want to gasp at words such as 'normal', 'significant' or even 'pie'.

Remember that statistical discourse has its own language, which we will attempt to introduce to you in this chapter.

There are essentially two aspects to data analysis. Franz needs to *describe* his data using descriptive statistics (which incidentally is especially applicable to qualitative data) and then he needs to *analyse* them in terms of similarity, difference and/or relationship, to make inferences from his data. Here he will use inferential statistics. We discuss each of these in two sections.

SECTION A: DESCRIPTIVE STATISTICS

Broadly speaking, descriptive statistics will summarise and describe a large body of data, and manage it in a way that is representative and valid. Descriptive analysis usually focuses on frequency distribution, and measures of central tendency.

Frequency distribution: How many/how much/what proportion?

Frequency distribution is simply a way of showing *how many* times something happens, or *how many* people are in one or other group, or *how much* time, or *how much* distance, or *how much* money. These questions suggest a proportion of a finite total. For example, if we ask 'how many of Franz' clients at Ivory Leaves Mental Health Unit have blue eyes', we are in fact, asking 'how many out of a total of 172 clients have blue eyes'; or, when asking 'what's the cricket score?' (when England and South Africa are playing limited-overs one-day test cricket), then we know whether the number of runs represents a high or low score by comparing it to the total number of runs possible in 50-overs one-day cricket. When asking yourself how much longer you'll spend reading this book, you're thinking in two possible ways: either how many more hours out of today you'll spend reading, or since it's taken you six hours to read two-thirds of the book, then the remaining one-third should take you about three hours.

In terms of Franz' study, Mr LeBain needed first to identify how many times the 172 clients attend Ivory Leaves per month within the three-month period preceding the beginning of Franz' study, in order to get a *baseline measure* of attendance record (AR). Frequency distribution statistics help to summarise and manage information such as this.

We're going to look closely at the process of how Mr LeBain groups clients – in order to understand how he gets to what proportion of the total number is in each group, and how many clients are in each of the groups. These are slightly different measures.

Remember that he begins by dividing the clients according to their AR into 'low', 'medium' and 'high' groups. Together these three categories encompass the total number of days per month. This is a way of summarising group behaviour, rather than setting out each client's AR, which would be laborious and not especially useful. In other words, clients are allocated to each AR group on the basis of their *average* monthly attendance scores, which statisticians call the *mean* attendance scores. The mean score is calculated by adding the scores for the three-month period and then dividing the total by 3.

As we saw earlier, Mr LeBain runs into a snag. Before simply designing his own categories of 'low', 'medium' and 'high' attenders, he first checks to see whether Smith and Redfern's (1984) delineations are useful for Franz' study (they define 'low', 'medium' and 'high' attenders according to standardised and tested criteria). What he finds is that this doesn't suit Franz' study, because according to *their* categories, the attendance proportion looks like this (NB we're making these figures up for now, to make a point):

Total = 172 clients (100%)

Low attenders (0–10 days per month) = 65 clients (31%)

Medium attenders (11–20 days per month) = 103 clients (63%)

High attenders (21–30 days per month) = 4 clients (6%)

Note that the percentages add up to 100 per cent, which means that three categories cover all attendance frequency possibilities.

Figure 9.1 shows that the problem with these proportions (i.e. how many clients out of the total number fit into each category) is that they are too uneven. The high attenders group has only four clients, and this is too small a group to select clients for Franz' study. Mr LeBain therefore has to redefine the three categories in order to get three evenly proportioned groups of 'low', 'medium' and 'high' attenders.

He begins by *ranking* all 172 clients from the highest to the lowest AR scores (Table 9.1).

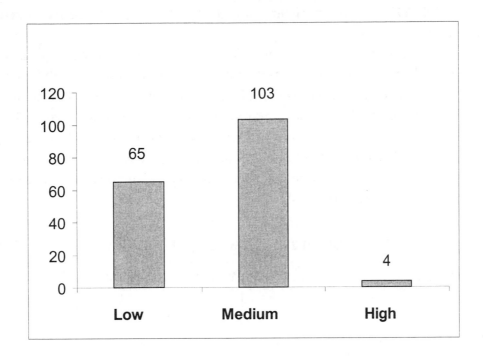

Figure 9.1 Attenders in each category

Table 9.1 Ranking clients by AR scores			
Rank order	Client initial	Total AR (3 mths)	Mean AR
1	CH	90	30
2	DV	87	29
3	SC	85	28.3
4	AJ	84	28
and so on			

Once he's lined them up, he draws a line between persons ranked 57 and 58 and another between persons ranked 115 and 116. This gives him three virtually equal groups of clients (57 + 58 + 57 = 172) and, critically, these groups are defined according to the clients' *rank ordering*. 'Low' = clients

ranked 1–57; 'medium' = clients ranked 58–115; 'high' = clients ranked 116–172.

At this point we should say that ranking is, in fact, a bit more complicated than this, because three clients might have the same AR scores – in that case, the three would get equal rank. In Table 9.2 you see that clients CA, AJ and SW each attend 46 days in the three-month period. All three are ranked 34th instead of being ranked 33rd, 34th and 35th respectively. Rank 34 is the average of 33, 34 and 35: to calculate any average, you add up the figures (34+35+36) and then divide that total (102) by the number of figures (3), which gives a *mean* rank of 34.

Table 9.2 Clients with equal ranks			
Rank order	Client initial	Total AR (3 mths)	Mean AR
31	EF	54	18
32	DA	51	17
34 (33)	CA	46	15.3
34	AJ	46	15.3
34 (35)	SW	46	15.3
36	DQ	45	15
37	FW	42	14

However, this still doesn't tell us *how* to define 'high', 'medium' and 'low' categories in terms of numbers of days per category, even though we now have three equal groups in terms of numbers of clients.

Mr LeBain needs to note the AR score of persons ranked 57th and 58th, and persons ranked 115th and 116th. The AR scores of these persons are the cut-off points for three categories, 'low', 'medium' and 'high'. He can now confidently define the new categories of 'low', 'medium' and 'high' for the AR for Franz' study. They now look like this (see Chapter 7).

Low AR = 0–6 days per month (57 clients)

Medium AR = 7–16 days per month (58 clients)

High AR = 17–30 days per month (57 clients)

Let's now see how we can represent all of this visually, saving a lot of verbal description which would be tedious to read.

Pie charts, bar charts, and histograms

We might represent these calculations in various ways: a pie chart (thus named because of its obvious similarity to a fruit pie or Melktert,[1] which Franz first tasted at Aunt Millie's in the Cape); a histogram (which looks like KitKat chocolate when you first unwrap it) or else a bar chart (when you break up KitKat chocolate and separate the bits). The advantage of presenting data spatially is that the reader gets an instant impression of the proportion of clients who are 'low', 'medium' and 'high' attenders.

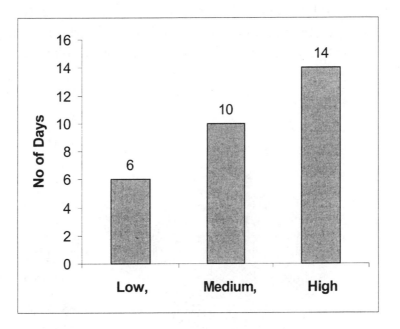

Figure 9.2 Days in revised AR categories

1 Melktert is a delicious traditional Cape Dutch recipe: a (short-crust or flaky pastry) pie filled with a baked custard topped with cinamon. Best eaten under shady oak tree at the Lanzerac Wine Estate in Stellenbosch on a summer's afternoon, with Earl Grey tea and a calm optimism about research.

Figure 9.1 presents a bar chart of AR groupings according to Smith and Redfern's categories. Here, the interesting information is about how many clients are in each category. In Figure 9.2, the interesting information is the number of days in Mr LeBain's revised categories. You'll note from looking at Figures 9.1 And 9.2 that they each have a horizontal line at the bottom (the x-axis) and a vertical line on the left hand side (the y-axis). These two interact with one another to give us global information about frequency. In both figures, the y-axis gives an ascending representation of quantity at equal intervals. The intervals are adjoining (i.e. there are no gaps between lowest and highest numbers), and the y-axis needs to cover all possibilities, i.e. for Figure 9.1, from 0 up until 103, and Figure 9.2, from 0 up to 14, the maximum numbers in each figure. The x-axis identifies 'low', 'medium' and 'high' as concepts, rather than representing an actual number of days. In each figure, the x-axis is less significant, and it is the height of the bar (the y-axis) that carries the weightier information. Finally, the bar chart is like a template that enables you to decide what information you want to illustrate.

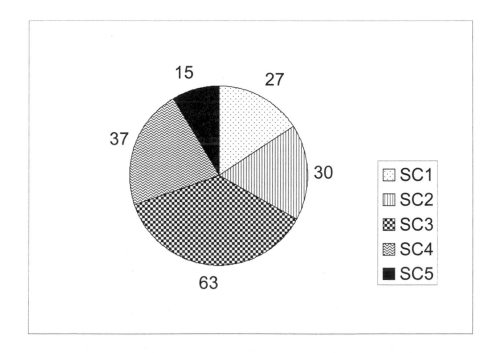

Figure 9.3 Distribution of attenders per social class

Figure 9.3 is a pie chart. Let's pretend that Franz is interested in the proportion of clients at Ivory Leaves that fit into each of the five social classes. As well as using a bar chart to represent these distributions, he can use a pie chart. Once again we have an instant visual representation of how many clients in each of the social classes, as well as the proportion of the total number in each class.

Contingency table

Contingency tables present data descriptively, and straddle this and the next section (on inferential statistics) because they are *descriptive* (in the sense that they do not carry out tests on the data themselves), and at the same time, show something about the *relationships* between different sets of data. Franz might, for example, want to see the relationship between the social class (SC) of his subjects and their 'high', 'medium' and 'low' AR. The contingency table (Figure 9.4) shows the 15 possible combinations of these variables, and also gives us a total for each of the rows and each of the columns (called row marginals and column marginals respectively).

	SC1	SC2	SC3	SC4	SC5	Total
AR low	24	19	11	6	5	65
AR medium	3	11	51	30	8	103
AR high	0	0	1	1	2	4
Total	27	30	63	37	15	172

Figure 9.4 Contingency table: spread of 172 attenders over social classes 1–5

At a glance we see that the majority of 'low' attenders come from social class 1 (24 out of 65); the majority of 'medium' attenders from social class 3 (51 out of 103); most clients at Ivory Leaves fit into the 'medium' attenders record (103 out of 172), and so on. The contingency table is a simple way of presenting a range of information at a glance. Also, look at Figure 9.3 once again to see how the information here is reflected in the pie chart.

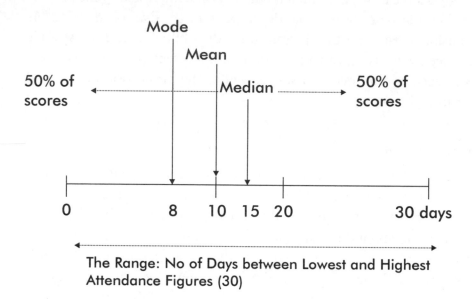

Figure 9.5 Measures of central tendency

Measures of central tendency

Measures of central tendency (sometimes called summary statistics) usually present an aspect of a set of data by one number – a central value around which the data revolve. The most common measures of central tendency are the **mean**, the **mode**, the **range**, and the **median**. None of these, alone, gives us a central value, and they are usually presented as a group of values that interact with one another (Figure 9.5).

Mean

The mean is the average score, obtained by adding up all the scores and dividing the total by the number of scores. Thus, to calculate the mean (or average) attendance record (AR) for all Ivory Leaves clients, Mr LeBain adds up all the AR scores for 172 clients. Let's say he gets a total of 1740 days per month for all 172 clients. To get the mean AR, he then divides this total of 1740 (the total number of attendance days for all clients) by 172 (the total number of clients) to get a mean score of 10.11 days per month, which we

would round off to 10. So for Ivory Leaves, the mean attendance frequency for 172 clients is 10 days per month.

However, Figure 9.5 shows that the mean alone does not adequately describe the 'spread' of attendance record across the group: all we know is the average attendance at Ivory Leaves. What we don't know is how many clients attend less than or more than the 10 days per month. We need to know the *range* of AR scores.

Range

The range is simply the distance between the lowest and the highest attendance record (0–30 days per month). So now we know that the average attendance figure for Ivory Leaves is 10 days per month, and that the group attendance ranges from 0 to 30 days. However, the range also does not give an idea of the spread, because many clients may, in fact, be attending only 8 days per month, while the range alone might make us think that the average attendance is the midpoint for 0–30, i.e. 15 days per month. We need a few more summary statistics to complete the picture.

Mode

The mode represents the most frequently occurring value in any distribution. This a far better indication of what the spread of frequency looks like among the 172 clients at Ivory Leaves. What Mr LeBain finds when he checks the attendance record for each of the 172 clients is that the largest group (let's say a group of 19 clients) have an AR score of 8 days per month: 8 is then the mode.

Median

To complete the picture, we need the median, which is simply the middle value of a set of scores. Thus, if the scores range from 0 to 30 days, the median will not necessarily be the same as the mode: it is the midpoint of the scores, and implicit in this position is that 50% of the scores lie on either side of the median.

All of these together interact in a way that gives us an idea of how the scores for 172 clients are distributed, and the grouping of these scores around the mean can be *normal* or *skewed*. Forget about your arts therapists'

sensitivities about the use of the word 'normal'. Normal in the statistical sense refers to the distribution of scores around the mean.

How are we spread?

Frequency distribution is usually represented by a curve – and here we need to pause and consider the **normal curve** (also known as **normal distribution**). The simplest way to think about a normal curve is that the mean (or arithmetic average), the mode (highest point in the distribution) and the median (half-way point in the distribution) are the same. A normal curve looks like Figure 9.6. As with the bar chart, there is an x-axis and a y-axis which interact with one another, although, unlike the bar chart, here the two axes are equally significant. The x-axis gives us the AR scores, with lowest on the left and moving towards highest score on the right. The y-axis gives us the number of clients, also from lowest to highest number. The curve is plotted by intersecting each point of the y-axis (the number of clients) with each of the AR scores, on the x-axis.

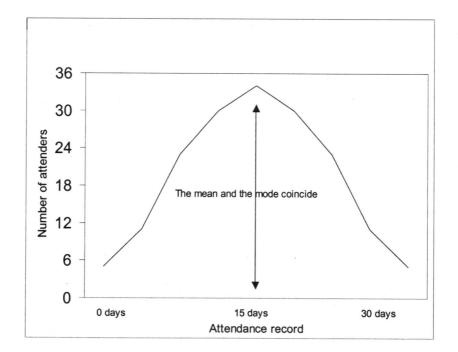

Figure 9.6 A normal spread of AR around the mean

Because this curve is *normal*, the mean, mode and median coincide at 15. In other words, the average attendance is 15 days per month, the highest number of clients attend 15 days per month, and 50 per cent of the AR scores fall on either side of 15. Real life, however, isn't quite like that, but the normal curve is a standard distribution of frequency against which we can compare the distributions of our own data.

The frequency distribution for Ivory Leaves clients is skewed positively (Figure 9.7). This means that most of the AR scores are *lower* than the mean score of 10, and as the *skewed* curve shows, most clients' scores are positioned to the left of the mean score of 10 – so the curve is higher to the left of the mean. We also see that the higher the AR scores (the x-axis), the fewer the number of clients – shown by the curve tapering off towards the right. The combination of all these measures of central tendency gives you an idea of the **variability** of the scores around the mean: in other words, how the scores are spread over the whole range of AR possibilities.

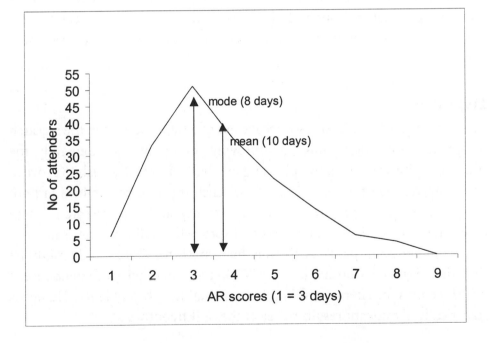

Figure 9.7 Positively skewed AR scores

Standard deviation

The standard deviation (identified by the letters SD or the Greek letter σ) is a numeric value that gives us the average distance of all the scores from the mean score. By giving us a standard measure of variability, the SD enables us to have an instant sense of the grouping of the data. It also gives us a set value against which to measure by how much an individual score differs from the group average distance from the mean.

For Franz' study, though, these measures of central tendency are not enough. He needs to do more than just 'describe' or 'summarise' his data. He needs to show that WGAT impacts on AR (research question 1) and on SM and GM (reseach question 2). In other words, he needs to show that there is a causal relationship between the *dependent* and *independent variables*, and show that these relationships are statistically significant.

SECTION B: INFERENTIAL STATISTICS

In this section we first introduce some general principles about inferential statistics, i.e. the hypothesis, levels of statistical significance and parametric and non-parametric statistical tests. As with the previous section, the emphasis is on *introducing* these concepts rather than telling you everything about them.

Hypothesis

Traditionally, inferential statistics make use of a hypothesis, and the research design sets about upholding or disproving the hypothesis. Generally, the **null hypothesis** is a negative phrasing of what you actually wish to prove in your research question (this is a way of ensuring that researchers are not biased in attempting to answer their questions), and your research design (and inferential statistics) then seeks to disprove the null hypothesis in order to verify your findings. Thus, the null hypothesis for Franz' study might be that 'there is no relationship between WGAT and frequency of attendance at health centres for clients suffering from mental health problems'. He needs statistically significant results to reject the null hypothesis.

Levels of statistical significance

At this point we need to discuss the **significance level** in statistical analysis. (Another instance where you need to eject your preconceptions about the meaning of 'significance' in everyday parlance.) Because statistical tests aim to prove *beyond reasonable doubt* that the result of any computation or test is really due to this test and not to any other factors, statisticians usually set a level of significance – identified by *p*. Most commonly used is *p = 0.05* (in other words, the 5 per cent level of significance) or *p = 0.01* (the 1 per cent level of significance). What this means is that Franz can be up to 95 per cent certain that the results of his tests are not due to chance factors. Levels of significance are cut-off points at which the *null hypothesis* is accepted or rejected (if the results do not reach *p = 0.05*). Scientific papers usually give you the level of significance with any result, and the smaller the value of *p*, the less likely is the result due to chance (and the more likely the result of the test itself). Robson (1993) points out that levels of statistical significance tend to depend on the size of samples tested, resulting in larger samples giving higher levels of significance (and therefore more robust results). This has resulted in research designs based on large samples in order to 'buy' statistical significance (so to speak). A statistician will help you to work out what size sample you need when planning your study, in order to reach the desired level of significance.

Parametric and non-parametric statistical tests

Franz will select the kinds of statistical tests to use depending on the nature of the data he has collected. To put it simply (and if you want more detail, read a book on statistical tests) the rule of thumb is as follows: non-parametric tests are for data that are nominal (e.g. gender, mental illness) and ordinal (social class, 'low', 'medium' and 'high' attender), and parametric tests are for ratio and interval data (such as age, height or distance). Moreover, data need to be normally distributed for parametric tests to be used – a non-normal distribution requires non-parametric tests.

Selecting which statistical procedure to use in order to test for similarity (or difference) between data sets depends on various factors, including whether your two groups of data are related (pre- and post-test scores), or independent (e.g. male/female or social class). The latter are independent

because subjects cannot be male and female at the same time. However, all subjects have pre- and post-test AR, GM and SM scores. These two sets of scores (pre- and post-test) are related to one another.

We discuss some tests briefly below.

Testing the relationship

Franz wants to explore the relationship between WGAT (the independent variable), and, let's say, attendance record (AR) (the dependent variable). In exploring the relationship between these two, he wants to know whether, for example, a change in the one is reflected in the other. The first thing he might want to do is look at the **correlation** between these. This is not looking at any *causal* relationship between these two (i.e. for now he is not testing whether a change in WGAT causes a change in AR, but merely whether one is reflected in the other).

The **correlation coefficient** simply explains the nature of relatedness between two variables, whether positive, negative, high or low. It does not seek to explain causation, i.e. that one variable *causes* the other. The calculation of the correlation coefficient will yield a number between -1 and +1, with 0 signifiying no correlation at all, +1 representing a positive correlation, and -1 representing a negative one (Figure 9.8). Calculating the correlation coefficient is usually done by software, according to set formula, so does not concern us here – but the underlying principle does.

Let's pretend that Franz wants to examine the relationship between General Moodstate and attendance record. For each subject, he'll pair their GM and AR scores on an x-axis and a y-axis, and will end up with something like Figure 9.8.

A negative correlation might make sense with e.g. clients suffering from mania, where 'higher' General Moodstate scores are accompanied by lower AR scores. This correlation could represent scores of patients whose increased mania is accompanied by lower attendance at Ivory Leaves. In contrast, a positive correlation means that the higher the GM, the higher the AR scores. This may represent depressed patients, whose 'higher' General Moodstate scores (i.e. less depressed) coincide with improved attendance (Figure 9.8). The nearer the correlation coefficient to +1 (positive correlation) or -1 (negative correlation) – e.g. a coefficient of 0.96 or -0.96 – then

the closer the relationship between the two data sets. A coefficient of 0.3, in contrast, would suggest a weak relationship between the two data sets.

Statistical manuals will clarify the two kinds of correlation coefficients: *Spearman's*, based on the ranked scores, and *Pearson's*, based on actual scores. If you want to read up on these, you know what to do.

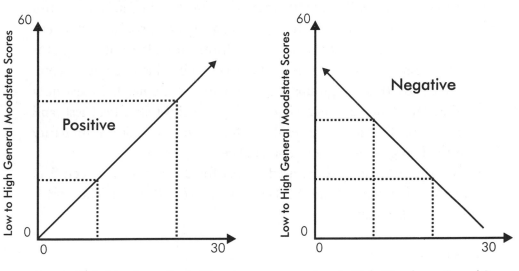

Figure 9.8 Positive and negative correlations

Testing for differences and similarities

The first thing to clarify here is that testing for difference or similarity between data sets is different from simply exploring the relationship between them – as does the correlation coefficient. Here, we test to see just how similar – or different – are two data sets. In Design 1, Franz needs to verify that his experimental and control groups are significantly similar to one another before the experimental group has WGAT. How will he show this? And how will he prove it? (And why does he need to?)

By matching the two groups in terms of age, gender, social class and attendance record, he'll be in an excellent position to convince us that any

changes in the post-test AR, SM or GM experimental group scores are the result of the *independent variable* (WGAT), rather than because the groups were different in the first instance. If he does not match the groups, then we might argue that the higher post-test AR scores are due to the groups being mismatched: we might see that this group were the more socially motivated group, and had better moodstate scores. These variables, if unaccounted for, would interfere with his results.

As we saw in Chapter 7, Mr LeBain matched the experimental and control groups as closely as possible, with regard to age, gender, social class, attendance record, General Moodstate and Social Motivation. It is not enough for Mr LeBain to say he has done this. Franz needs to be able to show, beyond reasonable doubt, that the groups are well matched: he needs to test how similar they are to one another. By choosing the right statistical test, and having a statistically significant result, he'll convince us that the similarity between the two groups is not due to chance.

Two non-parametric tests are used to test for differences between data sets: the *Mann-Whitney test* and the *Wilcoxon Matched Pairs test*. The *t-test* is used for parametric data.

Mann-Whitney test

The Mann-Whitney Test is usually used when testing for the differences in experimental conditions between different subject groups. The test calculates the test statistic 'U', which tells Franz whether, in Design 1, the WGAT programme has produced a significant difference in AR between the experimental and the control groups. In calculating the U statistic, Franz needs to check whether this meets the set level of significance – which, incidentally, Carmen Statistica will help him to set (it depends largely on sample size).

Wilcoxon Matched Pairs test

In contrast to the Mann-Whitney, Wilcoxon tests for difference between scores over a period of time for the same subjects. Wilcoxon's test would check whether the pre- and post-AR scores (*dependent variable*) for the experimental group are significantly different from one another. Next Franz would do the same for the control group. Franz would then check the T statistic against its level of significance, in order to accept or reject his *null hypothesis*

(e.g. that there is no difference between the pre- and post-test score for the experimental group).

The t-test

The *t-test* is described as the most powerful statistical test for difference between samples by comparing their means. However, it can be used only if the data sets fulfil the requirements for parametric tests (i.e. are normally distributed, use ratio or interval measures, and – usually – if the sample sizes are large enough). Thus, Franz could use it to compare the pairs of AR or GM or SM scores (pre- and post-test) within each of the groups – provided they met the requirements of parametric statistics. He would then accept or reject his *null hypothesis* according to the *level of significance* of the *t* statistic.

Comparing categories: Chi-square

The Chi-square test compares and predicts the data distribution in categories between different groups. The Chi-square test (represented by X^2), might be used by Franz to compare the social class distribution of clients that have different attendance records. If you revisit the contingency table in Figure 9.4, then you might imagine that Franz wants to know how the number of clients in each social class using the low, medium and high AR groupings (i.e. observed frequency) compares to the number of clients in each of the five social classes were there to be no difference between low, medium and high attenders (i.e. expected frequency). The X^2 statistic is checked against a standardised tabulated value (usually given at the back of statistical manuals).

A final word

There are many other statistical tests that we have not addressed here; we hope that we have presented the ones above simply and coherently. At this stage you need to *understand* the process of representing and presenting data numerically, and be able to think about what you night do with these numbers, and why. We hope that Franz' study has given you some insights about quantitative research thinking. Franz isn't much more clued up than you are. But he has Carmen Statistica. You need to find one for yourself.

Suzie's Project: Part 2

*Further qualitative methods – Qualitative 'tests' –
Interviewing – Moving from analysis to
synthesis – Evaluating – Concluding*

Introduction: Suzie's progress

We left Suzie at the end of Chapter 8 still 'riding the bicycle of qualitative inquiry'. She's finished the first stage of her design, which has begun to answer the first two of her research questions. However, her use of the O-D-I cycle to examine the phenomenon of 'quickening' has to an extent raised as many questions as it has answered. Suzie's research proposal also included a second part in which she takes a different perspective on her research questions. This chapter will outline Suzie's further research adventures, which lead us to consider, in Section A, further qualitative methods. Section B looks at the later stages of a qualitative research process: bringing together the findings of your analysis with the extant literature (the synthesis), evaluating and concluding your inquiry.

SECTION A: FURTHER QUALITATIVE METHODS

From subjectivity to intersubjectivity

In the first stage of her data analysis Suzie worked around the O-D-I cycle to sharpen her perceptions of the data, using colleagues and supervisors to challenge her developing theory. Coffey and Atkinson (1996) suggest qualitative research to be a process of *dialogue*:

> We can understand the research process, metaphorically, as a series of
> dialogues; with the data, with ideas, with informants, with colleagues

and with oneself. All of those interactions should lead to reflections and decisions. The qualitative research process unfolds and develops through these various transactions with and about the social world.

(Coffey and Atkinson 1996: 191)

Another description of this kind of research method would be **hermeneutics**, a more technical term (deriving from the Greek god of information, Hermes) for the interpretative approach to human situations. While this method is central to much humanistic inquiry, it also has certain dangers to it – characterised by getting trapped in the so-called **hermeneutic circle**, where we find only that which we already know. Our subjectivity can limit as well as expand our knowledge.

Chapter 8 began a discussion on the uses and abuses of subjectivity, and how qualitative and quantitative research have different attitudes to this. We concluded then that qualitative research aims to use subjectivity as a *resource* rather than as a problem, while trying to avoid the purely personal (which is potentially illusory). As Roger Grainger writes:

We permit research within real-life contexts to move into a new key, leaving objectivity to the study of objects and turning our full attention to investigating inter-subjectivity. This does not mean that we abandon the systematic elements of the research process, however. We simply change some of the techniques we use to reach an understanding of the state of affairs we find ourselves in.

(Grainger 1999: 124)

Grainger introduces the concept of **intersubjectivity** here – a term used in a variety of modern academic discourses in several ways (mostly in communication studies and psychotherapy theory: see Pavlicevic 1997). Here we simply mean (along with Grainger and others) a *shared subjective judgement* of a phenomenon or event – which will be determined by a common cultural and perceptual milieu, but where no objective verification could be reached. A group of people might, for example, find something funny, sad or tasteless. Their judgement is an intersubjective one.

Using an 'intersubjective perspective' in qualitative methods could be seen two ways: positively, as pooling subjectivity or, negatively, as 'controlling' the unwanted 'personal' side of unqualified subjectivity.

Coffey and Atkinson's characterisation of qualitative research as a series of *dialogues* takes us into the intersubjective perspective, where the researcher's monologue is expanded by a variety of dialogues: with the data itself (analysis as *questioning* your data or, more strongly, *interrogating* it), with the clients you are working with; with colleagues. There are specific methods of qualitative research such as **collaborative inquiry** (Reason and Rowan 1981) and **action research** (Edwards and Talbot 1999) where this perspective is particularly emphasised.

Though Suzie finds herself in agreement with the research methodology writers, she has already become aware of the 'subjective/objective issue' by the time she's completed Part 1 of her study. While she's aware that the use of her own subjective perceptions has been invaluable in making sense of the complex data in her excerpts, she also feels the need to expand this subjective view of the data in order to avoid it becoming purely personal.

That she has taken these issues into account was also implicit in Suzie's research design, where she structured in two other methods to extend her subjectivity:

> In order to expand my own perspective on the case material I will also include 'listening tests' on colleagues to determine whether they locate and describe similar moments from short audio-taped examples. The second half of the inquiry will tackle the third research question by surveying the experiences and views of other more experienced therapists on the subject. For this I will make six semi-structured interviews with practitioners working with a range of client groups.

These two additional methods in Suzie's design – **qualitative 'tests'** and **interviews** – are the most common ways of expanding and checking the subjective perspective by introducing the intersubjective. They also represent the move from the naturally occurring data of case material to the **research-generated data** of the tests and interviews.

The qualitative test as check and exploration: Suzie's 'listening test'

Let's ask some basic questions about Part 2 of Suzie's design.

Why do it?

Suzie's rationale for introducing a 'listening test' as part of her design is, in her own words, 'to determine whether [colleagues] locate and describe similar moments from short audio-taped examples'. She intends, that is, to *check* her own perceptions with those of others in order to increase the **trust-worthiness** of her study.[1]

We need to be clear that a 'test' in this sense is quite different from how Franz (in his quantitative design) uses 'experiment' as a method. Within her qualitative methodology Suzie is not trying to *prove* that her 'moments' exist at all, but to demonstrate the reliability of her subjective identification and location of them – and possibly to find out something further about them through others' ears.

What she hasn't thought through is just how to design such a test. She's left it until now, but has been warned by Peter Purt to think it through carefully – as this is just the kind of thing examiners love to pick holes in.

You need to attend to the following factors when aiming to test something within a qualitative inquiry:

- Have a **rationale** for doing it in the first place – *what* is the test going to achieve in terms of your research questions?

- Design the test **set-up** so that it is logical, clear and easy to do.

- **Utilise material** you already have (e.g. reproduced material, transcriptions, etc.).

- Have access to necessary **equipment** to conduct the test (e.g. recording equipment).

- Have easy access to **research participants** to do your test for you.

- Have an idea of how to integrate test results into your study.

Let's follow Suzie through developing her test, and discuss some of these issues along the way.

1 This term introduces issues of *validity* in qualitative research, which we deal with in more detail in the final section of this chapter.

Who with?

Suzie is clear what she wants the test to achieve and already has useful material: her three audio-taped excerpts (and the transcriptions of them), which are her subjective identifications of the 'moments'. Her aim for the tests is simply to see whether others locate them in the same places and describe them in the same terms (or indeed expand her descriptions).

When thinking about who suitable candidates might be as the 'listeners' she first considers her six colleagues on the training course, but soon discounts them on the basis that they've been listening to her talk about her project for months and have also heard some of the excerpts. Clearly she needs fresh ears. The six students on the first year of the training course would, however, be ideal, she thinks. They are used to listening to taped excerpts of music therapy and are easily available.

How?

She then remembers Peter Purt's comment that these kinds of tests take more time than you'd think to set up, administer and analyse, so it's wise to do no more than you need in order to make a convincing case. Suzie thinks again: three excerpts, why not three listeners – this is enough. She has access to good equipment, so that's OK. The only problem left is to design a clear and easy test. This takes a week to do, several revisions, several chats with Peter Purt, and one conversation with Franz, who tells her that her test is 'methodologically fundamentally flawed' and that she should do this and that and apply this, that and something else. 'It's only a *test*, Franz!' she'd said (but Franz didn't get the joke). In the end Suzie comes out with the following design:

SUZIE'S **LISTENING TESTS**: DESIGN

1. **Participants:** three first-year music therapy students at Gamut College (with no previous knowledge of the project or the audio excerpts).

2. **Test Data:** three audio-taped excerpts (maximum length three minutes) from music therapy sessions with clients 'B' and 'J'. Give test participants information only that these excerpts come from music therapy sessions with adult clients. Do not identify

who is who, their pathology, or the point in session where excerpt begins, or the purpose of the test.

3. **Test Equipment:** two tape recorders: one to play the excerpt, the other to record participants' 'stop' points and their comments.

4. **Test Procedure:** (i) Give participant background information in Point 2 above. (ii) Record all of the rest of the test on the second tape recorder. (iii) Give the following instruction: *'Listen once to the excerpt all the way through. Then listen a second time and, if during the excerpt you hear a change of energy in the music, stop the tape with the stop button at the point you hear a change. If you want to comment on this, do so. Stop as many times as you want.'* (iv) If they stop the tape, each time rewind it a bit before they begin listening again. (v) Repeat the procedure for all three of the excerpts. (vi) Play the excerpt a third time complete with no stops. Tell participants they can make any further comments after this if they wish.

Suzie is wise enough to test out this design on a friend on the course, and it seemed basically to work, though it took a long time to get through the three 'listenings' and it yielded a frightening amount of further data in terms of the participant's responses (Suzie began to wonder whether she'd given enough thought to the *analysis* of the data). She toyed with giving each 'listener' only one each of the three excerpts, but her friend convinced her to keep the three for each – as the comparison of the three had led to interesting material which might be important at a later point.

Suzie does the three tests in the next two weeks, discovering that it is fun to work with other people as part of your research (just hearing what people say in the tests immediately gets her thinking about different angles). It is also more time-consuming than she'd thought and occasionally frustrating – one test had to be rescheduled twice, and on another occasion they had to wait an hour for the second tape recorder to be available. In the third test the participant had to remind Suzie that she'd yet to turn the second tape recorder on!

After the tests are over: Data presentation and analysis

When the tests are completed Suzie gets her next shock: the tests have generated three hours of taped verbal material on the excerpts. Suzie faces a common condition in qualitative research – **data death**. She has more data than expected and now needs to tackle how to *analyse* data from such tests.

Suzie needs to make some pragmatic decisions about how to analyse this data in the light of what exactly she needs it for. One option is to transcribe word-for-word the whole of the participants' comments and then analyse these transcripts as **texts**. (In the next section on interviewing we will look at the analysis of text data in qualitative inquiry.) But Peter Purt had cautioned against transcribing for transcribing's sake, warning that it generally took four or five hours to transcribe one hour of talk. Suzie doesn't have time to do this if it's not necessary. In terms of her research questions and the rationale for the tests the first priority is to know exactly *when* the participants identified the changes of energy, and to show this somehow. Their comments she needs only in a more general way. After further thought Suzie comes up with the following protocol:

SUZIE'S **LISTENING TESTS**: PRESENTATION/ANALYSIS

1. Listen to tapes through several times to gain orientation to the material.

2. Work first on the participants' 'stop-points'.

3. Take musical transcription of excerpt 1 (from O-D-I cycle stage) and mark on the transcription where each participant stops the tape (use colour code: red = participant 1, green = 2, yellow = 3). Mark up the three excerpts this way. (NB make sure transcription has bar numbers.)

4. Listen through to comments for material directly relevant to research focus and transcribe only these comments, marking them at the beginning with the stop-point they apply to (using transcription bar-lines to mark this e.g. 1 [15/16] = comment by participant 1 at stop-point in bar 15/16). Transcribe the comments directly onto word-processor. Repeat this procedure for all the excerpts and participants.

Though it takes another week of hard work to process her data in this way, the thought she's given to how to go about it reduces an unwieldy body of data to manageable proportions and also means that she is (in classic qualitative way) analysing the data as she's reducing it.

In order to present the test data Suzie decides to use the musical transcriptions she did for Part 1 of her analysis. She marks on the transcriptions of the excerpts exactly where all three participants had stopped the tape to identify

1 [15/16] That bit's highly significant – it's the whole idea of a leap in music – it does something for you, it makes *you* leap! I really feel there's a shift of energy at that point, that comes somehow within the music, but is also something to do with the client playing the melody *daring* to leave the safety of note-by-note playing and jumping up there … and the way you prepare that and support it on the piano with those harmonies.

3 [15/16] I was surprised there! – I was just listening along to that rather repetitive rhythmic structure, and suddenly there's this *jolt* … and she's somewhere else! I felt a jolt in me, not unpleasant, a 'sit up and take note' moment: which must mean that suddenly she also feels free to do something a bit more daring than she's done up to now?

Figure 10.1 Presenting Suzie's 'test' data

changes of energy. Then underneath the musical stave she pastes quotations from their comments on these points, referring to the score via bar-numbers. She selects 'quotations' from the commentaries which best represent the essence of the participants' comments. This looks like Figure 10.1.

Using 'analytic vignettes'

When it is next Suzie's turn to present her evolving project at the research seminar it becomes clear to her that ten pages of transcription is too much to convert into acetates. So Suzie uses the qualitative technique of presenting **analytic vignettes** – smaller detailed examples of data analysis that are argued to be characteristic of the overall treatment of the data, and of the emerging sense of it.

Suzie uses Figure 10.1 as the basis of a vignette. From this example on a single acetate Suzie can demonstrate two things especially pertinent to her inquiry: first, that here two out of three listeners stopped the tape at the same location (which is one of the points she'd picked to discuss in her own analysis of the excerpt) and second, that their unprompted comments discuss why they stopped and the nature of the 'moment' in terms which relate to Suzie's developing theory of the 'moments'. In short, that her listening tests have intersubjectively validated the sense she is making of this phenomenon.

Other examples of the 'qualitative test'

Another example of a 'qualitative test' in the music therapy literature is when Brown and Pavlicevic (1997) set out to investigate the statement often made by music therapists that clinical improvisation (with clear therapist–client roles) is a different thing from musical improvisation such as two equal musicians might do. They investigated this by designing a test scenario in which each of them would take each combination of the possible client–therapist–musician roles. They taped these sessions and listened back to the music themselves, then got other music therapists to listen blind to them – seeing whether the various scenarios were indeed perceptible as different. Their conclusion that clinical improvisation could indeed be perceived as something different from just playing together (and the theoretical discussion based on this) can be seen to be based on demonstrable evidence, not just received opinion.

There are, of course, many ways to structure a qualitative test, but the principle is to construct a scenario where your research question(s) can be investigated from a different angle, and by others besides yourself. This approach is sometimes appropriately called **triangulation**, and can indicate both using multiple methods or multiple data sources within a qualitative inquiry. As Robson (1993) writes: 'triangulation…is an indispensible tool in real world enquiry':

> [Triangulation] is particularly valuable in the analysis of qualitative data where the trustworthiness of the data is always a worry. It provides a means of testing one source of information against other sources. Both correspondence and discrepancies are of value. If two sources give the same message then, to some extent, they cross-validate each other. If there is a discrepancy, its investigation may help in explaining the phenomenon of interest.
>
> (Robson 1993: 383)

Look into the literature of your own arts therapy research tradition and find examples of qualitative tests or triangulated designs, then critique them and try out ideas for your own inquiry.

Interviewing: Further expanding the dialogue

In a quantitative (or semi-quantitative) methodology the **questionnaire** or **survey** is the most common method for getting information out of other people (see Chapter 11 for how to approach *surveying*). The aim is to sample a large number of people and to limit what they say by pre-selecting what they *can* say. Whereas **interviews** (although still research-generated data) elicit a very different kind of information, largely because of the natural human tendency to ramble. Almost because of this, however, the interview is perhaps the central qualitative method of inquiry, as it can explore the full complexity of others' descriptions, opinions and versions of events. It can also expand the researcher's subjectivity by introducing perspectives which she has not previously entertained. Bell (1993: 92) quotes Cohen, who writes: 'like fishing, interviewing is an activity requiring careful preparation, much patience, and considerable practice if the eventual reward is to be a worthwhile catch'.

Suzie baulks at the thought of yet another aspect of her project that needs careful planning, but she has been looking forward to this part and wants to do it properly, so reads through a couple of guides for interviewing for research purposes (see Bell 1993: Ch.9; Edwards and Talbot 1999: Ch.6).

She is clear about the purpose of her interviews: 'Surveying the experiences and views of other more experienced therapists on the subject', as she writes in her proposal. She aims to do 'Six semi-structured interviews with practitioners working with a range of client groups'. Reading Bell (1993) and Edwards and Talbot (1999) makes Suzie realise that 'surveying' (in the technical sense of the word) is not what she is really doing, as this implies the semi-quantitative method of asking relatively set questions about a set topic to a relatively large group of people. What Suzie is proposing to do instead is to *interview* a small sample of people to elicit rich data by asking them to talk freely. The textbooks describe a range of types of interviewing. What's the difference, she thinks.

Choosing an interview method

The choice of what form of interview to do will depend on what depth of response you need. There are basically three forms of interviews which necessitate different roles for the interviewer and elicit different kinds of data:

- **Structured interview:** the nearest to a survey, except it's the researcher who notates the participant's short answers to set questions. Interviewee is a 'data machine'. Advantage: arguably more representative, easy to administer. Disadvantage: inflexible.

- **Semi-structured interview:** here the researcher-interviewer guides the interview and focuses the area of conversation using prepared questions, but allows the conversation to flow freely. The interviewer may prompt or ask further questions. The conversation is an *equal dialogue*. Advantage: rich information, flexible. Disadvantage: danger of bias from 'leading questions'.

- **Unstructured interview:** the 'I am a camera' approach to research, with the researcher as a passive partner in the dialogue, the interviewee determining the shape and content of the session. The conversation is a *passive dialogue*. Advantage: broad data, lower

risk of bias. Disadvantage: interviewee rambling, data not related to researcher's central interests.

Suzie realises that, as she'd guessed for her proposal, the *semi-structured interview* is the appropriate one. As a musician she is also attracted to Douglas' characterisation of this kind of interview as:

> ...a kind of improvisational performance. The performance is spontaneous yet structured – focused within loose parameters provided by the interviewer, who is also an active participant. The interviewer attempts to activate the respondent's stock of knowledge and bring it to bear on the discussion at hand in ways that are appropriate to the research agenda.
>
> (Douglas 1985: 123)

Despite the improvisational aspect, Suzie nevertheless takes to heart Cohen's warning (in Bell 1987) that a 'good catch' in interviewing is dependent on three factors: *preparation, patience, practice*. She sets about thinking through each of these systematically.[2]

Preparing for interviews and doing them

Suzie makes the following notes for her interviews:

SUZIE'S INTERVIEWS: **PREPARATION/PRACTICE**

1. **Decide Who**: proposal states six interviews. Too many! Reduce to three interviews – will yield quite enough data for my purposes and R, V and T are a varied selection of interviewees – all therapists with more than five years' experience, and who've worked with wide variety of client groups (adults and children) but within same model. All relatively easy to reach and have agreed to offer an hour and a half for interview.

2. **Focus Topic and Questions**: topic clear ('moments of quickening') – careful to have clear definition and explanation of this! Formulate 'guiding questions' (about four of these) and try these out for clarity on Alice.

2 Bell (1987) also has a good checklist of interview do's and don'ts in her book.

3. **Equipment**: a room which won't be disturbed and tape recorder plus enough cassettes.

4. **Time Management**: decide how much time of 1.5 hours to spend on each topic (questions on cards ready to refocus or go on to next topic).

5. **Ethical Issues**: do participants know why they're being interviewed and what use their responses will be put to? Have I permission to use direct quotations?

6. **Controlling Subjectivity**: avoid excessive bias by keeping complete recordings (these could be checked), reporting on analytic stages in supervision, presenting interview process and analysis to research seminars (**peer debriefing**). Be careful of 'leading questions' during interviews!

She then prepares her *guiding questions* which will structure the interview and reorientate it if the conversation starts to wander:

SUZIE'S **GUIDING QUESTIONS**

1. I'm researching sudden changes of energy in the musical relationship which I've experienced in my clinical work. I've called these 'moments of quickening'. Have you experienced anything like this in your work? Can you tell me about them?

2. Are the 'moments' different with different client groups? How? Can you give examples?

3. What specifically do you think makes the 'moments' come about? Can you give examples?

4. What is the significance of these 'moments' for your understanding of clinical process?

The trial run with Alice goes well (and convinces Suzie that with six interviews she would certainly die of 'data death'). She is less satisfied after completing the first real interview. 'R' spends half of the interview time challenging her formulation of 'moments of quickening' and reformulating this in his own terms. When she introduces the next of her questions he starts re-

formulating it again. She realises why one of the writers on interview technique had added 'patience' as a necessary virtue for an interviewer!

However, when Suzie listens back to the interview that evening she realises that, athough 'R' had not accepted her terminology, he did seem to be talking about the same phenomenon – and had given some fascinating examples in illustration of it. So what at first seemed a disaster had in fact yielded an interesting perspective on her study: that *language* is an issue in researching phenomena such as Suzie's. Peter Purt smiles when she mentions this event, and suggests she might read his paper on 'Discourse, phenomena and post-positivism'. Suzie's heart sinks.

The other two interviews go better, she feels. But again the picture is slightly different on listening back to them. She made a particular rapport with 'V' in the interview (they'd worked at the same clinical placement) but Suzie listens to herself talking more than V for about half of the interview and asks several leading questions beginning with 'Wouldn't you say that…' to which V had obligingly said 'Yes'. For the last interview Suzie makes good use of her rapid learning curve in the art of research interviewing and obtains some fascinating data which she is comfortable that she, as the interviewer, has not biased unduly with her own ideas.

Reducing and analysing interview data

Suzie enjoyed doing her interviews (which took two complete weeks to plan, arrange and do). She is left now with six hours of recorded material. As ever with research, the real work begins after the fun bit ends. Suzie listened through to each interview as she did them (and took notes on what to do and not to do for the next one), but is daunted now by what to *do* with all these data (a feeling she's now beginning to recognise).

She has yet another round of choices to make: transcribe the taped conversations or not? What level of detail is needed? What material does she have permission to use directly? How will the data be used in conjunction with the other parts of the project? What final form can these data take in the dissertation manuscript?

Word-by-word or note-and-quote?

Interviews yield rich but complicated data in the same way as did the O-D-I cycle we looked at in Chapter 8. **Data reduction** is again an important part

of the process of data analysis, and revolves around a pragmatic decision: what level of analysis do you need to address your research questions? In the same way as you wouldn't do complex transcriptions and musicological analysis unless this is clearly indicated by your inquiry, so you don't make full interview transcripts unless needed. Word-by-word transcription followed by any form of analysis will take at least ten hours per hour of tape.

A rule of thumb is to transcribe only if you're interested in the *actual language* your interviewees used (for example, your inquiry is 'How do dance movement therapists talk about clinical process?'). If, on the other hand, your research focus is simply the *ideas* of your interviewees then use what we call the **note-and-quote** method:

- Listen several times to the interview to orientate yourself to the flow and development of the conversation.

- Note the areas being discussed and the points made in summary form. When the interviewer makes a key point of relevance to your study and research questions, transcribe this fully as a quotation.

Which of these two methods you use, and for what purpose, has implications for what kind of analysis you do. A generic term – **content analysis** – is often given to any kind of analysis of textual data. But if what you need to analyse is not just the content but *how* people talk about their material you will need to use a more complex method called **discourse analysis**. We won't go into this here, but see Potter and Wetherell (1987) or Banister (1994).

Suzie decides that for her project she needs to analyse her interview data in a general way: to note and quote rather than make transcripts. Even so, going through this process takes her another week, and she still ends up with many pages of notes and quotes (some of the latter running to half a page).

Coding texts

This is still only a first level of treatment, which is essentially *data reduction* – though it also involves some degree of making sense of the data. As with the O-D-I cycle data of the first part of her project, what is now needed is a higher level of organisation and analysis – the **coding** and **categorisation** of the textual data. This is essentially no different from the coding procedure explained in Chapter 8, in regard to a musical text. With verbal text data the

point of coding is again to *decontextualise* any material from the three inter-
views that refers to the same themes, then *regroup* this material in higher level
categories. Figure 10.2 gives some Hints and Tips for doing this.

Hints and Tips
Coding textual data

1. Relisten to taped interviews (familiarise yourself with
 the conversation).

2. Transcribe text fully or 'note and quote'.

3. Read texts, note and mark **themes** or larger **meaning
 units** (code with coloured highlighter pens, write
 themes in margin).

4. Make a list of themes or units on a separate piece of
 paper.

5. **Categorise** them into more inclusive units (e.g. if
 theme 1 = 'eating apples' and theme 2 = 'eating pears',
 category = 'eating fruit').

6. Form **category baskets** importing notes and quotes
 from interviews into your categories (marking each
 quote's origin, e.g. 'George I/12' = first interview with
 George, line 12). Use your word-processor's cut and
 paste option (but keep original intact – always work
 with copies).

7. Experiment with your **category system** – redo it if
 necessary so that the maximum material goes into the
 minimum number of categories (i.e. the categories best
 represent the data).

Figure 10.2

After going through this procedure with her interview data Suzie ends up with more manageable 'cooked data' in the form of a series of five main categories (with subcategories and selected verbatim quotations from the interviews to illustrate and substantiate the categories). We won't go into Suzie's data findings here, except to look at how she will present her data and data analysis from the interviews.

For her tests she used analytic vignettes to present key points of her analysis. These fitted on single acetates for presentation to the research seminar. Suzie now searches for a form of data representation which will present her interview data in a more concise form than the rather linear series of categories and quotes that it's in at the moment. She looks for ideas in Miles and Huberman's (1984) textbook, which has a number of suggestions for organising and presenting qualitative data, and decides to organise her

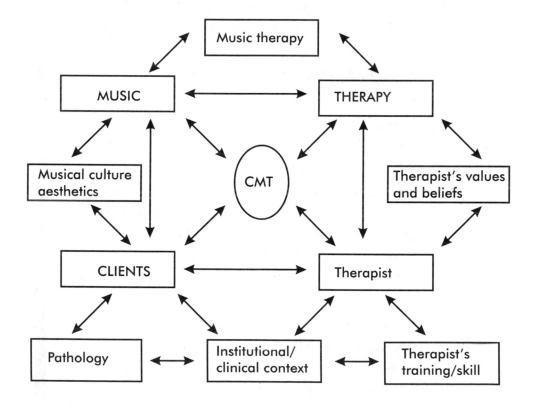

Figure 10.3 Example of a 'category map' (CMT = creative music therapy)

main categories in terms of a 'map'. This puts the data into a concise and visual format which can show the interrelationships between her categories. She can have other acetates for each of the main categories, along with the interview quotations from which these categories emerged.

Figure 10.3 shows a use of this category mapping technique from Gary's thesis, where he needed to represent his categories of the 'territory' around which a series of group discussions moved. Find other models like this, but be careful not just to copy the form without thinking exactly what you need it to achieve for *your* research.

Remember as a rule of thumb that if you can't condense your project into a maximum of five acetates for presentation then it's too complicated to start with.

SECTION B: MOVING FROM ANALYSIS TO SYNTHESIS

> Rare indeed is the man who knows what his thesis is about before he has written it.
>
> (Barley 1986: 11)

Evolving design, evolving theory

We've seen earlier that one of the chief characteristics of qualitative inquiry is the *evolving* nature of the design, methods and analytic procedures used. Your 'theory' also evolves as you go through the cycle of *observing–describing–interpreting*. The physicist David Bohm was fond of pointing out that the Greek word *theoria* (to view or speculate) led to both the modern words 'theatre' and 'theory'. Bohm saw theory as a theatre of the mind, a staging of phenomena which enables us to view them in certain ways.

As part of the process of analysing your data (teasing it apart in order to see how things 'work'), you will ideally be **theory-building** at the same time – as we've seen Suzie do in the process of her project. She's been encouraged to *reflect critically on her data* by comparing, contrasting and seeing connections within her material. In supervision and in her group seminars a main focus has been to keep relating ongoing analytic findings to her original focus and research questions (and to the ideas of others which she's written up in her Literature Survey). She has also been asked to demonstrate the 'strength' of her evolving theory against three criteria. Is it:

- coherent and logical?
- demonstrable?
- useful?

Another characteristic of qualitative inquiry which we've also seen in Suzie's research is that it has several interrelated, but not necessarily integrated, parts to it. She pursued her initial O-D-I cycle, then did the tests and interviews somewhat separately. All have influenced her emerging theory in an as yet unspecified way. Now is the time for Suzie to begin to draw the strands of her project together – she needs to move, that is, from analysis to **synthesis**.

Possible trials and tribulations

For Suzie things have gone pretty much as she planned in her proposal (due to careful thought in the planning stage, and good advice from her supervisor and colleagues). She is now in the fortunate position that her project is on-track in that there is a clear relationship between where she began (her introduction, research questions and the focus of her Literature Survey) and her emerging conclusions which have followed from the data analysis.

For some people, however, the process of doing a qualitative inquiry can be a little more bumpy – and this is the risk you take with an 'emergent study', where not everything is fixed from the start (though of course quantitative designs have their own problems). As your inquiry emerges you can find that your newly found concepts and focus (what your research is *really* about) do not match your initial research questions and your Literature Survey.

This could (but need not) be a time for panic! It's time instead for what specialists call 'revisioning your project' (and cynics call 'cooking it'). You may remember that earlier we compared the research process to cooking – an aspect of which is how to rescue a good dish by adding to it, developing it in a different direction, throwing away something or, importantly, *presenting it differently*. Within the research methodology we're dealing with in this chapter this is not necessarily intellectually dishonest. You may find what your study *really* has to say about your topic only at the end of it – or your data may have suggested interpretations you had not expected. The important thing in terms of your research being useful to others (and being

marked well by examiners) is *how* you present it honestly as a whole – and, if necessary, how you rebrand it at the writing-up stage. Moving from analysis to synthesis will bring up these aspects of your inquiry. Treat this stage creatively too. Here are some questions and answers on typical scenarios:

Question: At the synthesis stage I realise my analytic method doesn't do what it needs to do in terms of my evolving theory. My aim was to use musicological analysis to show how rhythmic flexibility develops in an excerpt, but I now realise that this method demonstrates only rhythmic *construction*. What do I do?

Answer: Ask yourself what's missing in the analysis. How can you extend it, or add another perspective on even a small part of the data you have? And integrate the finding honestly in your account – what you see as an 'error' is a valid part of your research process. It has generated knowledge for others. In the example here you've demonstrated something about the limits of musicological analysis for these purposes. Explain this further in your discussion section.

Question: Attempting to bring together all the different parts of my study I can't see the wood for the trees! It all looks very complicated and suddenly I'm aware that my analytic sections show *lots* of things. What do I do?

Answer: Return to your research questions! Return to the rationale for each part of your study and go through our 'Hints and Tips for Synthesis Problems' in Figure 10.4. Then go back to your analysis section and make sure that for each example you discuss you're clear *why* it's there and *where it leads the evolving argument*. Write explicitly something like the following:

- 'This example shows…'
- 'My idea that x is central can be shown in the following detailed example, where y…' etc.

Synthesising: 'I link therefore I am'

The **synthesis** of your project will be written up in the *Discussion* or *Discussion and Conclusions* section of your dissertation or report. It aims to:

- bring together the different parts of your study in reference to the original research questions

- demonstrate to the reader or examiner that your conclusions are convincing, trustworthy and logically related to the other parts of your work. As we've seen in the previous section this is sometimes not as easy as it sounds.

In the course we teach, the assessment criteria for dissertations ask that, in this part of a dissertation, the examiners look for a candidate's competence in:

- outlining the significance of the analysis, and being able to synthesise research questions, previous findings, data analysis and emergent theory

- communicating significance and trustworthiness of conclusion(s) and demonstrating relevance of research findings for the field of music therapy.

There are two main aspects to the synthesis stage of your inquiry.

Relating the different parts of your inquiry to your conclusions

However many windings and twistings your project may have taken, you must now be explicit about *how* the different findings from the analysis of your data sources relate to your basic research focus (and specifically to your research questions).

Relating your discussion and conclusions back to your Literature Survey

You also need to be explicit about how your findings relate to what has already been written by others on the subject (often, after all, the starting point of your own inquiry). Ask yourself whether your conclusions:

- just *confirm* what is previously known or written about (if so, your project could nevertheless be important in demonstrating evidence for such beliefs)

- *contradict* current thinking or previous evidence – in which case you will need to explain precisely *how*

- introduce *new angles* or *new evidence* which needs more attention by others, possibly further studies: enlarge on this if you can.

What happens if you have problems with the synthesis process? The Hints and Tips in Figure 10.4 have some suggestions.

Hints and Tips
Synthesis problems

1. Take three sheets of paper marked 'End', 'Beginning' and 'Synthesis'.

2. Write no more than six statements on the 'End' piece of paper about what your inquiry has demonstrated, suggested or tentatively pointed towards. This is your 'emerging theory'.

3. On the 'Beginning' paper write a new summary (also in no more than six statements) of your Introduction and Literature Survey). Give attention to the logic of the argument.

4. Take the 'Synthesis' paper and write down the connections between the two poles of your current work. How do they match up? How do the conclusions follow from the opening questions and from what others have previously written about the subject?

5. Is there a serious mismatch? If so, what is this telling you about what your data are 'really' saying to you? How are you understanding and presenting your study as a whole?

Figure 10.4

Evaluating and concluding

You may find yourself agreeing at this stage with the anthropologist Nigel Barley's (1986) comment that 'Rare indeed is the man who knows what his thesis is about before he has written it'. There is no shame in this (and indeed it is somewhat characteristic of qualitative inquiry), but what your reader or examiner *will* need is a clear and honest account of where your research has taken you and your subject.

The **Conclusions** section of your report or dissertation may be part of the Discussion section or may be separate. As well as a final summary of your results you will need to **evaluate** your project and suggest **future directions** for inquiry in this area (by yourself or others).

In quantitative methodology there are formal, built-in ways of assessing the **validity** (reliability) of a study. That is, whether or not its conclusions can be trusted. In Franz' research the statistical procedures described in Chapter 9 have built-in validity checks. Qualitative projects, however, cannot be judged on identical criteria of evaluation. This doesn't, however, mean that 'anything goes': throughout Chapters 8 and 10 we have been emphasising that qualitative designs must be rigorous and must incorporate their own checks and reflexive elements. At the end of your study you need to summarise these aspects in the light of the whole project.

Qualitative researchers have replaced the categories for assessing the validity of quantitative studies (reliability, validity, generalisability and probability) with their own formulations for assessing whether a piece of research is 'rigorous and systematic' (Robson 1993: 402). Instead of 'reliability' the criterion of **trustworthiness** has been established for qualitative research – and within this general category the four checks of **credibility, transferability, dependability** and **confirmability** have been suggested as benchmarks.[3] You may not want to write about each of these explicitly but use them as a guide to thinking about the issues.

Any research must be concerned with **bias**, and this is the main focus for establishing *trustworthiness*. While quantitative protocols (and post-research audits) aim to *eliminate* bias, the qualitative researcher aims to *acknowledge* it, and to give the reader the necessary information to assess how the re-

3 We have based this discussion on Robson's (1993: 402ff) formulations.

searcher's personal and professional stance may have influenced the handling of the inquiry and its conclusions. What influence, that is, has the researcher's position, theory and location in a particular time and place had on the research results? These factors are particularly important when the qualitative researcher is often a 'one-person research machine'. This overall self-monitoring and acknowledgement of biasing factors is part of the **reflexive** aspect we've discussed previously.

Suzie has been encouraged to consider herself a 'reflexive researcher' throughout her project – to monitor how her current situation influences what research she chooses to do, how she does this, and any agenda she may have for certain kinds of conclusions. The musicologist Nattiez (1990: 173) writes of the 'lurking philosophical projects' we all have when writing and researching a subject. Establishing trustworthiness entails acknowledging the influence of these (they need not necessarily have a negative influence if acknowledged). Suzie writes in her Introduction about her 'research stance': she is a student in training, writing to find something out about her own clinical work; she is working from a 'music-centred' music therapy theory, and hopes that her research will demonstrate something about the 'inherent powers' of working with clients musically.

In her Methodology section she justifies her choice of a qualitative methodology and relates this to the research tradition in music therapy. In her Discussion section Suzie tackles the trustworthiness of her inquiry more specifically, using the four checks we mentioned above.

Credibility

As Robson (1993: 403) writes: '[the] goal is to demonstrate that the enquiry was carried out in a way which ensures that the subject of the enquiry was accurately identified and described'. This is a matter of defending your research questions as valid and real ones (not, that is, research which generates its own problems, which it then fails to solve).

Suzie aims to demonstrate that the question regarding her 'moments' had been identified by other music therapists, that its investigation was of current concern to the music therapy profession and that the phenomenon of study could be examined through the modes of analysis her study utilised.

Transferability

This is equivalent to the generalisability criterion of quantitative research, but it is acknowledged that qualitative studies often work from an idiographic stance, claiming only to describe and interpret the conditions or phenomena of a particular time and place – not to claim that research results will apply generally, to all people in all places. Lincoln and Guba (1985) suggest that, while it is the responsibility of the researcher to make explicit the specific and unique factors of an inquiry, it is the user of the research who has the responsibility to determine *whether* the situation and conclusions of the research are transferable to other situations.

Suzie (as we said earlier) has been careful to frame her inquiry within a particular context of work and theory, though she also suggests that her research questions and conclusions have at least some relevance to all current music therapy traditions. She writes several caveats to her conclusions, however: that they are based on only a small data sample (three excerpts) and that, although she has involved other therapists in the inquiry, these are also relatively few, and come from the same theoretical background as she does. She makes a tentative, qualified suggestion that her main conclusions could be transferable to music therapy practice in general, though each practitioner will need to make their own sense of her findings.

Dependability

This criterion 'audits' the processes from which the findings were derived. Whether, that is, as Robson writes: 'the processes followed are clear, systematic, well documented, providing safeguards against bias…this constitutes a dependability check' (1993: 406). Because there are no standard methods of data-gathering or analysis in qualitative research it is vital that you explicitly describe the process and rationale for these, in order that the reader or examiner can assess that they are indeed rational and systematic. This is probably the criterion that an examiner will be most keen to assess in terms of a piece of research.

Suzie makes reference in her evaluation of her inquiry to earlier sections of her dissertation (Methodology and Data Presentation and Analysis) where she has explicitly documented:

- the types of data she selected and the rationale for their selection

- her methods of data collection, reduction and presentation

- the theoretical basis of her data analysis (e.g. why she chose not to analyse the language of her interviews in detail).

She states that she has reflected on these issues and can defend her research process as *explicit, justified and documented*. In a research seminar when the class discuss evaluation issues (using Suzie's project as an example) a colleague asks how a reader of Suzie's research could challenge her interpretations of the data against the original sources. This is an issue in qualitative research as the sheer bulk of data generated by a study often means that the pre-analysed data are not accessible to the reader for checking. As a result of this discussion Suzie consults the examination regulations and decides to accompany her dissertation with several primary data sources from which the examiner or reader could check for unnecessary bias in her data analysis. She adds a cassette tape of the three excerpts and as much transcript of the listening tests and the interviews as she has on a floppy disk. (The availability of original source material may sometimes be limited by ethical considerations.)

Confirmability

The final check aims to correspond to the quantitative criteria of the objectivity of the research findings. As we discussed in Chapter 8, qualitative inquiries cannot be judged on standards of objectivity (in the positivist sense). We can, however, ask of a qualitative study: 'Have we been told enough about the study not only to judge the adequacy of the process, but also to assess whether the findings flow from the data?' (Robson 1993: 406). That is, can we *confirm* the results of the research?

Suzie tackles this check by stating that her results represent not a final 'Truth' (capital 'T') but a 'truth-within-a-situation', and that her interpretations of the data have been intersubjectively validated by several others. She has presented possible (but still challengeable) conclusions which give one version of a research problem which might be useful to other practitioners.

This last point of Suzie's assessment of the 'trustworthiness' of her inquiry brings in the pragmatic criterion of the *usefulness* of the research (instead of

becoming too obsessed by its 'truth value'). A significant motivation for the development of qualitative research within the arts therapies in the last decade has been to enable therapists to investigate therapeutic process – to make research useful to practice concerns. Suzie characterised her research as 'process research'. As long as she can adequately demonstrate the integrity of her project in terms of the four checks above, it could be that the final judgement of its trustworthiness will be based on its usefulness to her colleagues. In order to underline this Suzie writes in her Discussion section how her inquiry fits into current concerns within the music therapy discipline.

You may decide to place the 'usefulness' comments in your **Conclusions** if you choose to make a separate final section. If you do have a separate Conclusion make it short. Summarise your basic findings and suggest future directions for research in this area (either by yourself in a further project or by others).

Viva voce

If your research is part of a course, your dissertation may be further examined in a viva voce. If not, you will nevertheless need to present it at some time. Either of these occasions is a good opportunity further to *defend your thesis* by addressing many of the considerations we've outlined in this section. If this sounds frightening, bear in mind that it's unlikely to be as bad as when the philosopher Foucault defended his doctoral thesis for six hours in front of one hundred people! Communicating your research is nevertheless an important part of the whole procedure, which we shall talk more about in the Epilogue.

And finally

These two chapters on Suzie's research have been a long and rather complicated journey. But in the way in which qualitative research inquires into the arts therapies *process* itself, so too is beginning research very much a *process* matter for you. And as you know as therapists, the process is often more important than any product. So when the going gets tough … don't go shopping – sustain your inquiry!

It's the last week of June. Suzie and Franz meet at the inaugural session of the Council for Research in the Arts Therapies.

'Glad you made it, Suzie,' says Franz, 'I thought you'd still be wading through your data analysis. Where are your carrier bags of transcripts?'

'There's no need for sarcasm! It's all very well for you, Mr Number-Cruncher Franz: some of us have complex data to process.' Suzie tosses her head and her new earrings match the glint in her eye.

'Mine's complex too Suzie – it's just easier to handle if you're organised – though not as easy to interpret.'

At this point Alice brings them coffee. 'Now you two! Sounds like the debate we've just heard between Porschia Tutoria and Peter Purt. I thought they were...you know...but the way she went for him when he called control trials "philosophically and ethically bankrupt", well.'

'All I can say', says Suzie rather sourly, 'is that neither of them were around at Gamut last week when I needed help with my data analysis Section IIIb. It's all glitter and glory with these academics.'

'We are a bit jaded, aren't we?' says Alice. 'Anyway it's not Peter's job to hold your hand – just get on with it, Suzie!'

Alice turns to Franz.

'Has Suzie invited you to our barbecue? Do come! It'll be the evening after we've handed our dissertations in.'

'That'll be nice,' says Franz. 'Ivory Leaves is unlikely to put out the flags when I put my report in next week, so it will be nice to celebrate with you all...even if you are doing qualitative research!'

A bell rings and everyone takes their place for the next presentation: 'Is Outcome Research Dead?' by Professor Beth Torke.

Questionnaire and Survey Methods

Designing a questionnaire –
Coding replies – Analysing data

While Franz and Suzie write up their respective projects, let's look at another way of collecting data – the survey method. We're preparing to find out whether arts therapists in the UK think that social sciences research methods (SSRM) are useful for their own research projects.

Sample size

Instantly we know that we are in for a large data collection, because:

- there are many arts therapists in the UK (let's say there are 500 altogether)

- there are many kinds of social sciences research methods (let's say six main SSRM)

- there are at least four arts therapies disciplines (art, drama, dance movement and music).

As you can figure out, the permutations of just these three points are potentially overwhelming.

Managing large amounts of data calls for a specific way of collecting it: we cannot interview all 500 arts therapists in Britain, and neither do we want to interview a 'representative' sample (in the way that Mr LeBain selects a number of 'low', 'medium' and 'high' attenders for Franz' study) because even that is complicated in terms of geography, the four professional disciplines, the variety of training courses and so on.

Instead, we want to collect information (and opinions) from as many arts therapists as possible – while knowing that not everyone will reply to our requests. The information cannot be open ended, because organising this will take forever – and nobody is likely to fund, or be too interested in, an inefficient way of collecting (and by implication, organising and analysing) information. Remember: the better you plan ahead, the more efficient the use of your time, patience, energy and thinking!

Designing a questionnaire

One way of collecting large amounts of data is the **survey method**. Here we design a **questionnaire** which asks respondents to answer questions *in a specific format*. Questionnaires, by their very nature, offer structured ways of answering questions – the snag being that we need to think through not only how to ask the question, but also all the possible answers that each question might elicit.

We need to think about exactly what information we want to collect, and how best to elicit it. We need to be able to *code* the information quickly and easily, for *data analysis*. We also need to be aware of our personal interests and **researcher bias**, as these can work for and against us. This is because although the structure of the questionnaire will, inevitably, give the answers we are looking for, we may be missing out on unexpected answers by not having thought about asking other kinds of questions (which is why we need to *pilot* the questionnaire, as we'll see later). Our personal interests, enthusiasm and passion are, however, great motivators. Don't let anyone tell you that you have to be cold and detached to be a researcher.

Implicit in our survey is that we're looking at combinations of facts: there are four arts therapies professional groups, six SSRM, younger and older practitioners, experienced and inexperienced researchers, etc. Each of these subgroupings offers interesting combinations of information, and the way we structure questions and group them will enable us to explore relationships between sets of answers. For example, the survey may reveal that movement therapists seem to use certain SSRM more than drama or music therapists, who prefer others; or that younger arts therapists feel more confident about SSRM than do older practitioners, and so on.

The questionnaire cannot be too long: people may lose interest and not respond, or we will collect information that we don't need – and that may distract us from what we want to know. Neither can the questionnaire be too short: after all, we want to make some conclusive statements about what arts therapists think.

We have to hope that a high enough proportion of arts therapists responds; another motivation for making the questionnaire interesting and succinct. A good response will help us to make some useful (and generalisable) statements about what arts therapists think of the usefulness of SSRM. If too small a sample responds, then we have to think carefully about how to interpret the respondents' statements and opinions – and the lack of response. Generally, a statistician will help you to calculate what proportion of responses you need, to be able to make generalisable statements – and this usually depends on your sample size. Robson (1993: 250–2) suggests ways to improve the response rate for postal questionnaires. These include:

- appearance (the questionnaire should look easy to complete, with the contents well laid out)

- thinking through the mailing (using good-quality envelopes, enclosing stamped addressed envelopes)

- enclosing a covering letter assuring confidentiality and explaining aims

- sending a follow-up letter emphasising the importance of the study, possibly sending another copy of the questionnaire with another stamped addressed envelope, and so on.

Structuring questions and answers

As you see, designing a questionnaire needs a lot of thought. Implicit in the design, layout and order of questions are the answers we require. Essentially, we offer respondents a choice out of a group of all possible answers, while also maintaining sensitivity of information. If the categories of answers are too broad, we'll end up with potentially dull, unrefined data. Below we'll discuss some question and answer formats, at the same time looking at numerical codings of answers.

If a question and answer simply state:

Q: Do you ever read up on SSRM?

A: Yes (21) / No (22)

then this doesn't tell us very much: just whether arts therapists do (code 21) or do not (code 22) read up on SSRM. Here, be careful about how to interpret questionnaire codings. As we saw in Chapter 7, these numbers simply identify which of the answers is selected. Thus, 22 is not 'more than' 21 in terms of quantity, neither does 21 mean that this answer comes before 22. The numbers simply represent different answers, and their value is nominal. Answers to the next question might be coded 31, 32, 33, 34 etc. The first digit '3' identifies the question, while the second identifies the selected answer.

However, if the possibilities for answering are a little more refined, we might get more sensitive data, e.g.

Q: Do you ever read up on SSRM?

A: Never (31) / Only very rarely (32) / Sometimes but not often (33) / At regular intervals (34) / Frequently (35) / All the time (36)

Here, we already have six different possibilities (coded from 31 to 36) that are far more revealing about arts therapists' habits, not just whether they do (codes 32–36) or do not (code 31) read, but how often. However, even this is a bit vague. Let's try and be more specific:

Q: Over the past 12 months, how often have you consulted SSRM?

A: Never (41) / Once or twice (42) / Three or four times a year (43) / Monthly (44) / Weekly (45) / All the time (46)

Here is more specific information. The options for answering cover all possibilities, ranging from 'never' (code 41) to 'all the time' (code 46), within a specific period of time. This is far more relevant to the current scenario, and is more likely to impact on arts therapies training courses, research seminars, research literature, and so on.

By now it is becoming obvious that we need to think of answers in terms of categories. The answers are discrete from one another, and as a group, need to cover all eventualities. If we are not sure that the answers we provide do cover all eventualities, then we need an extra category called 'Other'

(more about this later). Do refresh your memories about **categories**, in Chapter 7 regarding Franz' research designs.

Now, in continuing to compile our questionnaire, what soon becomes obvious is that simply to ask everyone these questions isn't enough since it is not going to help us to identify which arts therapy groups consult SSRM more or less than others. We therefore need to ask the respondents to identify what kind of arts therapy they practise.

At the very beginning of their questionnaire, therefore, we ask respondents to tick one of the following:

Art Therapist (71) / Drama Therapist (72) / Movement Therapist (73) / Music Therapist (74) / Other (75)*

(* Please specify ...)

Some respondents may call themselves arts therapists and not be identified under the UK definitions. They may be theatre or poetry therapists, so we provide a space under 'Other' to specify which arts therapy they practise. Here, an unexpected result of the survey may be that there are various other arts therapists in the UK – and we might recommend in our report that the professional definitions need to be altered.

We may want to explore other relationships in the questionnaire. Let's say that we want to establish whether it is the 'younger generation' of arts therapists who seem to consult SSRM far more than the 'older'. What question should we ask here? More critically, what do we mean by 'generation'? Do we mean the 'age' of respondents? Do we mean when they trained? Do we mean how long they have been practising for? Think about it: if we simply ask respondents for their age, then we might not get quite the information we need: after all, we are researching what *arts therapists* think about SSRM – so here, surely the 'younger' or 'older' generation may rather pertain to how long they have been practising.

At the same time, we might as well collect data about their age – after all, this might reveal another interesting relationship: something about whether older or younger (in developmental age) arts therapists tend to consult SSRM more or less; or tend to have practised for an interrupted or uninterrupted stretch of time.

Now we are beginning to get an idea of what the questionnaire might look like. Incidentally, we purposely chose not to talk you through the ques-

tionnaire from the beginning and work through it in a predictable way. This is to make the point that planning seldom begins at the beginning. The process of putting together something like a questionnaire (or a research proposal) is often one of beginning with one idea and unfolding in various directions at the same time. What is critical, though, is to know when it is time to draw the line – like we're doing now – and say, right, time to begin at the beginning.

Let's now work our way through the questionnaire. We have a commentary for each bit.

Name ...

NB: Most research information is usually collected on the understanding that it will be presented in an anonymous way. This is part of **research ethics** *(which we talked about in Chapter 6), i.e. ensuring respondents' privacy and maintaining anonymity of information sources. After all, you, as respondent, might be the head of a famous training course and everyone knows who you are. It turns out that you never read SSRM – and are embarrassed about this. Unless your anonymity is guaranteed, you might simply not bother to reply. We have to assure respondents that information will be confidential and anonymous – and explain that we may want or need to follow-up unclear or especially interesting replies, hence our request for names and contact addresses. Ethically speaking, we need to give respondents the option of not identifying themselves.*

Q1: Please circle which of the arts therapies professions you practise:

A1: Art Therapist (71) / Drama Therapist (72) / Movement Therapist (73) / Music Therapist (74) / Other (75)*

(* Please specify ...)

Q2: Please indicate how long ago you trained as an arts therapist:

A2: Over 20 years ago (80) / 15–20 years ago (81) / 10–14 years ago (82) / 5–9 years ago (83) / 1–4 years ago (84) / Currently training (85)

Q3: Please indicate the total number of years that you have practised your profession. If this period has been interrupted by years of not practising, then add the number of years that you have been practising (e.g. you trained 15 years ago, but have practised for 10 years – you then enter 10 as your answer).

A3: Over 20 years (90) / 15–20 years (91) / 10–14 years (92) / 5–9 years (93) / 1–4 years (94) / Less than one year (95) / Currently training (96)

Q3a: Also indicate whether practice was interrupted (97) or continuous (98)

Q4: Over the past 12 months, how often have you consulted SSRM?

A4: Never (31) / Once or twice (32) / Three or four times a year (33) / Monthly (34) / Weekly (35) / All the time (36)

IF YOUR ANSWER IS 'NEVER' THEN SKIP THE NEXT QUESTIONS AND GO DIRECTLY TO Q5.

Q4a: Did you consult SSRM as part of

A4a: a project at work (37)

Teaching research methods (38)

Your arts therapies training / dissertation (39)

Other (40) (please specify ..)

Q4b: Please list any SSRM books that you found especially useful – please list these in order of preference.

A4b: ..

..

..

..

Q4c: Please list any SSRM books that were not useful – and state briefly reasons.

..

..

..

Reasons: ..

..

..

..

..

..

Q5: Please assign a value for 'familiarity' to each of the SSRM below. You may assign the same value to more than one method.

Most familiar Least familiar

 (1) (2) (3) (4) (5)

 (81) (82) (83) (84) (85)

(Enter level of familiarity)

(41) Survey Method ☐

(42) Experimental Method ☐

(43) Interview Method ☐

(44) Repertory Grid Method ☐

(45) Action Research ☐

Here in Q5, respondents assign a value (from 1 to 5) to each of the five methods. They may assign a value as many times as they want to, so that three of the choices might have value '4', and none of them have value '1'. This is different from what we ask respondents to do in Q6.

Q6: If you are familiar with statistical methods of analysis, please rank the following from (1) very familiar to (6) least familiar (if you're not familiar with these, then skip this and go to Q7).

Please enter ranking of familiarity from 1 (most familiar) to 6 (least familiar)

(61) Chi-square ☐

(62) two-tailed tests ☐

(63) level of significance ☐

(64) correlation coefficient ☐

(65) degree of freedom ☐

(66) standard deviation ☐

Here in Q6, respondents rank the six methods from highest degree of familiarity (1) to the lowest (6). These numbers have ordinal values, in the sense that 3 is greater than 2 which is greater than 1 – though we have no idea as to what quantity any of these numbers denote, or what distance they are from one another. Although strictly speaking, respondents are asked to rank *these methods from 'highest' to 'lowest', suggesting that the numbering will go from 1 through to 6, some methods may have 'tied' rankings. Have a look at Chapter 9 to refresh your memory about ranking.*

Q7: Please place a tick on one of the lines for each of the following statements:

1 SSRM are easy to understand

 Strongly agree *Strongly disagree*

2 SSRM are useful for researching the arts therapies

 Strongly agree *Strongly disagree*

3 The arts therapies should develop their own research methods

 Strongly agree *Strongly disagree*

4 SSRM need to be adapted for use in arts therapies research

 Strongly agree *Strongly disagree*

5 SSRM are difficult to understand

 Strongly agree *Strongly disagree*

There is no numeric scoring (as in Q5) or ranking (Q6); rather, the placing of a tick on a line gives respondents a chance to respond spatially rather than numerically. Some people respond more easily to numbers than they do spatially and vice versa, so we need to think about how best to collect information. We also see that there appear to be some contradictory statements (e.g, 1 and 5). This is a way of 'controlling' for alertness of respondents: an alert respondent will place their tick differently depending on the

statement, whereas someone not paying attention might place all ticks on the middle line.[1]

Q8: Please feel free to make any other comments regarding your opinion about SSRM and arts therapies research.

It is always a good idea to give respondents the opportunity to comment spontaneously – and also a good idea to provide a defined space for their answers, or you might get a three-page essay.

Thank you for your help and for your time and patience in completing this questionnaire. If you'd like us to send you details of the answers, please tick ().

It is important to thank respondents – they've given us their time and energy – and without them, we could not carry out our project!

Coding responses

We've already discussed the fact that each of the possible replies is coded numerically (probably with the help of computing software) to save having to construct codings after collecting the information. The only non-coded replies are in Questions 7 and 8. In Question 7, we've purposely omitted codings, since these may – even subliminally – influence where respondents place ticks (especially respondents who are sensitive to the value of numbers). However, in the score sheet, we will, in fact, have a numeric value for each of the dotted lines. For instance, the line may be 15cm long, and we can divide it into 5 × 3cm intervals and assign each segment a coding. We

1 You might want to read up some more on attitude scales in general, especially on the Lickert Scale and on the Semantic Differential. Robson (1993) is a good introductory source.

can also measure the position of the tick with a ruler, which gives us a numeric value. Question 8 is an 'optional extra' for respondents, and not amenable to coding. This is open-ended, rather different kind of information: an opportunity for respondents to be creative and idiosyncratic, and give us tangential information.

Piloting the questionnaire

The questionnaire is ready to be posted out…but is it? It makes sense to us…but let's not be too confident just yet. Remember that we may have constructed questions (and answers) in a specific way: i.e. according to what we want to know, but will we get the information we need? Are our questions sensitive enough? What have we left out? Best first to pilot the questionnaire – in other words, try it out on a few people. But on whom? If we ask arts therapists to pilot it, then they will do it twice (once as a pilot run and then as the real thing), and their answers the second time round may be affected by **practice effect**. On the other hand, if we ask friends who don't know too much about the arts therapies, we may not get the fine tuning that we need.

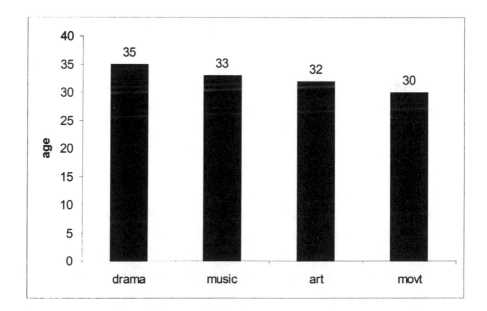

Figure 11.1 Mean ages of respondents

Generally speaking, a pilot is a small-scale pre-run of any instrument that you design in order to collect data. It needs to be carried out on the same population that we are targeting for our research. By piloting the questionnaire, we sort out any glitches in the structure and content of it. Also, even if we decide to ask one or two arts therapists to do this as a trial run, our sample size is so large (500), that practice effect on two people is unlikely to affect the overall results. If the sample size is smaller, then those colleagues who've helped us to pilot our questionnaire may be omitted from the actual run.

Analysing the data

The data are collected, many arts therapists have responded, everything is coded – what now? We need to carry out various analyses, using any of the methods of analysis we have described in Chapter 9. For example, we may want to present some of the responses using **pie charts, histograms or bar charts**; we may want to explore the relationship between various bits of information to other bits using a **correlation coefficient** – either **Pearson's** or **Spearman's**.

Table 11.1 Attitudes towards SSRM				
	Positive attitude	Negative attitude	Uncertain	**Total**
Art therapists	63 (68.5%)	21 (23%)	8 (8.5%)	**92**
Movement therapists	43 (53%)	33 (41%)	5 (6%)	**81**
Drama therapists	55 (80%)	13 (19%)	1 (1%)	**69**
Music therapists	29 (56%)	18 (35%)	5 (9%)	**52**
Total	**190 (64.5%)**	**85 (29%)**	**19 (6.5%)**	**294**

For example, the relationship between the age of respondents and their practice experience may reveal that the greater the age of respondents, the more practice experience they have; or else we may find that drama therapists are the oldest group, music and art therapists are marginally younger, and

movement therapists quite a lot younger (Figure 11.1). We may want to comment on this in our report: it may be that movement therapy is a lot younger as a profession, or else that more movement therapists cease practising (or do not respond to questionnaires), whereas the other three arts therapy groups tend to go on practising for longer, etc. Clearly, our interpretations will be linked to other responses.

We may also want to illustrate positive and negative attitudes towards SSRM by each group and can do this with both a table and a bar chart (see Table 11.1 and Figure 11.2).

Table 11.1 reveals various bits of information. *Within* each of the four groups, it is clear that drama therapists have the highest proportion of positive attitude to SSRM (55 out of 69 respondents), with movement therapists having the lowest proportion of positive attitudes (43 out of 81). Unsurprisingly, they also have the highest proportion of negative attitude to SSRM (33 out of 81). This is within each of the four groups and is illustrated by the bar chart (Figure 11.2). However, if we now go back to Table 11.1 and look *across* all four groups, then we see that art therapists are the largest group with positive attitudes to SSRM (63 out of a total of 294 respondents) and

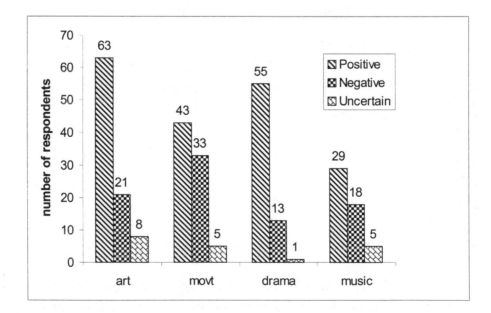

Figure 11.2 Attitudes towards SSRM

music therapists the smallest positive group (29 out of 294). Movement therapists are the largest negative attitude group (33 out of 294) and music therapists the smallest (18 out of 294). The overall results show that 65 per cent of arts therapists are positive about SSRM, and only 6.5 per cent are uncertain about them. In our report, we might want to comment on this, and suggest that it reflects on training, on the specialities of each profession – and that the impact of these results might be to increase SSRM teachings on the other arts therapies trainings, to offer specialised modules as part of continuing professional development and so on.

Incidentally, we could also represent each of the arts therapy group attitudes with a pie chart. Figure 11.3 shows the attitude proportions for the drama therapists.

Figure 11.3 Dramatherapists' attitudes to SSRM

Then we might want to **rank** responses, from the most to least used SSRM. Be careful here – we are showing all respondents as one group, rather than showing each group's responses.

(1) Action Research (SSRM6: 22%)

(2) Survey Method (SSRM2: 20.4%)

(3) Semi-structured Interview (SSRM1: 19%)

(4) Interview Method (SSRM5: 14.6%)

(5) Repertory Grid Method (SSRM4: 12%)

(6) Experimental Method (SSRM3: 12%)

However, we may want to refine this ranking with a contingency table showing how each group ranks the six SSRM (Tables 11.2 and 11.3). (Refresh your memory about contingency tables in Chapter 9.)

Table 11.2 Global and within group use of SSRM							
	SSRM1 Semi-structured Interview	SSRM2 Survey Method	SSRM3 Experi-mental Method	SSRM4 Repertory Grid Method	SSRM5 Interview Method	SSRM6 Action Research	TOTAL
Art therapists	15	21	6	18	9	23	92
Drama therapists	10	18	3	2	17	19	69
Movement therapists	19	16	11	10	17	8	81
Music therapists	12	5	16	5	0	14	52
Total	56 (19%)	60 (20.4%)	36 (12%)	35 (12%)	43 (14.6%)	64 (22%)	294

Table 11.3 Ranking of SSRM preferences within each arts therapy group						
	SSRM1	SSRM2	SSRM3	SSRM4	SSRM5	SSRM6
Art therapists	4	2	6	3	5	1
Drama therapists	4	2	5	6	3	1
Movement therapists	1	3	4	5	2	6
Music therapists	3	4.5	1	4.5	6	2

Table 11.2 shows the actual numbers that use each of the SSRM. Note that the totals for each group in the right hand column, and the totals for each SSRM on the bottom row both add up to 294, which is the total number of respondents. Also note that in the bottom row, we've inserted percentages – and that these add up to 100 per cent. A quick look at this table suggests that, as a group, arts therapists rank SSRM6 (Action Research) as most used, and *both* SSRM3 and SSRM4 tie as least used (Experimental and Repertory Grid Methods). Can you see how this corresponds to the listed rankings, above?

In Table 11.3 we've taken the trouble to show the actual rankings of each SSRM within each group. Here, you notice some similarities and differences between groups. For example, SSRM6 (Action Research) is ranked as most useful by both art and drama therapists, as second most useful by music therapists, and – most interestingly – movement therapists rank this as their least useful!

SSRM3 (Experimental Method) ranks near the bottom for art, drama and movement therapists, but first for music therapists. Once again, the contingency table summarises results quickly – reading a text describing all these relationships would be tedious, and you'd soon lose your readers' interest and attention.

Writing up the questionnaire report

We're not going into too much detail here, since Chapter 13 talks you through writing up research. You do, however, need to think about the best way of presenting the information you've collected – and here, presenting it spatially (i.e. through charts, graphs or diagrams) as well as verbally is the most useful. It gives readers a chance to get an instant visual impression of results and relationships – and then to read your text if they need or want to. You also need to remember that simply presenting the results is not enough: you need to offer interpretations of the results – and make suggestions as to where next for the profession, practice or research trends or whatever it is you are surveying.

Conclusion

The main point of this chapter on questionnaire and survey methods is to alert you to the complexities of collecting information from a large group of people.

You need to make sure that:

- You really *do* need this size of sample (questionnaires are not efficient or economical in terms of paying for postage, including a pre-paid addressed envelope for replies, waiting for people to reply, risking only a small proportion of replies, collecting large amounts of data that then need analysing).

- You clearly explain the purpose of your questionnaire.

- You reassure respondents about anonymity (and give them the option of not entering their names if they prefer this).

- You get good advice as to how best to construct and code your questionnaire.

- You get good advice about what proportion of responses you need in order to get information that is generalisable (if this is what you want or need) – this will depend on your sample size, and you need a statistician to help you work this out. If you want a small in-house survey at your place of work, then hand out your questionnaires and make sure people return them by a certain date – chase them up if they don't.

- Your questions are clear, and address the issues you need.

- You ask all the questions you need to ask – and not too many.

- Your answers cover all possibilities.

- You give respondents the opportunity to comment spontaneously at the end.

- You offer to send them the results, should they wish to (by now you should know how to construct this question – and you don't even need to code the answer).

- You get good advice as to how best to analyse the responses.

- Finally, think again as to whether a questionnaire really is the best way for you: think of the time you've got (revisit the time-line in Chapter 3).

Good luck!

STAGE 4

Producing the Goods

Finishing Off

Writing up – Clarity of presentation –
Checking through – Producing

Serving up

If you'll allow us to strain the culinary metaphor one final time, it's now time to give attention to how you *serve up* your research. As in cooking, an adequate dish can be rescued by careful presentation, while fine cooking is further enhanced by care and taste at the last stage. So too with research – you can spoil the impact of a good piece of work by shoddy presentation.

The last stage includes writing the final draft of the manuscript and checking that your account of the research is as clear as you can make it. You then have to produce a professional-looking product according to the required protocols of your institution. As we advised in Chapter 3, when planning a time-scale for your research leave yourself a complete week for producing the dissertation or report after you've finished writing up. Nervous breakdowns over the photocopier are not an ideal way to end your research process. Nor are reports with the margins the wrong size, mis-aligned punch-holes, misspelt titles or missing references!

This chapter provides a guide to the final stages of writing up and checking your work, and to the physical production of a good-looking manuscript. Depending on your character, this stage of the research process is either the nice bit – where you can (nearly) stop thinking and tidy up your manuscript, or else an irritating symbol of the bourgeois conspiracy which respects form over content.

The truth is that, whatever you think about the virtues of presentation, care is needed at this stage to ensure that your dissertation is accepted, or that your report is taken seriously. Attention to the clarity, layout and presenta-

tion of your manuscript will encourage people to read it. This is, after all, what we want – that people actually *use* our research findings.

Safety first!

This is a dangerous time! At this stage you will probably have several different drafts of your manuscript floating around. Before you know it, you have a corrupted disk, a hard-drive failure and only an old draft on a floppy, somewhere. You have been warned! So, before you do anything else, take just 15 minutes NOW to safeguard your work (see Figure 12.1). Better this than tears before bedtime…

Hints and Tips
Safeguarding

1. Make a new copy of your nearly final draft on two floppy disks and rename them *Print Copy 1 & 2*. Put each chapter or section on a separate computer file, clearly labelling each. Each time you amend text or change layout, update the label e.g. *Chap3–2* (= Chapter 3, second update). This will save you printing out an old version.

2. Print out all nearly final drafts to check for layout problems – have a paper folder for the final draft + diagrams.

3. **DON'T** start using a new computer or new program at this stage because you think it prints better, does pretty diagrams, etc. Because you're not familiar with it you'll probably do something drastic and/or waste hours that are better spent on improving your text. Stick with the devil you know!

Figure 12.1

Writing up – writing down

It's perhaps significant that we talk of 'writing up' a piece of research, rather than 'writing it down'. You are doing more than just writing it out – you are presenting your inquiry in the clearest and most interesting way possible. This involves close attention to how you present and organise your data and arguments in written prose and in diagrams. Like most of the previous stages of the research process, this last one requires a combination of technique and artistry.

We've presented (in Chapter 4) some ideas about how to write for academic purposes. By now you should have had lots of practice of putting pen to paper – we're assuming that you have taken our earlier advice of *not* waiting until 'later' to write about your project. As we suggested in Chapter 4, the process of *drafting* is the best way not only to hone your prose but also to sharpen your thinking. Now you're working on the final draft of your manuscript, some reminders about writing style may be in order.

Look back again to the advice in Chapter 4, then read through your 'nearly final draft'. Read with a pencil and mark any passages that are unclear, long-winded, wandering or simply inelegant. You should also have enlisted an outside eye for this process too – either a formal supervisor or a colleague or friend. When checking for style and clarity it can be helpful to have a reader who *doesn't* know much about the subject – they will be more sensitive to jargon-ridden nonsense!

Then begin your final draft, working from your corrected copy (bearing in mind our safety advice to keep drafts carefully labelled at this stage). When rereading you might bear in mind Orna and Stevens' (1995) 'top turn-offs' in academic texts:

- unexplained unfamiliar words
- lots of 'grey text' with no headings
- complicated sentences in which the reader gets lost
- illustrations and tables remote from the relevant text
- unclear links between ideas.

Writing an abstract

Exercise your new resolve to produce clear but elegant prose by writing an **abstract** for your manuscript. This is the short summary that goes right at the beginning of a dissertation – but is typically written last. It may later be 'abstracted' from your text to put on a database. Your abstract is the first contact most people will have with your work – whether they are browsing the dissertation on a shelf or using a database as part of a literature search. As you'll remember from this part of your own research, reading an abstract gives you a flavour of the work and gives you enough information to decide whether the study is worth reading further.

Your abstract needs to be clear and attractive to potential readers; to be well set out, easy to read, informative and precise. As you embark on the final draft of your manuscript let your work on the abstract set the standards for your writing as a whole. It will need several drafts – but it's worth it.

The abstract should state the following:

- your **reasons** for doing the research

- the **research perspective** you worked from and the main **methods** you used to conduct the inquiry

- your main **results** and the conclusions you draw from these

- use **keywords** where possible so that your study can be indexed by others.

The abstract should be no longer than 150 words (and shorter when possible). Think of Orna and Stevens' 'top turn-offs' again and make sure you haven't succumbed! Read some other abstracts as a guide to format, style and content. Critically evaluate them.

There are a few other conventions concerning abstracts:

- Don't use direct quotations – paraphrase these if necessary.

- Don't litter the abstract with citations – mention only the key ones relevant to your study.

- If the overall style of your prose is in the 'first person' then use this in the abstract, but don't make it too chatty – the abstract should be relatively impersonal.

Checking the plot

Reading through your nearly final draft and writing an abstract may have alerted you to some things about your work. You may have realised that the plot of your study is not quite as clear and consistent as you'd imagined. Particularly in qualitative studies (as we've seen in Suzie's case) there's an evolving aspect to the research. This can mean that a process of cleaning-up may be necessary at a relatively late stage. We've looked at the more conceptual area of this in the synthesising section of Chapter 10, but there's also the matter of how your final text presents the story of the research so that the reader is confident of the plot.

We suggest that as you read through your nearly final draft you annotate your text not only for prose style but for **plot logic**. To help you with this we suggest you keep in mind the following questions for each section or chapter of your manuscript.

Is the function clear?

When you begin a section or chapter is it clear to the reader what that section or chapter is doing? Does it try to do more than one thing at a time (a typical mistake is for data analysis to drift into discussion). It's best to keep sections discrete, and doing just one thing at a time. Use our earlier hint for clarifying writing: start off chapters or sections with the following beginnings:

- 'This chapter/section aims to...'
- 'It is organised in the following way:...'

Then rename these starts to the sentences at the final draft stage (if necessary), and the logic of the sections should be clearer.

Is the content clear?

Do you read a section and think 'What's that bit got to do with this section of the manuscript?' Someone else certainly will if you don't! What typically happens is that you leave in favourite bits of writing from an earlier stage — which are not justified by its final shape and conclusions. To someone else these read as bulges in the main plot, diversions which obscure your main argument. A student of ours referred to needing to 'chuck out the chintz' at

this stage. A process of culling or winnowing is required to ensure that all that's left in your final text is absolutely necessary to your main plot.

The problem of bulges can also apply to the data presentation and analysis sections. In all styles of research there's a temptation to put too many raw data, or too much analysis, into the final text. Although you're looking to demonstrate that the conclusions you've reached have really come from the analysis, you will need to make decisions at this stage as to whether more bulk of material reassures or confuses the reader. It's tough removing that passage that you spent so long polishing two months ago, but that's life!

Is the form clear?

Have you made it as easy as possible for readers to find their way around your text? If it's confusing you can be sure that an average reader (or examiner) will give up. Clarifying the structure of a text is a matter of carefully labelling sections and subsections so that the reader is led through the structure of the research project in a clear and logical way. Remember that opening sentences of a chapter or section can signpost where the argument is leading.

The ends of chapters and sections are also important parts of your text – ideally the end of each section should set up the next. Again, you can always take out any sentences which seem to overdo the signposting, but it's better to have too much help when reading than too little.

Some common 'structure problems'

It is typically in the data presentation and data analysis sections that people get into problems. Your external reader might have read your nearly final draft and said something like: 'This section is very long and complicated – I'm not always sure what is what…'. With qualitative designs in particular, there can be a confusion between *presenting* the data and *analysing* it. Often the *primary data* as well as the researcher's coding of this and the analytic comment are in verbal form. This problem is compounded when primary data come from several sources.

You may therefore need to rework your analysis section at this stage to signpost the reader through it. We've found some ways of helping with this.

Play with fonts

A change in how a text looks alerts the reader to a change in content. You might use a change of font, or put certain material in a text-box to clarify different forms of material in your analysis. For example, primary data might always be in italics, coded material in another font and researcher's commentary in bold. Provide a key to these of course.

Use flow-diagrams

It's essential that readers follow the logic of your data presentation and analysis in terms of: Where did the data come from? How did you collect them? How did you reduce/organise/code them? How did you analyse

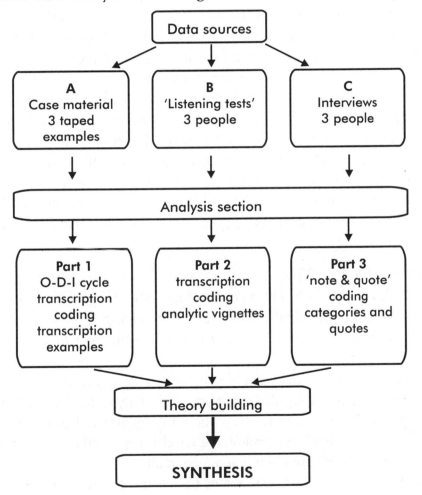

Figure 12.2 Flow diagram of Suzie's inquiry

them? Trying to cover all of these in one section can often leave readers disorientated. A simple way of orientating them is to produce a flow diagram for the whole process, showing data sources, levels of analysis and levels of interpretation that are then systematically worked through in the remainder of the section. Figure 12.2 gives a simple example, based on Suzie's project.

Checking through

A good way of being critical about your text is to look at it through the eyes of the examiner or critical reader. In the case of academic dissertations, your course documentation will usually tell you what criteria are used to assess your work. Use these criteria to guide a final check through your manuscript. In Figure 12.3 are the criteria used to assess MA dissertations on the course we teach. These go through each of the sections of the dissertation in turn and give hints as to what the ideal dissertation might present.

Remember that in genuine scholarship it's no shame to say that there are problems in your initial conception of the study; that there are flaws in the methodology and that the findings are provisional and need to be qualified by considerations x, y and z. This is not fudge, but intellectual honesty. Those reading your text will learn something about both content and method from your honest and dispassionate discussion of the above. Gary knew someone who wrote up a whole PhD about how his conception of plasma was fatally flawed. It stopped anyone else going down the same road!

Formatting and styling

As Oscar Wilde wrote: 'It is only shallow people who do not judge by appearances'. **Styling** your final manuscript means giving attention to the details of appearance – which can help (but not guarantee) that readers respect its content.

You need to attend to the **format** of your manuscript (particularly if it's a dissertation). Look up the regulations of your university or institute – there will be pages of detailed instructions on how to organise and produce the dissertation in the official way. Follow the regulations exactly – otherwise you will run the risk of it not being accepted at all.

If you don't have detailed instructions follow the classic format for an academic work as in Figure 12.4.

Hints and Tips
Final checklist

- Is the **abstract** clear? Does it give enough information to characterise the study?

- Does the **introduction** set the scene appropriately? Is it clear why the writer has embarked on the study?

- Is the **purpose** of the research clearly stated?

- Are the **research questions** clear and logical?

- Is the **literature survey** comprehensive, informed and critical/comparative? Does the discussion take the research questions into account?

- Is the choice of **methodology** appropriate to the study?

- Is the choice of methodology contextualised (within the arts therapies tradition) and suitably justified?

- Are **data collection methods** clearly described?

- Are **methods of analysis** justified and clearly described?

- Is **data presentation** clear and elegant?

- Are **results** adequately discussed in relation to research questions?

- Are **wider implications** of the results discussed?

- Is the literature logically revisisted in the **synthesis**?

- Are **conclusions** supported by results?

- Are **reliability and validity** discussed in relation to findings?

- Is awareness of issues of **reseacher bias** demonstrated?

- Is an understanding of the **relevance of the study** communicated?

Figure 12.3

Hints and Tips
Academic format checklist

- **Title page** – see regulations for format of this.

- **Abstract** – 150–200 words (in one A4 side if possible).

- **Acknowledgements** – of tutors, colleagues, other professionals, for help with the study.

- **Contents** – correlated with page numbers. Make sure it presents the organisation of the manuscript as clearly as possible.

- **List** – of examples, figures (diagrams), tables, etc.

- **Main text** – broken up into chapters or sections and subsections, all clearly labelled with appropriate numerical and/or typographical 'signposts'.

- **Appendices** – includes letters of consent, any additional material that will clog the main text, but which needs referring to in order to check, clarify or contextualise your argument.

- **References/Bibliography** – presented alphabetically in the house-style of the university or publication.

Figure 12.4

Getting things in the right order is the first task. Then you need to make sure your manuscript *looks good*. Some aspects of formatting and presentation will vary according to the regulations of your institution. Check things like required margins, line-spacing, whether printing must be on only one side of the paper, how quotations should be handled in the text, how figures and diagrams must be labelled, etc.

The Hints and Tips in Figure 12.5 advise on producing a visually pleasing manuscript.

Hints and Tips
Styling your manuscript

- Most computers have 'styleboard' options, where you can choose and label **different styles of text** (font, size, spacing, bold/italic, etc.) for different functions, e.g. to distinguish headings, subheadings, quotations, etc. Using 'styles' ensures that this remains consistent throughout your typescript.

- It's sometimes necessary to do **graphics** on another program, but then difficult to 'drop' this into your main text. If this happens, a trick is to print out the diagrams separately and paste them in (physically with glue, then photocopy). Print a blank page on the document for this, which will then have the right page number on the original file.

- **Spacing** is very important for overall look and readability – never skimp on paper for the final version – and design all of the spacing carefully – e.g. between main text and indented quotations; between headings and text.

- **Check:** that all aspects of the typescript are the same all the way through – headings, spacing, emphasising, referencing.

- **Check:** for 'wrap around' problems in the final print. Often a new section's title can end up on the bottom of the previous page.

- **Check:** that page numbers are totally correct and tally with the contents page.

Figure 12.5

Final production...a warning!

The best advice we can give you in the final stage is simply **give yourself TIME!** We won't bore you with tales of how many students we've witnessed in tears over the photocopier, but don't assume you will be the exception to the universal Law of Sod. Deadlines raise emotional temperature, and computers and photocopiers seem to empathise. Leave yourself time for one final check and get someone who knows little about the content to check the language. Gremlins get working at this stage. We'll leave you with some cautionary tales: Gary left Chapter 8 out of his doctoral thesis on sending this off to the examiners and Mercédès submitted a previous book manuscript to the publishers minus Chapter 12. Need we say more?

Suzie has invited Franz to the Gamut College Summer Barbecue, which is timed to follow the hand-in deadline for the dissertations. Relief and hysteria abound, the Tequila Sunrises flow.

'All in, then?' says Franz to Suzie and her colleagues.

'Just!' says Suzie (there are some raised eyebrows). 'You won't be surprised to know that my printer broke down, my Bibliography came unformatted and...'

Peter Purt joins their group at this point. 'We're hearing about Suzie's disasters, are we?' he says.

Franz explains that his report was handed in two weeks ago and John Audit is considering it in his Resources Meeting today.

Suzie gets another drink and when she comes back to the group finds Franz and Peter deep in conversation. Peter is saying: 'Yes, Franz, I'll have that information for you tomorrow and we'll talk further then.'

A rather awkward pause follows (why awkward? Suzie examines her counter-transference for clues).

A second round of Tequila Sunrises helps things along. They finish the evening in the Bull and Last pub where Peter tells some of his research anecdotes.

Epilogue
Towards a Community of Inquiry

What now?

It's all done, typed up, corrected and handed in. The board has approved your funding, or the external examiner your dissertation. Is this all?

What difference does your bit of research make to the world?

None at all, of course, if you keep your dissertation on your bookshelf or your ideas in your head, where they can remain safe and stagnant. Ideas and thoughts are part of the currency of thinking and debating among ourselves, among colleagues at work. Ideas belong 'out there' in the world. There is no point at all in spending hours and hours refining your methodology and your data analysis, and writing elegant conclusions, if your work remains closeted, unshared, unable to be developed. Ideas need to flow, be turned inside out, be shaken up thoroughly – usually by others – if we are really to develop a common culture of inquiry among arts therapists. This sharing of ideas can feel frightening, since we might be criticised, shown to be unrigorous, or others might steal our ideas and present them as their own. Take the risk! Be brave! We invite you – indeed, we plead with you – to link up: publish, present your work at conferences, collaborate with others, *share* your work.

One way to begin sharing your own work with others is to have smaller, intimate platforms at which first-time researchers can present their work – rather than diving straight into rather intimidating and large conferences. At the Nordoff-Robbins Music Therapy Centre in London we have dissertation presentation evenings – after the dissertations are in and examined. The new graduates have 30 minutes to present their work to clinical colleagues, and are allowed five acetates each. By this time, they have a fresh distance from all the slog, and present their 'research message'. This is an excellent, friendly

opportunity to practise formulating and communicating research thoughts and ideas in a simple way and in a supportive environment. Try it!

A theme we have revisited several times in this book is the difficulty of analytic presentation of the essentially non-verbal media of the arts therapies. But, as David Aldridge (1999) has commented, we can use new technologies to provide different, and possibly more appropriate, platforms for debate and exchange: especially multimedia formats such as CD-ROM.

What Aldridge comments about the current music therapy profession surely applies to all of arts therapies:

> We need to establish research as a sub-culture of the music therapy profession and offer a research infra-structure by sharing our various resources. There is enough expertise, the problem remains of how to utilise it and co-ordinate it.
>
> <div align="right">(Aldridge 1999: 25)</div>

So we urge you to collaborate rather than ploughing on isolated and lonely. There are difficulties in collaborating, and also wonderful rewards. In our own collaboration, our differences in research backgrounds and ways of thinking have helped us to sharpen our thoughts. Were we to keep our ideas private, this book (and other papers) would not have happened: Gary loves ruminating, reflecting and quoting philosophy, while Mercédès doodles and is slightly addicted to numbers and charts. We trust one another, have splendid arguments, agree to disagree – and revisit our ideas at Café Mozart over sachertorte and gossip. Our disagreements help us to think more incisively, and our reliance on one another's minds to be critical allows us to 'test' undeveloped ideas on one another.

We both agree that our own experiences of research even at PhD level have taught us to think slowly and carefully, to be organised (more or less), and to want to know what others think about our work. But to know what others think, we need *them* to publish, to have access to their thinking and research processes – to help us to refine our own. This does not mean that we need to agree with, or be convinced by, what we read – some writing is terrifically inspiring, and some makes us wring our hands in despair. Each of these can be useful in developing our work, if we're able to read and listen to others' work with an open yet critical mind. And we then owe it to others to write our responses to their work.

On a more sober note, we need to remember that our various arts therapy professions need some substantial, rigorous research. Managers, directors, auditors – those with financial responsibilities within health, community and education structures – may not be familiar with (or interested in) the inner workings of what we do, but they certainly want assurances about the quality and effectiveness of our work. Also, as funders generally become more insistent on 'evidence' that what we do makes a difference, and that it makes economic sense to support our work, it is no longer enough for us just to be practising and presenting our work. The 'Wow!' is over. Most people – the general public – are now informed in one way or another about the arts therapies; many professionals in allied fields are familiar with our work, through direct working relationships with us.

Part of providing 'evidence' about the arts therapies in a wider context is to publicise our research. Our research writing needs to be contextualised within rigorous theoretical thinking; clarifying its overlaps with – and distinctions from – other existing studies; demonstrating that, for example, it is perhaps more than the aesthetic experience that happens to heal, as both Suzie and Franz so courageously managed to explore.

As you've gathered (since you've got this far), writing does not happen within a void, but with readers in mind. Just as we've kept you in mind throughout our process of redrafting our chapters, by imagining what kinds of questions, curses and compliments you might be sending our way – you, as reader, need to keep in mind what *you* want to say; how *you* respond to what we've written. In other words, as a writer, you need to remember that reading is not simply a passive, receptive exercise, but is potentially dynamic, interactive, contrapuntal, canonic, polyphonic. You cannot say something within a theoretical or professional void: our disciplines have generated a world of research out there – waiting to be read, and commented on – by you. In fact, this research *needs* you to read and respond to it, just as your own writing will call upon others to respond, criticise and possibly challenge.

In other words, we're proposing that, as arts therapy students, practitioners, teachers and researchers, we all form a community of inquirers – working with the information and wisdom which our collective practice generates, and from which we can all gain. But we must all contribute to this community in order to ensure that its freshness and imagination does not wither or atrophy.

We've provided you with an introductory guide specifically tailored to arts therapists rather than to a broader readership; a hands-on book that will accompany you along your research path. Remember that this text is not meant to be comprehensive – since reinventing parts of the wheel is futile. Excellent and helpful background and complementary texts exist, and we've pointed you towards them several times.

It is our hope and our wish that this book will encourage and inspire you to begin contributing to inquiry, exploration, debate and argument, by shedding your preconceptions about what research is and is not. And by whole-heartedly, and with passion, embarking on your own journey of discovery. As an arts therapist you already know about passion and discovery, and about the unexpected. We invite you to use these qualities to colour, extend, challenge and shift your own practice and our common thinking – by writing and sharing your research with us all.

> *Suzie picks up the phone. It's Franz.*
>
> *'Suzie, I just wanted to give you my good news! John Audit called to say that his board was suitably convinced by my evaluation and I can work at Ivory Leaves three days a week for a three year period.'*
>
> *'Wonderful, Franz! That's really good news.'*
>
> *'Pity you have to wait all summer to get a verdict on yours,' says Franz.*
>
> *Suzie's actually forgotten there was a verdict. But then thoughts of Porschia Tutoria picking away at every loose end of her work come to mind.*
>
> *'Oh what the hell!' says Suzie. 'It's holiday time now, time for a bit of play after a very hard year…talking of which, have you made any plans for going away?'*
>
> *There is another of those pauses.*
>
> *'Well, actually, I have made a plan,' says Franz, 'I was going to tell you, we're going to Patmos on Friday.'*
>
> *'We…?'*
>
> *'Yes, me and…er…Peter.'*

'Peter who?'
The penny drops. Suzie blushes…and then she smiles.

Moral

Franz and Suzie's story is a caution that the evidence is usually there, but we may not attend enough – or may want to believe otherwise for a variety of reasons. The true researcher lets the evidence speak, lets it lead us where it will.

Bibliography

As we've said throughout this book, you need to hunt out the specialist texts in your own discipline, as those listed below are somewhat biased to the music therapy literature. Material indicated with an asterisk below we particularly recommend as more general starting points to your reading.

Aigen, K. (1993) 'The music therapist as qualitative researcher.' *Music Therapy 12*, 16–39.

Aigen, K. (1995) 'Principles of qualitative research.' In B. Wheeler (ed) *Music Therapy Research: Quantitative and Qualitative Perspectives*. Gilsum, NH: Barcelona.

Aldridge, D. (1996) *Music Therapy Research and Practice in Medicine*. London: Jessica Kingsley.

Aldridge, D. (1999) 'Developing a community of inquiry.' *Nordic Journal of Music Therapy 8*, 1, 26–36.

*Banister, P., Burman, E., Parker, I., Taylor, M. and Tindall, C. (1994) *Qualitative Methods in Psychology: A Research Guide*. Buckingham: Open University Press.

Banister, P. (1994) 'Discourse analysis.' In P. Banister, E. Burman, I. Parker, M. Taylor and C. Tindall *Qualitative Methods in Psychology*. Buckingham: Open University Press.

*Barley, N. (1986) *The Innocent Anthropologist*. Harmondsworth: Penguin.

*Bell, J. (1993) *Doing Your Research Project*, 3rd edn. Buckingham: Open University Press.

Brown, S. and Pavlicevic, M. (1997) 'Clinical improvisation in creative music therapy: musical aesthetic and the interpersonal dimension.' *The Arts in Psychotherapy 23*, 5, 397–405.

Bruscia, K. (1995) 'Differences between quantitative and qualitative research paradigms: implications for music therapy.' In B. Wheeler (ed) *Music Therapy Research: Quantitative and Qualitative Perspectives*. Gilsum, NH: Barcelona.

*Coffey, A. and Atkinson, P. (1996) *Making Sense of Qualitative Data: Complementary Research Strategies*. London: Sage.

Douglas, J. (1985) *Creative Interviewing*. Beverly Hills, CA: Sage.

*Edwards, A. and Talbot, R. (1999) *The Hard-pressed Researcher*. London: Longman.

Everitt, A., Hardiker, P., Littlewood, J. and Mullender, A. (1992) *Applied Research for Better Practice*. London: MacMillan.

Forinash, M. and Lee, C. (1998) 'Editorial.' *Journal of Music Therapy 35*, 3, 142–149.

*French, S. (1993) *Practical Research: A Guide for Therapists*. London: Butterworth and Heinemann.

Grainger, R. (1999) *Researching the Arts Therapies: A Dramatherapist's Perspective*. London: Jessica Kingsley.

Greene, J. and D'Oliveira, M. (1982) *Learning to use Statistical Tests in Psychology*. Milton Keynes: Open University Press.

Harris, P. (1986) *Designing and Reporting Experiments*. Milton Keynes: Open University Press.

Lincoln, S. and Guba, E. (1985) *Naturalistic Inquiry*. Beverly Hills, CA: Sage.

McLeod, J. (1994) *Doing Counselling Research*. London: Sage.

Maranto, C. (1995) 'Ethical Precautions.' In B. Wheeler (ed) *Music Therapy Research: Quantitative and Qualitative Perspectives*. Gilsum, NH: Barcelona.

Nattiez, J-J. (1990) *Music and Discourse: Towards a Semiology of Music*. Princeton, NJ: Princeton University Press.

*Orna, E. and Stevens, G. (1995) *Managing Information for Research*. Buckingham: Open University Press.

Pavlicevic, M. (1997) *Music Therapy in Context: Music, Meaning and Relationship*. London: Jessica Kingsley.

Potter, J. and Wetherell, M. (1987) *Discourse and Social Psychology: Beyond Attitudes and Behaviour*. London: Sage.

Reason, P. and Rowan, J. (1981) *Human Inquiry*. Chichester: John Wiley.

*Robson, C. (1993) *Real World Research*. Oxford: Blackwell.

Ruud, E. (1998) *Music Therapy: Improvisation, Communication and Culture*. Gilsum, NH: Barcelona.

Sacks, O. (1985) *The Man who Mistook his Wife for a Hat*. London: Duckworth.

Shah, I. (1985) *The Exploits of the Incomparable Mulla Nasrudin*. London: Octagon.

*Sher, G. (1999) *One Continuous Mistake. Four Noble Truths for Writers*. London: Arkana.

Siegel, S. (1956) *Nonparametric Statistics for the Behavioral Sciences*. New York: McGraw-Hill.

*Silverman, D. (1993) *Interpreting Qualitative Data*. London: Sage.

Smith, J., Harré, R. and Langenhove, L. (1995) *Rethinking Psychology*. London: Sage.

Wheeler, B. (1995) *Music Therapy Research: Qualitative and Quantitative perspectives*. Gilsum, NH: Barcelona.

Yin, R.K. (1989) *Study Research: Designs and Methods*. Beverly Hills, CA: Sage.

Subject index

Author index